W9-BZB-404

# GRAPHIC DESIGN BASICS

### THIRD EDITION

## AMY E. ARNTSON

*University of Wisconsin–Whitewater*

HARCOURT BRACE COLLEGE PUBLISHERS

Fort Worth   Philadelphia   San Diego   New York   Orlando   Austin   San Antonio
Toronto   Montreal   London   Sydney   Tokyo

|                        |                                    |
| ---------------------: | ---------------------------------- |
| Publisher              | CHRISTOPHER P. KLEIN                |
| Acquisitions Editor    | BARBARA J.C. ROSENBERG             |
| Product Manager        | PAT MURPHREE                       |
| Developmental Editor   | DIANE DREXLER                      |
| Project Editor         | LAURA J. HANNA                     |
| Art Director           | CANDICE JOHNSON CLIFFORD           |
| Production Managers     | MELINDA ESCO, DEBRA JENKIN         |

Cover image and chapter opener images: M.C. Escher, *Metamorphosis III*, © 1997 Cordon Art-Baarn-Holland. All Rights Reserved.

ISBN: 0-03-018734-6
Library of Congress Catalog Number: 97-70871

Copyright © 1998, 1993, 1988 by Holt, Rinehart and Winston.

All rights reserved. No part of this publication may be reproduced or transmitted in any form or by any means, electronic or mechanical, including photocopy, recording, or any information storage and retrieval system, without permission in writing from the publisher.

Requests for permission to make copies of any part of the work should be mailed to: Permissions Department, Harcourt Brace & Company, 6277 Sea Harbor Drive, Orlando, Florida 32887-6777.

Address for orders:
Harcourt Brace College Publishers
6277 Sea Harbor Drive
Orlando, FL 32887-6777
1-800-782-4479

Address for editorial correspondence:
Harcourt Brace College Publishers
301 Commerce Street, Suite 3700
Fort Worth, TX 76102

Web site address:
http://www.hbcollege.com

Printed in the United States of America

9  0  1  2  3  4  5  6      039      9  8  7  6  5  4  3

# PREFACE

*Graphic Design Basics* introduces students to an exciting and demanding new field. Design is linked tightly to society as it both reflects and helps to shape the world around us. Designers are part of this dynamic, important process. To enter this field requires discipline-specific information, hands-on practice and an understanding of time-honored principles. The third edition of this text continues to weave a concern for design principles with specialized information about applications in the field of graphic design.

Students will find a comprehensive introduction to the field of graphic design that stresses theory and creative development as well as production techniques. The third edition includes more color plates and many new, beautiful visuals that reflect current stylistic directions. Although graphic styles are constantly evolving, the structural underpinnings of good design remain constant. Their application leads to successful design solutions. The new designs and illustrations are shown with the best work from the history of twentieth-century design.

The tools of the graphic design field are evolving quickly now, offering electronic opportunities for new complexities of layering, manipulation and communication. The third edition of *Graphic Design Basics* integrates information about computer graphics throughout the text and includes a guide to generating successful files for electronic prepress.

*Graphic Design Basics* introduces the form and function of graphic design to students who have little background or understanding of its nature. It works well for courses in the field of design, as well as related courses dealing with visual communication and advertising. Projects and exercises challenge the student to internalize the lessons in the text and to learn by doing. Chapters 1 and 2 present an introduction to the design process and the last one hundred years of design history. Chapters 3, 4, and 5 discuss the vital principles of perception, dynamic balance and Gestalt, and how they relate to graphic design.

Chapters 6 and 7 focus on design principles and applied skills in the special areas of text type and layout design. Illustration and photography (traditional and electronic) are now combined in Chapter 8. The boundaries between these disciplines are less rigid than in the past, especially as electronic media makes photographic manipulation, drawing tools and typography available to a broad range of professionals. Advertising Design is covered in Chapter 9 with new samples of a complete, integrated campaign. Chapters 10 and 11 contain extensive new material on computer graphics. Traditional and electronic color are discussed in Chapter 10 with information about color theory and its application both on and off the computer. Traditional and electronic prepress production are covered in Chapter 11,

with a step-by-step guide for creating successful electronic prepress documents. This section is extensively updated in order to keep pace with rapidly changing practices in the field.

The pedagogical features in *Graphic Design Basics* are useful for both students and instructors. The extensive Glossary explains technical terms and has been revised and updated to include new computer-related terms. The Bibliography opens the door to further discoveries and is helpfully arranged by chapter. The Index provides a ready access to locating topics.

Thank you to the following reviewers for their help in preparing this edition: David Andrus, John Brown University; Theo Becker, Napa Valley College; Peter Bushnell, Illinois State University; Jacque Dellavalle, Daytona Beach Community College; Judith Landsman, Bergen County Community College; Terry Roller, Baylor University; Susan Russo, Youngstown State University.

A.E.A.

# ABOUT THE AUTHOR

Amy E. Arntson is a Professor of Art at the University of Wisconsin–Whitewater, where she teaches design and illustration. Her art and design is exhibited nationally and internationally. Her recent presentations on the nature of design and perception have been given in China, England, and Costa Rica, as well as in the United States, from New York to California. Professor Arntson has twenty-five years of experience as artist, designer and educator.

# CONTENTS

# GRAPHIC DESIGN HISTORY 15

# PERCEPTION 39

# TOWARD A DYNAMIC BALANCE 53

CHAPTER FOUR

# "GOOD" GESTALT 73

CHAPTER FIVE

# CHAPTER EIGHT

## ILLUSTRATION AND PHOTOGRAPHY IN DESIGN 143

# CHAPTER NINE
# ADVERTISING DESIGN 165

# CHAPTER TEN
# THE DYNAMICS OF COLOR 175

# PRODUCTION: THE TOOLS AND PROCESS  189

CHAPTER ELEVEN

# GRAPHIC DESIGN BASICS

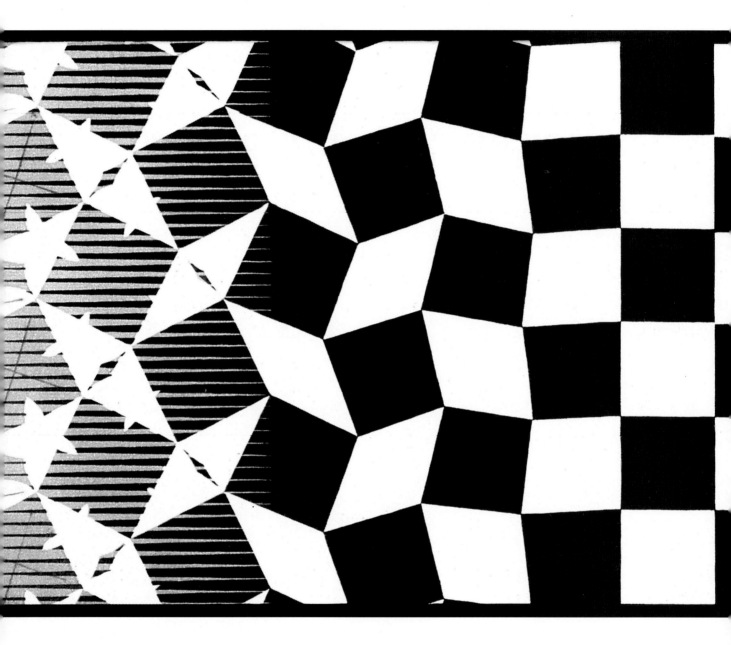

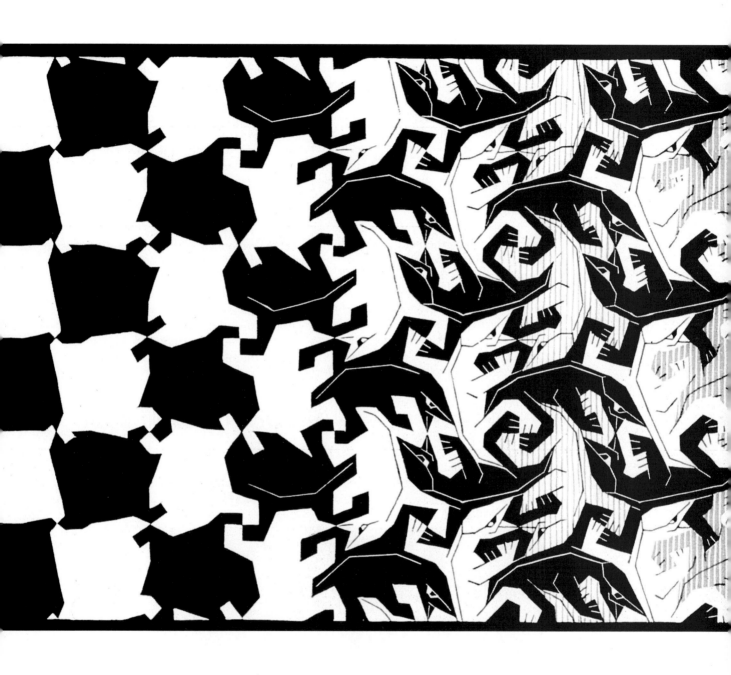

# APPLYING THE ART OF DESIGN

## PRINCIPLES AND PRACTICES

This book is about applying the *principles* of visual perception to the *practice* of visual communication. The premise is that a course of study in graphic design should begin by applying the principles and theory of basic design. Interwoven with information about how we perceive and shape a two-dimensional surface will be its application to graphic design problems.

Information from one college class is still pertinent in the next. Although you will be learning special information and terminology in this text, you will discover how closely it ties in with the basic theory of design you already know.

Problems in graphic design almost always relate to communication. There are methods of making a design hold together as a unit to communicate information. This text will discuss them in simple and straightforward language. Readers will discover how applying basic design principles enhances visual communication. You will also explore the nature of visual perception, the role of visual illusion, and the contrast between visual and verbal communication, as well as the full range of basic design skills.

Visual arts in general and two-dimensional disciplines in particular share a common language. The study of shapes on a flat ground has yielded a great deal of information about how we see and interact with the image on the page. You will learn to apply this universal information to solve graphic design problems.

A designer is not in search of one solution, but of several. There is no one correct answer in graphic design, but a rich set of possibilities. This book presents principles like Gestalt unit-forming, balance, emphasis, and eye direction as tools, not as rules. Use them to increase your options and widen your vision. These methods may become intuitive after a while, but in the beginning you will need to study and consciously apply them.

## WHAT IS GRAPHIC DESIGN?

Graphic design is problem solving on a flat two-dimensional surface. The designer conceives, plans, and executes

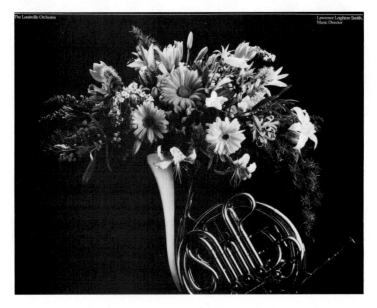

1·1 **Julius Friedman.** The Louisville Orchestra. Photograph from PW, Inc. Courtesy of the artist.

designs that communicate a specific message to a specific audience within given limitations—financial, physical, or psychological.

A poster design, for example, may be restricted to two colors for financial reasons. It may be physically restricted in size because of the press it will be run on or because of the mailing method. It may be restricted psychologically by the standard viewing distance for a poster in a hall or store window, or by the age and interests of the group for which it is intended. Nevertheless, the designer must say something specific to a given audience about a given product or piece of information. Communication is the vital element in graphic design.

It is this element of communication that makes graphic design such an interesting and contemporary area. Designers must present current information to modern taste with up-to-date tools. They must stay informed about trends, issues, inventions, and developments. What is the impact of computer-aided design? How will film, television, holograms, and computers integrate? Will designs be delivered by computer direct to their destination? Will print become obsolete? What about digital presses?

Design education is a lifetime activity. Constant change will require constant renewal. It is not a career for a slow-paced, nostalgic person. To keep up with this fast-changing field you must approach the basic principles and practices with a flexible, curious mind.

## VALUES

Our current society is based on processing information more than producing goods. The product a designer helps to sell, the information disseminated, the point of view illustrated, and the mode of communication all contribute to shaping the world. It is a good idea to ask early in your career (now would not be too soon) where you stand on certain

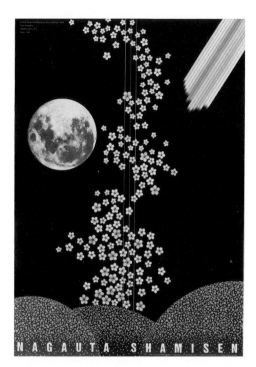

1-2 **Kazumasa Nagai** (Nippon Design Center, Inc.). Design for UCLA Asian Performing Arts Institute. Courtesy of the artist.

issues. You will be making career decisions that shape your life and the character of our society. Figure 1-1 is an example of design work that helps to advertise and support a not-for-profit arts organization.

A successful designer vividly described one of his early career decisions. His first job out of college was as a junior designer at a small advertising firm, where he was put to work designing a hot dog package. After preparing several roughs, he presented them to the client, only to be sent back to the drawing board. Rejected time after time, the designer grew more familiar than he ever wanted to become with hot dogs. He persevered, learned the basics, and now has his own firm specializing in educational and service-oriented accounts. This allows him more creative freedom and work that is consistent with his personal values.

The Japanese artist Kazumasa Nagai created the design in Figure 1-2 for the UCLA Asian Performing Arts Institute.

Such a client gives the designer an unusual degree of creative options.

Most design jobs, however, do not offer a vast field for the exercise of creative freedom. For the most part, we're designers working in a consumer society. However, it is important that while acquiring design skills we also consider the relationship between the condition of our society and the production and marketing of consumer goods. Designers are an integral part of that process. The major artistic movements of the twentieth century each had a theory of society that provided a structure and direction for their artwork. The futurists, constructivists, Dadaists, and surrealists actively helped to define their society and their role in relationship to it. As designers, we have a vital role in our society that needs to be constantly examined as it shifts and changes in the twenty-first century.

Creating a design that is appropriate for a given product and its audience may

not always give you an opportunity to exercise your own sense of aesthetics. (Laying out a motorcycle products catalog may not provide much of an opportunity to experiment with visual effects.) In addition to directing the visual to a particular audience, the individual client's preferences often also need to be considered. In the face of all the compromises that must be made, it is good to keep sight of your own goals and not become frustrated early in your career. There are many different kinds of jobs in this field, and most beginning designers should plan on staying at their entry position only until the skills required in that job have been mastered and experience gained.

Each of us must satisfy our own values in our career path, as well as learn to satisfy the requirements of the workplace. Keep your goals in sight. Are there products or points of view you do not want to promote? Is there something you do want to promote? How important

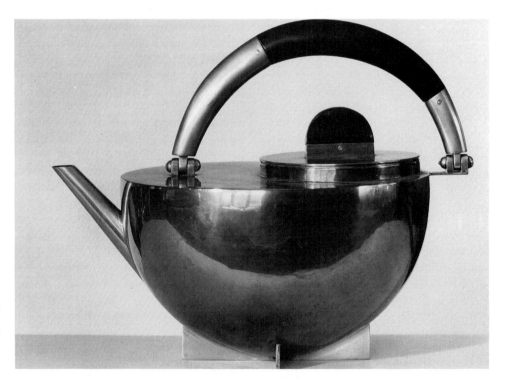

1-3 **Marianne Brandt.**
*Teapot.* 1934. Brass, 7″
(17.5 cm). Staalich
Kunstammlunger,
Weimar.

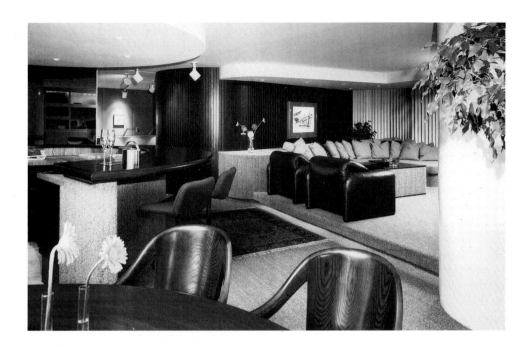

is salary? What will make this career successful for you? What kind of lifestyle do you want for yourself? How hard are you willing to work for it? Where do you want to be in 10 years?

## DESIGN FIELDS

The field of applied design includes industrial design, environmental design, and graphic design. *Industrial design* is the design and development of three-dimensional functional objects (Figure 1-3). Machines, tools, kitchen implements, and other products are shaped by the industrial designer. Package design for these objects is often placed in the category of graphic design because it must be designed and printed flat before assembling. The industrial designer attempts to simplify the use and manufacture of objects as well as increase their safety and efficiency.

*Environmental design* is a large general category that includes the design of buildings, landscapes, and interiors.

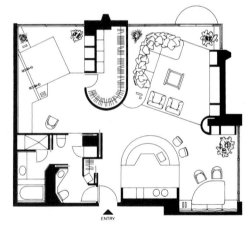

1-4, 1-5. **David Saylor** (ASID). Interior and floor plan of the Cohen apartment, Milwaukee. Photo by Jim Threadgill. 1983.

Again, the designer attempts to fashion designs that are safe, efficient, and aesthetic. In the unified, flowing floor plan shown in Figures 1-4 and 1-5, curves and angles and varying levels are used as unifying elements.

*Graphic design* is the design of things people see and read. Posters, books, signs, billboards, advertisements, commercials, brochures, and Web sites are things graphic designers create. They attempt to maximize both communication and aesthetic quality.

Buildings, environments, products, and written communications will affect us whether they have been deliberately designed or not. Design cannot be eliminated. The printed piece will always communicate more than its words. It may, however, communicate exactly the opposite of the intended message. It can damage the image of a company or cause. Learning to apply the *theory* of design and information processing to the *practice* of graphic design will help you achieve the intended communication.

Designers must interface with fields other than their own. They must learn to address the basic marketing concerns of the client, the problems of special workers such as illustrators or photographers, and the difficulties of the printing process.

Some graphic designers do a whole range of work—typography, illustration, photography, corporate identity, logo design, and advertising. Others specialize in one area.

While many illustrators do design work, and many designers do illustration, it is important to realize that illustration and design are different fields of expertise. Chapter 8, on illustration and photography, provides background information specific to those areas. Problems in any area, however, can best be solved by following the design process.

# THE DESIGN PROCESS

## RESEARCH

The first step in preparing a design solution is determining the parameters of the problem. Who is the audience? What constraints are there in format, budget, and time? What is the goal of the project?

Now you must gather and study all the related materials you can find. Selling this design to a client (or an instructor) will be easier if it is backed with research and justified from a perspective the client will understand. In the future, you may work in a large firm or agency where most of the research and information gathering is done by marketing professionals. Visual research, however, both then and now, is your area. It's important to know what has been done before and what is being created locally and nationally for this type of design situation. Develop a feeling for contemporary work by studying design annuals and periodicals.

Keep a file of anything that is interesting or well done. A personal file of such samples can be useful to look through when you are stuck for ideas. Subscribe to graphic design magazines and plan to save all the back issues. Never simply lift another designer's solution; that is unethical. Lifting isolated parts from someone else's work will not give a unified design, and lifting the entire solution will be immediately recognizable as plagiarism. Looking at how someone else solved a particular problem, however, is part of your education. Designers are expected to build upon the work of others. We do not create in a vacuum. We are influenced by the hundreds of samples of good and bad design we are all exposed to every day.

Expand your visual vocabulary and plan to use that vocabulary to build new and reactive designs. A colleague describes the process as similar to that of an author using a verbal vocabulary developed over time. These elements are used to create an original story. An author does not have to create a new alphabet or a new language in order to create an original piece of literature. As part of the research stage, search for a creative approach to your design problem in as many ways as possible. Build your visual and conceptual vocabulary. Try looking up a dictionary definition of your topic. Look in an encyclopedia for addi-

tional background. Search the World Wide Web for information on the topic. Use a thesaurus. Make a word association list of everything you can think of that is associated with your topic.

## THUMBNAILS

A designer needs to explore many alternative solutions. Thumbnails are the second step in the design process. Thumbnails are idea sketches; they are visual evidence of the thinking, searching, sorting process that brings out solutions.

Exercising the mind with thumbnail sketches is like exercising any muscle.

The more it is exercised, the more powerful it gets. The more you work to develop ideas through small preliminary sketches, the richer the range of solutions available to choose from for the final design. Never shortcut this stage, because it determines the strength of the final solution. For a student, the thumbnails are more important than the final project, because they demonstrate thinking, experimentation, and growth. Keep these thumbnails. The ideas in them may be of use to you later. Prospective employers may wish to see evidence of the flexibility and tenacity of your thinking (Figure 1-6).

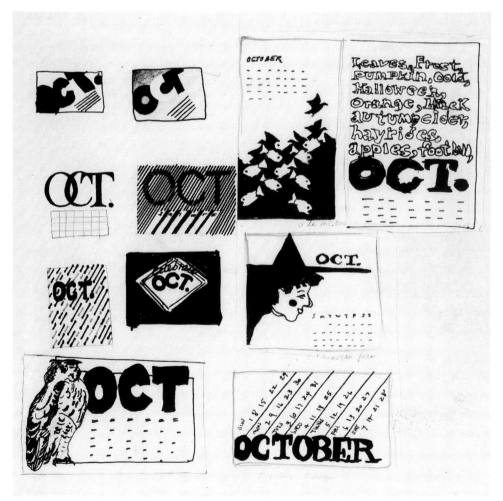

**1-6 Amy E. Arntson.** Thumbnail designs for October calendar.

Thumbnails are usually small because they are meant to be fast and undetailed. They are around 2″ × 3″ (5 × 8 cm) and drawn in proportion to the dimensions of the finished piece. Fill a sheet of paper with ideas. Never reject an idea; just sketch it in and go on. Work through the idea with your pencil from every perspective you can imagine. Then try taking one good idea and doing several variations on it. Tracing paper or lightweight bond is excellent for this purpose. You may also want to cut and paste and recombine existing images for new effects. It may be faster to work at a size determined by existing elements, so the thumbnails may become larger or smaller. The principle of "sketching" through ideas holds true no matter what the size or format of your preliminary investigation. Be as neat and precise as is necessary to show the relationship between elements and their general shapes. The stages of thumbnails, roughs, comps,

and camera-ready art, however, often blend together when exuted on a computer. The danger with this blending is that, while software may help provide quick, workable solutions, it can be tempting to shortcut the planning stages. Thumbnails are vital to good design, no matter how they are produced, in whatever size or stage of polish. Even if they are created while sitting at a monitor, they must continue to exhibit flexible, tenacious, visual thinking (Figure 1.7).

## ROUGHS

Once the range of ideas has been fully explored, select the best two or three thumbnails for refinement. You may want to talk this choice over with other designers and with your instructor. Later, as a professional designer, you will be presenting roughs to an art director or a client for review, or you may be reviewing someone else's design. Often

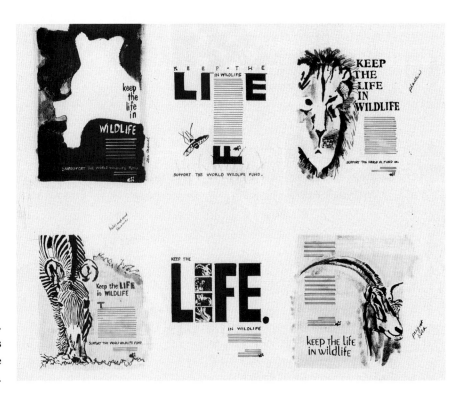

1·7 **Amy Sprague.** Thumbnail sketches for wildlife advertisement.

considerable redefining and rethinking occurs at this stage. The thumbnail process may begin all over again.

On a computer, you may want to do a full-size rough. The purpose is to test whether the idea still works on a larger scale. Take this opportunity to work out small problem areas that could not be dealt with or foreseen at the thumbnail stage. The type style, the other shapes, the exact proportional relationship of these elements to the edge of the format, and the color and value distribution can all be refined at this stage (Figure 1-8).

## COMPREHENSIVES

The comprehensive or "comp," the fourth step in the design process, is the piece of art that you will present to the client for final approval. Based on the rough, it is much more carefully done. Once again, consult with art directors, editors, or the instructor before choosing the rough idea to refine.

The client is able to judge the design solution from the comp because it looks much like the finished printed piece. There is no need to explain "what would go there" or how "this would be smoother." A comp might include photographs shot to size, computer generated type, silkscreen printing, tight illustrations, pen and ink rendering, or a totally computer-generated design. Polish to sell your idea.

In most projects from this text, the comp will be the final step. These comps will be the basis of your portfolio that you will develop throughout future classes.

Comps take different forms depending upon the media for which they are intended. Television and film ideas are presented as storyboards with key scenes drawn in simplified and stylized fashion or as abbreviated animation. The three-dimensional comp for a package design

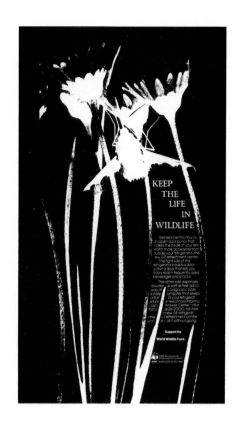

1-8 **Amy Sprague.** Rough design for wildlife advertisement.

may be presented in multiples in order to demonstrate the stacking display possibilities of the package. A publication such as an annual report or a newsletter will usually be represented by the cover and certain "key" pages in the layout design. Computer design makes it possible to send a rough or a comp to a client for approval via disk, modem, or fax. This streamlines the process and makes the designer and client's locale a less important consideration (Figure 1-9).

## PRESENTATION

Practice "selling" your concept verbally before you present it. Demonstrate that you understand the client's perspective and goals. Discuss your design enthusiastically in terms the client can understand. Be prepared, however, to listen and to compromise. If revisions are called for, note them carefully. Figures

*Just Follow the Trails*

**The Domes**
*Milwaukee, WI*

1-9 **Jenice Carolan.** Comprehensive design prepared as a magazine advertisement for botanical gardens. Original photo scanned on Macintosh, retouched and incorporated with ad slogan.

1-7 and 1-8 show a student's thumbnails and rough for a magazine advertisement.

## CAMERA READY

The job is now ready for production. The comprehensive you have shown to the client may look exactly like the finished piece, but it cannot be used to produce the final printed product. Everything must be sent to the printer "camera ready," by either traditional mechanical means or by electronic file transfer.

If the job is to be printed via traditional mechanical means, it must be converted into a black and white print. All headline and text type must be set and pasted precisely into position. All illustrations and photographs must be indicated precisely for positioning and resizing, and sent with the job. Printer's inks must be indicated, as well as paper selection. A separate flat or overlay must be prepared for each process ink color (unless you are working with four-color reproduction).

If the job is to be printed as an electronic file, the file must be cleanly prepared, with all links and fonts included. Electronic files that print well inside a classroom may not "rip" on an imagesetter. The disk that contains the file must be carefully prepared. Chapter 11 on production discusses this topic, as well as covering information on the traditional mechanical processes.

The designs you create should be based upon a sound knowledge of the reproduction and printing process. Develop a respect for tools and procedures, since no design is successful if it is flawed in execution. Begin your very first project with a respect for precision, accuracy, and cleanliness. There can be no compromise with perfection in this line of work.

Many designers are responsible for selecting and dealing with a printer. Often the work must be "bid" to two or three printers, giving each an opportunity to estimate costs. Selecting printing firms to bid for the work is often based

upon prior experience. A designer unfamiliar with a printing firm should ask to see samples of its work, especially samples with production problems similar to those of the new job. Quality in printers, like quality in designers, will vary. Finding a good printer and establishing an easy working relationship is important. A good printer can be an excellent reference for answering tricky production questions and suggesting alternate solutions to an expensive design.

# CAREERS

A variety of working environments occur in the design field, with varying advantages and limitations. What suits one person may feel like a limitation or undue pressure to another. It is important for the new designer to have an idea of what to expect before beginning a job search.

## DESIGN STUDIOS

Clients with various needs and backgrounds may seek the assistance of a design studio. The studio will have designers, keyliners, account service representatives, and often illustrators and photographers on staff or on call. Design studios hire freelance creative help when their regular staff is too busy or lacks specific skills to handle a project. Designers working in a studio generally have other artists around to discuss and share ideas. The number of working hours spent on each assignment is logged and the time billed to a client's account or to the studio itself. A high value is placed on an ability to work quickly and with a clear understanding of the client's needs and preferences. Clients consist primarily of various advertising agencies and large and small companies or institutions. The graphic design work pre-pared for these clients includes brochures, mailers, illustration and photography, catalogs, and display materials.

Many small studios are springing up as computers make it easier for one or two people to provide full-service design.

## IN-HOUSE DESIGN

Many institutions employ their own in-house design staffs. These in-house designers serve the particular needs of institutions ranging from hospitals, banks, newspapers, insurance companies, publishers, colleges and universities to large and small manufacturing concerns. In-house design organizations vary greatly according to the type of product or service their company provides. Designers work on projects that relate to the parent corporation's activities. Individual designers may keep track of their hours, if the design area bills its time to other departments. Many in-house operations offer services free to departments within the company. Individual designers may work closely with the client, or receive all information and instructions funneled through an art director. It is sometimes possible to develop a corporate career by moving up within the organization. An in-house design organization may lack the presence of other artists and the challenge of interpreting and representing various clients that a design firm provides. However, an advantage to working in an in-house operation is the opportunity to get to know one company in depth by developing a relationship with it and its various departments. Oftentimes the deadline pressure is less and the job security better than in a studio. Computer-based design has caused a boom in this area as more and more companies find it possible to meet many of their publication needs in-house.

Many positions exist for designers at area printing companies. These compa-

nies sometimes have their own in-house design departments or will hire graduates to do prepress work. A printing company can be an excellent place to gain valuable experience in the technical aspects of reproduction.

## THE ADVERTISING AGENCY

Ideas and sales are the cornerstones of the advertising agency. It is dominated by people who deal in words. Account executives bring in the jobs and develop the advertising concepts with the creative director. The art director, designer, and copywriter execute the concepts, although the number of people involved and the exact tasks performed vary from agency to agency. Projects cover all forms of print and multimedia advertising, from film and video work to packaging, display, print ads, billboards, and Web sites. A good art director is versatile. He or she is skilled at conceptualizing and presenting ideas verbally and visually as well as directing others and organizing assignments. More money is spent on advertising than on any other area of graphic design, and this is reflected in the salary a designer can expect to earn in this field.

## FREELANCE

Working as a freelance artist allows a maximum amount of freedom, but calls for certain business-related skills. Personal promotion, networking, and a constant vigilance to find new customers will help establish a freelance career. Good organizational skills in billing and record keeping along with talent and hard work will keep a freelance business going. Computers, modems, and fax machines make it possible to live outside a metropolitan area and still maintain client contact, once it is established.

## NEW OPPORTUNITIES

Every situation is unique, and this is a generalized description of the types of situations in which a designer can find employment. Many, many variations occur within these categories. The continued growth of computer-aided design is opening up new opportunities in the design field. Web pages increasingly call for design skills with page layout, logo design, scripting, illustration, typography, and animation. Many companies now use the Internet to communicate with prospective clients, and designers play an important part in facilitating this communication.

## THE CHALLENGE

The challenge of being a designer involves working through the restrictions and demands of the design process. It involves visualizing the job although the actual finished product will not be done by hand, but on a press with printer's paper and inks, with elements that may have been photographed or drawn by other artists, and with copy written by others. (Or it may be shown at a Web site or via another electronic mode of presentation.) It involves meeting personal design standards as well as the needs of the client and the audience. It calls for organization and self-discipline to meet the constant deadline pressure. In the classroom, students generally get one project at a time and a generous length of time to complete it. The emphasis in school is on learning. On the job, however, designers will work on several projects at once and must uphold design standards while concentrating on time and money issues. A good education in design fundamentals that stresses theory and creative development as well

as production techniques is important in this environment. It is vital that a designer constantly update his or her education and stay current with new technologies. Technology has made major changes in the design field the past several years, and greater changes are on the way. There is a discussion of these changes at the end of Chapter 2, Graphic Design History.

Your final challenge is to take a responsible stance in the world. Knowledge of current events and attitudes will help you to create designs that reflect and affect society. Traditionally, it has been the fine-arts artist who has set new visual trends and opened fresh creative ways to see ourselves. The designer now also plays this role (see Figure 1-10). One of the issues facing contemporary design is the impact of our product on the environment. Recycled paper products are part of an attempt to lessen the negative impact of printed materials on the environment. The aesthetic qualities of design affect our lives in many ways, but the total effect of a design solution has numerous varied and important impacts on our lives.

Designers are in the process of redefining their field. We need to examine how our culture functions, and how both our perceptions and our values shape and are shaped by the world around us.

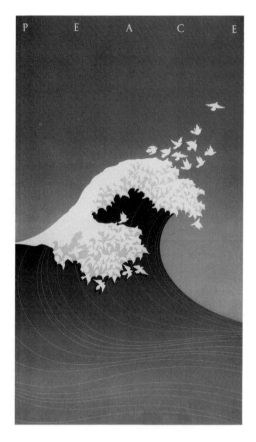

1-10

*Wave of Peace* poster design by **McRay Magleby.** Courtesy of the artist.

# EXERCISE

Research the types of employment opportunities in your geographic area. Find samples of a design firm, an in-house facility, and an advertising agency. Arrange a field trip to one of each.

# GRAPHIC DESIGN HISTORY

TWO

For a graphic designer the movement of ideas is as important as changes in style. Design is affected not only by artists in other fields but by scientists, psychologists, and new technologies. The study of design history is a relatively new discipline, but it can provide inspiration and insight into the future of design. This chapter's overview will show how design developed both as an art form and as a reflection of society.

## THE BEGINNING

The birth of graphic design could be traced back 30,000 years to cave painting, or about 550 years to Gutenberg's invention of the printing press. Whatever the origin, the explosive development during the last decade of the nineteenth century is a good beginning point for study.

The Industrial Revolution brought about new attitudes and inventions, both of which contributed to the sudden growth of graphic design. A spirit of innovation and progress gave rise to a new interest in providing information to an entire culture rather than only an affluent elite. The growth of population centers, industry, and a money-based economy all increased the need for the dissemination of information. Advertising flourished during this exciting time, and great strides were made in printing. The first photographic metal engraving was invented in 1824; the first halftone screen was made in 1852. Color process work was first successfully printed in 1893. The first automated steam press for lithography was designed around 1868, and the first offset press in 1906.

Advancement in stone lithography work in color in the 1880s encouraged artists to work directly on the stone for multiple reproductions of large-scale posters. They were freed from the stiff, geometric confines of the letter press.

*(bottom left)*
**2-1** **Jules Cheret.**
*Pastilles Poncelet.* 1895. Color lithograph, 21⅜″ × 14⁹⁄₁₆″ (54 × 36.8 cm). Milwaukee Art Museum Collection, gift of Mr. and Mrs. Richard E. Vogt.

*(bottom right)*
**2-2** **Henri de Toulouse-Lautrec.**
*Divan Japonais.* 1892. Color lithograph, 31½″ × 23½″ (80 × 59.7 cm). Milwaukee Art Museum Collection, gift of Mrs. Harry Linde Bradley.

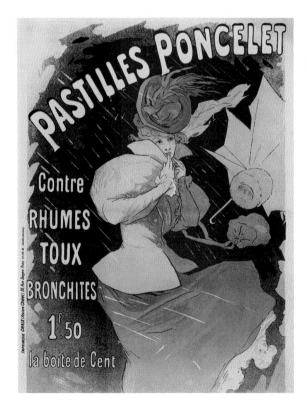

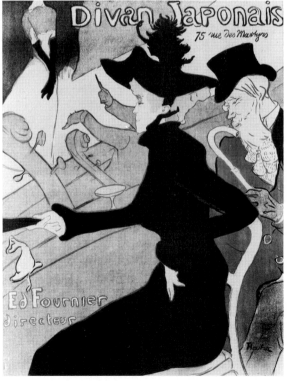

2-3 Trade card. Nineteenth century. Wisconsin Historical Society Iconographic Collection.

The resulting burst of sensual and decorative images in the advertising posters of the 1880s are classified as *art nouveau.* The movement began in France, and the names most closely associated with its development are the Frenchmen Jules Cheret (Figure 2-1) and Henri de Toulouse-Lautrec (Figure 2-2), and the Czech Alphonse Mucha. Cheret himself produced over a thousand posters.

These posters brought art out of the galleries and into the streets and homes of the working class. The illustrations in Figures 2-3 and 2-4 show early United States design flourishing in the form of trade cards.

All of the functional arts grew during this period. In the United States, Lewis Tiffany created stained glass windows, lamps, and glassware. Scottish

2-4 Trade card. Nineteenth century. Wisconsin Historical Society Iconographic Collection.

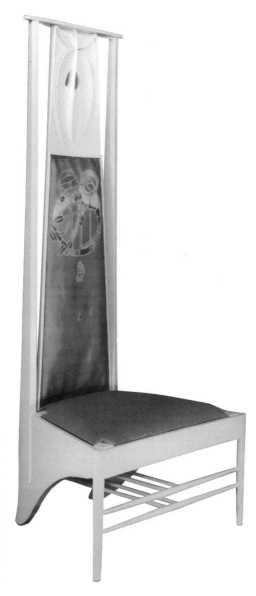

**2-5  C. R. Mackintosh.**
Chair designed for the
Rose Boudoir, Scottish
Section, International
Exhibition of Modern
Decorative Art, Turin,
1902. Courtesy the
Hunterian Museum and
Art Gallery, University
of Glasgow.

sensual line and a compelling tension between the figure and background (Figure 2-6).

Among the many U.S. art nouveau artists is Maxfield Parrish, an illustrator for *Harper's* and *Life* as well as many other clients (Figure 2-7).

Not all reactions to the Industrial Revolution embraced progress. William Morris founded the Kelmscott Press in 1890 against what he regarded as the mass-produced, inferior, inhuman product of the machine. Styles of past eras were being copied in art schools and factories with an emphasis on quantity over quality. He and the writer/philosopher John Ruskin wished to renew an appreciation for hand-crafted, unique, labor-intensive products. Morris worked with every kind of design, including fabric, rugs, wallpaper, furniture, and typography. His highly stylized hand-printed books and tapestries are examples of English art nouveau. Morris was a key

**2-6  Aubrey Beardsley.**
Pen and ink drawing for
an illustration in
Salome. 1894. 8¹³⁄₁₆″
× 6⁵⁄₁₆ ″ (22 × 17 cm).
Courtesy the British
Museum.

architect, designer, and watercolorist Charles Rennie Mackintosh, his wife, Margaret Macdonald, and her sister Frances Macdonald developed furniture and cutlery designs as well as interior and graphic design (Figure 2-5).

An English artist whose work is an important example of art nouveau style is Aubrey Beardsley. His illustrations for Oscar Wilde's *Salome* and other books are characterized by a curving,

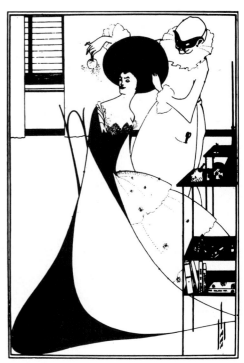

figure in the English Arts and Crafts movement. An intensely romantic idealist, he was deeply concerned with the ethics of art. He is credited, along with the Bauhaus, with bringing about a renewal of the standards of craftsmanship (Figure 2-8).

# THE TURN OF THE CENTURY

The turn of the century brought fundamental changes in our understanding of the world. In 1905 Albert Einstein made public his theory of relativity and altered our ideas of space and time. They became interrelated variables instead of isolated absolutes. After Sigmund Freud published *The Interpretation of Dreams* in 1909, dreams were no longer considered simply fantastic, clearly divided from reality. Sexuality also was no longer safely reserved for the bedroom, but appeared in various symbols in everyday life. The accepted boundaries of reality began to shift.

Existentialism further undermined faith in absolutes by suggesting that there is no single correct answer or moral action. Instead we are individually responsible for shaping meaning.

Meanwhile travel and the growth of a communications network made it possible for us to hear of cultures with different lifestyles, beliefs, and perceptions. This communications explosion continues to be one of the most important influences on society today. As designers we are an important part of its development as we approach the new century. Design is a reflection of society and helps to shape it.

In 1907 Pablo Picasso completed his painting *Les Demoiselles d'Avignon* (Figure 2-9). Pointing the way to cubism, it emphasized the flat surface of the canvas and resembled the symbolic,

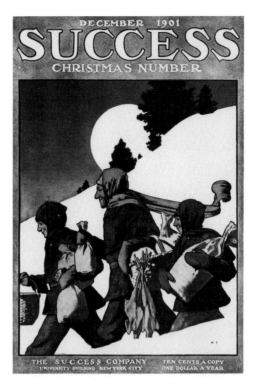

2-7 **Maxfield Parrish.** Cover illustration for *Success* Magazine. December 1901. Rare Book and Manuscript Library, Columbia University.

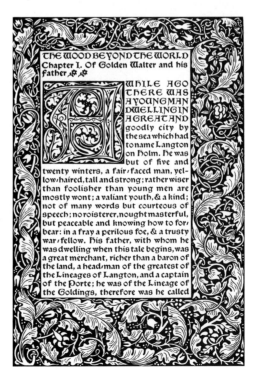

2-8 **William Morris.** Page from *The Wood beyond the World.* 1894. 9½″ × 6¾″ (24 × 17 cm). Kelmscott Press.

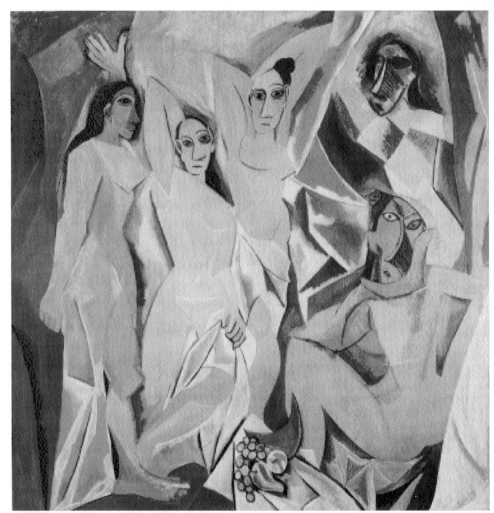

**2-9** **Pablo Picasso.**
*Les Demoiselles
d'Avignon.* Paris
(June–July 1907). Oil on
canvas. 8′ × 7′8″ (243.9
× 233.7 cm). The
Museum of Modern Art,
New York. Acquired
through the Lillie P.
Bliss Bequest.
Photography © 1998
The Museum of Modern
Art, New York.
Copyright 1998 Estate of
Pablo Picasso/Artists
Rights Society (ARS),
New York.

patterned figures of African art. The relationship between the figures and the picture plane itself was ambiguous. As cubism developed, shapes became increasingly abstracted, showing objects from multiple points of view, with transparent overlapping that denied an absolute, inviolate place in space for any single object. In these respects cubism influenced the subsequent development of twentieth-century design. Nature was no longer the only form of reality to depict. The human mind itself played a part in structuring reality.

In Germany, Friedrich Nietzsche and the nihilist rebellion contributed to the expressionist movement, which ap-

peared around 1905. The idea that art is primarily self-expression led to a dramatic nonnaturalistic art that is typified by Oskar Kokoschka and Ernst Kirchner (Figure 2-10). In Paris in 1905 the first exhibition of a group of artists who would be called "les Fauves" ("the wild beasts") was held. Similar in look to expressionism, with its open disregard of the forms of nature, fauvism favored wild expressive colors. Neoexpressionism, influenced by the expressionists and the fauves, shows up today in contemporary illustration.

In 1890 the German psychologist Christian von Ehrenfels published an essay called "On Gestalt Qualities." Within

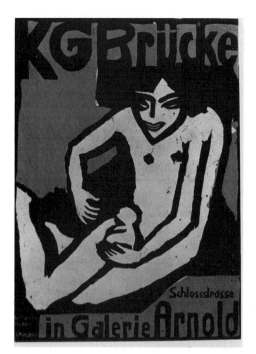

2-10 **Ernst Kirchner.**
Cover for Catalog of
K. G. Brucke exhibition.
1905–07. 32.7″ × 31.9″
(83 × 81 cm). Collection
Kaiser Wilhelm Museum.

applied these principles to art and visual perception.

Germany also gave birth to Peter Behrens, a pictorial and graphic artist who moved into architecture. He was an artist of the Deutscher Werkbund, founded in 1907. Inspired by William Morris and the English Arts and Crafts movement, the Werkbund artists believed in examining the moral questions inherent in art and in preventing commercial and industrial abuse. Behrens was given the first corporate identity job in the history of design. He was asked to design for AEG, a large German corporation, the architecture, advertising, products, and everything else (Figure 2-11). He taught Walter Gropius, who would later become famous as a leader of the Bauhaus.

this paper was the suggestion that the "Gestalt" (total entity) is larger than the sum of its parts. Ehrenfels suggested that the parts interact to form a new whole. Our perception of an object is influenced by the arrangement of objects around it. This work pointed the way to another new idea. Reality could be seen as dependent on context rather than as absolute.

In 1910 at the Frankfurt Institute of Psychology, Max Wertheimer, an admirer of Ehrenfels, began research on apparent movement, which is the basis for the motion picture. He asked why we perceive some images as belonging together and others not. He arrived at the Gestalt principle of unit forming, which describes how we organize and interpret patterns from our environment: Simply put, things that are similar will be perceptually grouped together. (A more detailed description of unit-forming factors is in Chapter 5, Good Gestalt.) Wertheimer's investigations were carried on by Wolfgang Köhler and Kurt Koffka and later by Rudolf Arnheim, who

## WORLD WAR I

The years before World War I brought new movements that continued to expand our notion of reality. The futurist movement showed time itself on canvas

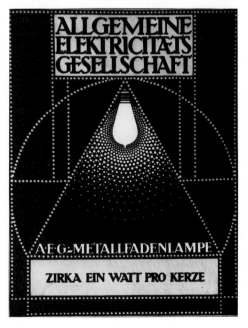

2-11 **Peter Behrens.**
Poster for AEG light
bulbs. 1901.

**2-12 Marcel Duchamp.** *Bottle Rack.* From a leather case containing reproductions of the artist's work. 16⅛″ × 14¾″ (41 × 37.5 cm). Collection, The Museum of Modern Art, New York. James Thrall Soby Fund. Copyright 1998 Artists Right Society (ARS), New York/ADAGP, Paris/Estate of Marcel Duchamp.

**2-13** *(bottom left)*
**2-14** *(bottom right)*
*Der Dada* covers. 1920. Collection, The Chicago Art Institute. Mary Reynolds Collection.

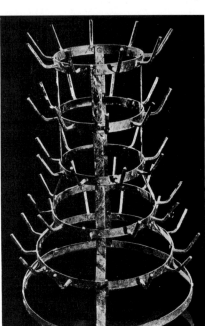

by capturing motion through multiple images. The movement was established around 1909 by the Italian poet Emilio Marinetti and developed by artists such as Giacomo Balla and artist/designer E. McKnight Kauffer. The futurist artists were so named for their optimistic belief that the machines of the industrial age would lead to a better future. Ironically and sadly, most of the leaders of the movement were killed in World War I.

Futurism's influence continued. Motion pictures were popular by 1910. They widened our visual reality, creating images that moved through time, as music had always done.

Around that same time, a movement surfaced that would strongly influence graphic design. Dada was founded in 1916 by a group of poets, the chief of whom was the Rumanian Tristan Tzara. Its name, like the movement itself, had no meaning, according to the Dadaists. The following poem is by Tzara:

> *Colonial syllogism*
> *No one can escape from destiny*
> *No one can escape from DADA*
> *Only DADA can enable you to escape*
>   *from destiny.*
>     *You own me: 943-50 francs.*
> *No more drunkards!*

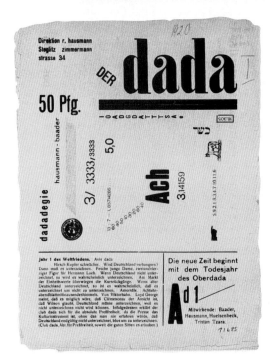

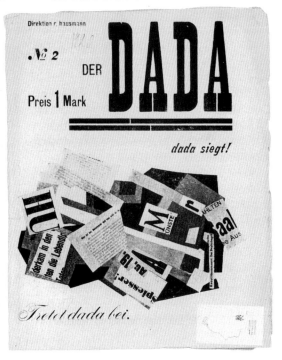

*No more aeroplanes!*
*No more vigor!*
*No more urinary passages!*
*No more enigmas!*

The Dadaists have been extremely important in twentieth-century art and philosophy because they questioned meaning itself with an assault on all accepted values and conventional behavior. Marcel Duchamp exhibited such things as bicycle wheels, urinals, and bottle racks, challenging the criteria by which we define something as art (Figure 2-12). He stated, "I was interested in ideas—not merely in visual products. I wanted to put painting again at the service of the mind."

The Dadaist poet Guillaume Apollinaire created a series of "Calligrammes" around 1918 that seemed to break every known rule of typography. One of the many Dada publications, *Der Dada,* introduced photomontage. It was characterized by an intentional disorder. Letters of all types and sizes, Hebrew characters, sentences in French, and dictionary illustrations mingled (Figures 2-13 and 2-14). Figurative photographic images were treated with the same freedom from conventions. With "rayographs" or photograms and techniques such as solarization, Man Ray made an important contribution to graphic design. Kurt Schwitters, another Dada artist, combined cubism with Dada for a series of collages that remain a rich visual resource for artists today (Figure 2-15).

**2-15 Kurt Schwitters.** *Merz Drawing 83. Drawing F.* {Merzzeichnung 83. Zeichnung F}. 1920. Collage of cut-and-pasted paper wrappers, announcements, tickets, 5¾″ × 4½″ (14.6 × 11.4 cm). The Museum of Modern Art, New York. Katherine S. Dreier Bequest. Photograph © 1998 The Museum of Modern Art, New York.

# ABSTRACT MOVEMENTS

The first totally abstract poster is attributed to Henry van de Velde in 1897 (Figure 2-16). A Belgian art nouveau artist, he moved to Germany in 1906 to teach and became interested in

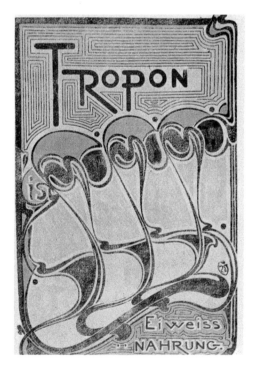

**2-16 Henry van de Velde.** *Tropon.* 1897. Poster, 13¾″ × 10⅝″ (35 × 27 cm). Collection Kaiser Wilhelm Museum.

**2-17 Wassily Kandinsky.** *Light Picture.* December 1913. Oil on canvas, 30⅝″ × 39½″ (77.7 × 100.3 cm). Collection, Solomon R. Guggenheim Museum, New York. Photo by Robert E. Mates.

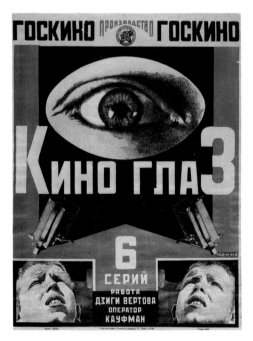

**2-18 Aleksandr Rodchenko.** *Kino Glaz* {Film Eye}. 1924. Lithograph, printed in color, 36½″ × 27½″ (92.5 × 70 cm). The Museum of Modern Art, New York. Gift of Jay Leyda. Photograph © 1998 The Museum of Modern Art, New York.

architecture and a more structural approach to art. His ideas contributed to the later development of the Bauhaus movement. The first abstract painting is attributed to Wassily Kandinsky. He, Frantisek Kupka, and others were working in an abstract fashion by 1911 (Figure 2-17). Such paintings, in Kandinsky's words, issue from "inner necessity." For Kandinsky, a painting was above all "spiritual," an attempt to render insights and awareness transcending obviously descriptive realism. Author of *On the Spiritual in Art,* he later joined the Weimar Bauhaus around 1920.

In 1913 the Russian Kazimir Malevich began painting abstract geometric compositions. Malevich formulated a theoretical basis for his paintings, which he called suprematism. He viewed them as the last chapter in easel painting that would point to a universal system of art headed by architecture. This

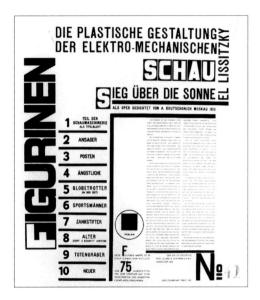

architectronic approach led the way to constructivism, a movement that saw painting as a structurally driven construction, like architecture.

The Russian Revolution of 1917 had many Russian artists eagerly contributing to the social and cultural aspect of revolutionary change. Russian artistic thinking in the 1920s combined propaganda and commerce in support of the new state enterprises. Civic-minded artists designed boxes, posters, and packaging intended to attract buyers to state products. Advertising became a means for artists, poets, and others to advance the goals of Soviet society. Malevich, Aleksandr Rodchenko, and others were abstract painters whose goal to directly access the viewers' consciousness adapted readily to advertising propaganda for the good of the Soviet society. The state enterprises flourished with the support of painters turned graphic designers (Figure 2-18).

El Lissitzky is a Russian constructivist and designer who devoted a great deal of effort to propaganda work. He also developed the rules of typography and design that laid the groundwork for the development of grid systems. Design-

ing a book of Vladimir Mayakovski's poetry, he wrote: "My pages relate to poetry in a way similar to a piano accompanying a violin. As thought and sound form a united imagination for the poet, namely poetry, so I have wanted to create a unity equivalent to poetry and typographical elements" (Figure 2-19). Lissitzky experimented with the photogram and foresaw the importance photography would come to have in graphic design (Figure 2-20). This innovative thinking and design work spread its vision to other countries. In Germany, Lissitzky and the Bauhaus influenced advertising and packaging design. The contemporary designer Paula Scher uses the strong constructivist approach of Lissitzky's layouts to create a modern design (Figure 2-21).

Lissitzky's influence spread to the United States when Mehemed Fehmy Agha, who was inspired by Lissitzky, moved from Germany to the United States in 1929, bringing a European vision with him. He redesigned *Vogue*,

**2-19  El Lissitzky.** *Table of Contents from Plastic Figures of the Electro-Mechanical Show: Victory over the Sun.* 1923. Collection, The Chicago Art Institute. Gift of the Print and Drawing Club. Gaylord Donnelley and Wm. McCallin Mckee Fund, 1966.

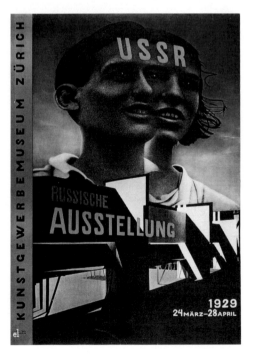

**2-20  El Lissitzky.** *USSR Russische Ausstellung* {Russian Exhibition}. 1929. Gravure, printed in color, 49″ × 35¼″ (124 × 89.5 cm). The Museum of Modern Art, New York. Gift of Philip Johnson, Jan Tschichold Collection. Photograph © 1998 The Museum of Modern Art, New York.

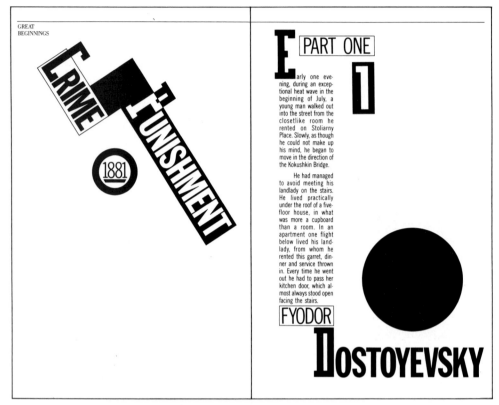

*(above)*
**2-21 Paula Scher.**
Two-page layout from
*Great Beginnings.* 1980.

*(below)*
**2-22 Theo van Doesburg.**
*Kontra-Komposition mit
Dissonanzen XVI.* 1925.
Oil on canvas, 39½″
× 71″. (100 × 180 cm).
Haags Gemeentemuseum,
Den Haag. Copyright
1997 Artists Rights
Society (ARS), New
York/Beeldrecht,
Amsterdam.

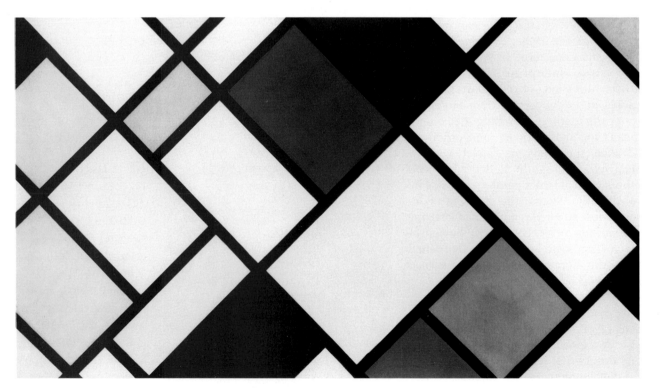

2-23 **Josef Albers.** *Structural Constellation NN-1.* 1962. Machine-engraved vinylite, 20″ × 26½″ (50.8 × 67.3 cm). Copyright 1998 The Josef and Anni Albers Foundation/Artists Rights Society (ARS), New York.

wrote about design trends, influencing a generation of designers, and helped introduce the sans serif as a modern type style.

Closely related to constructivism, de Stijl developed in Holland, where artists fled to avoid direct involvement in World War I. It flourished during the 1920s in Europe and strongly influenced the later Bauhaus work. The most widely known painters of the period are Piet Mondrian and Theo van Doesburg. Their style is the epitome of de Stijl, with straight black lines set at right angles to one another and a careful asymmetrical balancing of primary colors. These de Stijl artists strongly influenced graphic design (Figure 2-22).

The School of Applied Arts and Crafts, founded by Henry van de Velde (Figure 2-16) in 1906 and closed at the outbreak of war, was reopened as the Bauhaus at Weimar in 1919. Walter Gropius, who had worked with Peter Behrens at the German Werkbund, became the Bauhaus director. In 1922 the constructivist El Lissitzky met with Theo van Doesburg and Lazlo Moholy-Nagy in a congress of constructivists and Dadaists in Germany. Their exchange of ideas formed a core for the Bauhaus after 1923.

The Bauhaus trained artists in all areas. It attempted to bridge the gap between pure and applied art, to place equal importance on all areas of arts and crafts. It stressed clean functional forms. The weavers, metalsmiths, and carpenters did not attempt to produce works of art, but rather good and useful designs in which form was tied to function. The industrial designer was born from this movement.

The important contributions by artists of the Bauhaus are too numerous to mention in this brief overview. Here are a few who were influential in the development of graphic design. Joseph Albers is known for his research into color and structural relationships (Figure 2-23). Lazlo Moholy-Nagy developed photography as illustration. Herbert Bayer created

# abcdefghi jklmnopqr stuvwxyz a pd

**2-24** **Herbert Bayer.** *Studie zum Universalalphabet.* 1925. Bauhaus-Archive.

several typeface designs, among them Futura and the "Universal" type (Figure 2-24). In keeping with the Bauhaus philosophy, he believed in removing personal values from the printed page, leaving it purely logical and functional in design (Figure 2-25). A looser design by Lyonel Feininger forms the title page for a portfolio, featuring the work of many famous Bauhaus artists (Figure 2-26).

Many of the Bauhaus artists immigrated to the United States after the Nazis forced the closing of the Bauhaus in 1933. There they had a great influence on American architecture and graphic design. The Swiss also continued to develop the idea of the Bauhaus in typography and layout design from the 1950s onward. Among those artists are Josef Muller-Brochmann, Jan Tschicholod, Emil Ruder, and Armin Hofmann. Their emphasis on quality and formal elements contributed greatly toward shaping the design field.

**2-25** **Herbert Bayer.** *Kandinsky zum 60. Geburstag.* 1926. Offset lithograph, printed in color. 19″ × 25″ (48.2 × 63.5 cm). The Museum of Modern Art, New York. Gift of Mr. and Mrs. Alfred H. Barr, Jr. Photograph © 1998 The Museum of Modern Art, New York.

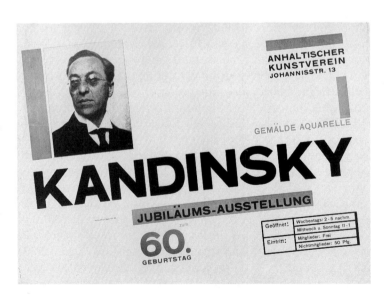

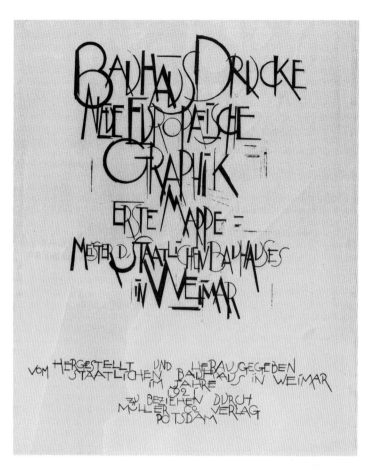

2-26 **Lyonel Feininger.** Title page from *Nelle Europaeische Graphik I,* First Bauhaus Portfolio. 1921. Gift of Mrs. Henry C. Woods, Steuben Memorial Fund, Emil Eitel Fund, and Harold Joachine Purchase Fund. Collection, The Chicago Art Institute.

## FIGURATIVE MOVEMENTS

Art deco appeared as a definite style in Paris around 1925. It was especially influenced by art nouveau and also by African sculpture and cubism. Although it developed at the same time as the Bauhaus, art deco emphasized the figurative image with decorative appeal. Artists associated with this movement include the Russian Erte and Georges Lepape (Figure 2-27), who contributed to *Vogue* magazine. Perhaps the best known and respected art deco artist, who exerts a strong influence today, is A. M. Cassandre. His posters and advertisements show the influence of cubism,

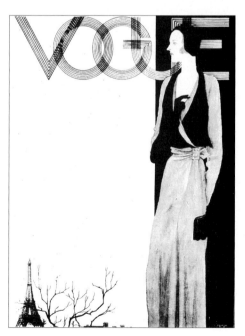

2-27 **Georges Lepape.** Cover for *Vogue* magazine, 1930. Gouache. Courtesy *Vogue.* Copyright 1930 (renewed 1958, 1986) by the Condé Nast Publications Inc. Photo courtesy UW-Whitewater Slide Library.

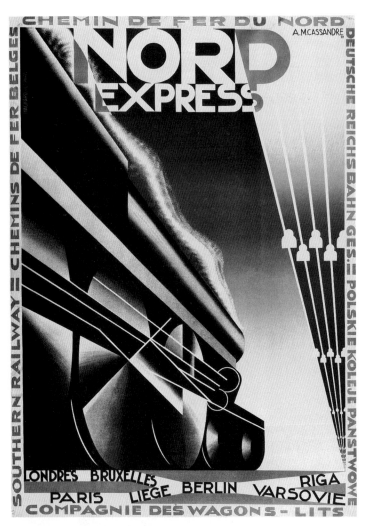

**2-28** **A. M. Cassandre.** *Nord Express.* 1927. Lithograph, printed in color, 41″ × 29½″ (104.1 × 74.9 cm). The Museum of Modern Art, New York. Gift of French National Railways. Photograph © 1998 The Museum of Modern Art, New York.

but the forms retain a recognizable physical identity balanced with an intricate Gestalt unity (Figure 2-28). Art deco was out of favor for a time in the eyes of architects and designers because it followed none of the Bauhaus tenets of functional, nonornamental design. Now the style is enjoying a renaissance and is often incorporated into the eclectic style of contemporary design.

Surrealism also surfaced in the 1920s. Owing a philosophical debt to Dada for its questioning attitude, it was joined by several Dada artists. Andre Breton established it in 1924. He was another poet and writer starting a philosophical movement that would find visual expression. The surrealists drew inspiration from Freud's *Interpretation of Dreams*. Like the author James Joyce, who used stream-of-consciousness techniques rather than rational, linear development of characters, surrealists sought to reveal the subconscious.

Surrealism has exerted a strong influence on illustration. René Magritte is much imitated today and in fact did quite a lot of advertising illustration. Other surrealists, like Max Ernst and Man Ray, show the influence of Dada in the unorthodox and compelling arrangement of elements. Surrealism's search for unconscious motivation continues to interest today's designer/advertiser.

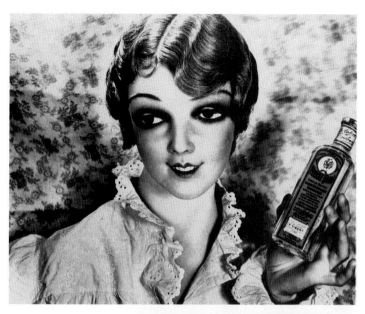

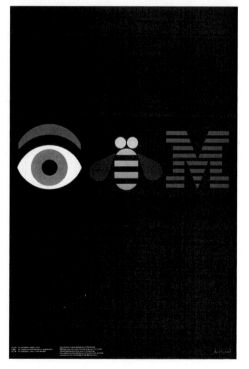

**2-29** Studio Ringl & Pit **(Grete Stern** and **Ellen Rosenberg Auerbach)** *Pétrole Hahn.* 1931. Gleatin silver print. 9⅜″ × 11⅛″ (23.8 × 28.3 cm).

Figure 2-29 is an advertising photo that shows the original interest of the time in surrealism. Upon close examination, we realize the attractive woman is a mannequin, though her hand is real. This forces the potential buyer to look again, a major aim of an advertisement.

## AMERICAN DESIGN

Lazlo Moholy-Nagy came to Chicago in 1937 to direct the New Bauhaus. It closed after one year, and Moholy operated his own Institute of Design from 1938 to 1946. This school offered the first complete modern design curriculum in America. The Illinois Institute of Technology is a descendant of the New Bauhaus.

Lester Beall, an American-born Chicago artist, embraced modern design and European influences from cubism, constructivism, and Dada. Working in New York in the 1940s, he combined drawing, symbols, photography, and mixed typefaces into a coherent, eclectic design. Many young American designers of the time drew inspiration from European modern art and design, in-

**2-30** **Paul Rand.** *IBM.* 1982. Offset lithograph, printed in color, 36″ × 24″ (91.4 × 61 cm). The Museum of Modern Art, New York. Gift of the designer. Photograph © 1998 The Museum of Modern Art, New York.

cluding Paul Rand. Rand realized that his role as a designer involved reinventing the problem presented by the client. He focused on restating the problem, and he drew inspiration from painters such as Klee and Miro (Figure 2-30). His books on design and his life's work are

**2-31** **Herb Lubalin.**
Logo for *Eros* magazine.
A magazine with a
graphically beautiful ap-
proach to love and sex,
there were only four is-
sues published.

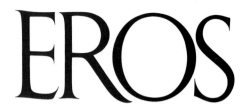

important contributions to the field.
Cipe Pineles, art director for *Seventeen,*
was one of the few women designers dur-
ing this period. After achieving national
prominence as art director for *Glamour,
British Vogue,* and *Seventeen,* Pineles
became the first female member of the
New York Art Directors Club. Designers
from this period synthesized the influ-
ences of European avant-garde and de-
sign movements to create new designs
for magazines, posters, advertisements,
and corporate communications.

By the 1950s marketing research
was an important influence in business
decisions. Advertising designers dealt
with the proliferation of national televi-
sion and radio networks, the emergence
of large chain stores, and the importance
of public perception and corporate iden-
tity. The International Design Confer-
ence in Aspen was founded in 1951 to
assess and discuss the role of design in
the commercial environment. This con-
ference continues to meet in Aspen
every summer.

The 1950s saw the emergence of de-
sign curriculums in universities and art
schools and the articulation of an im-
portant concept. Leo Lionni (art direc-
tor for *Fortune* magazine) stated that
"Whatever . . . (the designer's) activities,
they involve, to some, and various, ex-
tent, the shaping, interpretation and
transmission of values." This issue of val-
ues and the role of design in society is
an important topic now.

Push Pin Studios was founded in
1955 in opposition to the spirit of Swiss
design. The founders included Seymour
Chwast, Reynold Ruffins, Ed Sorel, and
Milton Glaser. Glaser stated that "We fre-

quently find corruption more interesting
than purity" (see Figures 4-6 and 4-8).
This studio revived art nouveau, art
deco, and narrative illustration, turning
to visual history for inspiration. Its
founders continue to contribute to the
shape and direction of design in the
1990s.

Marshall McLuhan noted the influ-
ence of television on communication
and wrote about the potential for a
Global Village united by a shared vision.
McLuhan saw print media as an isola-
tionist influence, giving rise to catego-
rization, linear sequencing, and dogma-
tism. Television, according to McLuhan,
has the potential to reunite society. It
certainly exerts a major influence on
advertising and communication and,
thus, on society. McLuhan's writings re-
main thought-provoking today.

Magazine design was a creative area
in the 1960s. In 1964 Ruth Ansel and
Bea Feitler took charge of *Harper's
Bazaar* as co–art directors. Drawing in-
spiration from pop art and underground
images, *Harper's Bazaar* represented
the glamour and glitter of the 1960s.
Herb Lubalin was art director and de-
signer for the counterculture magazines
*Avant Garde* and *Eros* (Figure 2-31).
Alternative publications with political
and cultural commentary flourished dur-
ing the 1960s. *Rolling Stone* fused mu-
sic industry and personality features
with politics of the day.

In the early 1970s, type in America
was dominated by Helvetica and an em-
phasis on the clear, clean transmission
of information. It was also in the 1970s
that the term "postmodernism" was first
applied to architecture and when a ques-
tioning of rational "Swiss design" led to
"New Wave" or "postmodern" graphic
design. Contradictory and coexistent
trends make the 1970s a rich period for
study. April Greiman's work is an exam-
ple of "New Wave" design, mixing formal
experiments with popular imagery
(Figure 2-32). The 1970s and 1980s saw

history as a shopping mall of styles. Art deco and art nouveau are among the styles that were revived and revised.

Women had an important impact on design during this time and afterward. Katherine McCoy cochaired the highly visible design program at Cranbrook Academy of Art. She joined in questioning the modernist ideal of a permanent, universally valid aesthetic. She encouraged the production of visually rich and complex designs, believing that there is more to design than the clear, impartial transmission of information. McCoy believes that designers interpret and communicate cultural values through the forms they create.

Technology became an increasingly important issue during this time. Murial Cooper and others at Massachusetts Institute of Technology (MIT) developed the Visible Language Workshop, a multidisciplinary, multimedia program that brings together artists, designers, computer scientists, sociologists, and others to study communication in the electronic age.

During the 1980s the question of "style over substance" became an important issue. Theorists such as Stuart Ewen questioned the role and impact of advertising design on society. Fine-arts artist Barbara Kruger worked for a time as a layout artist and used those skills to develop an "advertising campaign" that is anti-advertising. Her mock ads and billboards used typographical devices and images to expose the persuasion/consumption cycle of commercial advertising (Figure 2-33).

A concern for the intellectual and historical foundations of design led to the publication of Philip Megg's *A History of Graphic Design,* which provides a foundation for many design history classes. Today there are many sources available for the study of design practice, history, and theory, and the field is filled with "how-to" books on computer software.

2-32  **April Greiman,** art director/designer. *Design Quarterly #133. Does it Make Sense?* Publication insert, Walker Art Center, 1986. MIT Press Publisher.

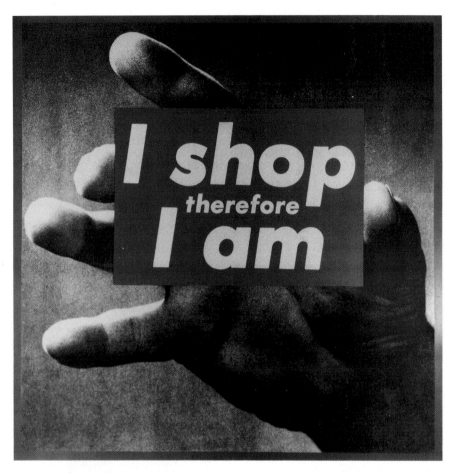

2-33  **Barbara Kruger.**
*"Untitled" (I shop there-*
*fore I am),* 111″ × 113″
photographic
silkscreen/vinyl, 1987.

## NEW TECHNOLOGIES

In the 1990s the use of electronic tech-
nology in the United States and interna-
tionally has revolutionized design and is
effecting the structure of society itself.
Style and content are effected by the
technology used in their creation. This
chapter's brief history of design has
shown that relationship, citing the in-
vention of the printing press and of stone
lithography as examples of earlier tech-
nologies that affected design and societal
patterns of communication. The mid-
twentieth century's emphasis on clarity
and structural integrity is now replaced
by an interest in rich textural layers of
information. Graphics are now gener-
ated and prepared for prepress with soft-
ware programs that encourage stylistic
complexity (Figure 2-34).

## THE DEVELOPMENT OF COMPUTER GRAPHICS

The use of computers to draw images
dates back to 1953 when a simple visual
display of a bouncing ball was used to
calculate and show military targets.
Funding for the development of com-
puters and computer graphics in the
United States originally came from the
Defense Department. In 1962 at MIT the
first interactive computer graphics dis-
play was created by Ivan Sutherland. A
light pen touched to the video screen
could draw a line stretched from the pre-
vious point. Although its early develop-

2-34

ment was tied to defense and aerospace, today computer graphics has a wide variety of applications, from engineering, medicine, and geology, to graphic design and the film industry (Figures 2-35 and 2-36).

## THE FUTURE

During the twentieth century we have progressed along a visual escalation from photography to film to video to computers. Computer graphics has come a long way since the Macintosh was introduced in the mid-1980s. The Internet is rapidly becoming a vehicle for marketing products. Producing visuals for home pages is a growing market for graphic designers, and the complexity of these visuals is increasing rapidly. Our ability to communicate with interactive visuals and to create "desktop" video and 3-D animation are helping to develop a new market for graphic designers.

Virtual reality is another new and developing technology. It extends our

2-34 Poster and brochure design by MacPros Inc. MacPros was founded in 1992 as the first company in Milwaukee, Wisconsin, dedicated to the placement of Macintosh professionals. Today, it is a full-service agency.

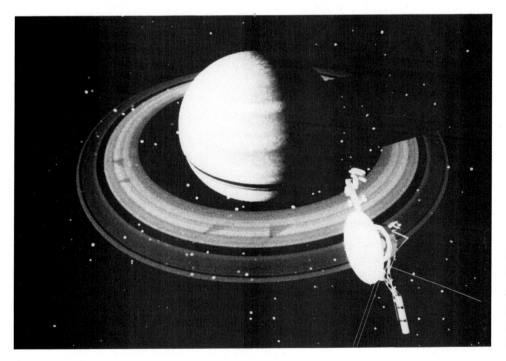

2-35 **Don Davis.** *Voyager 2 at Saturn Minus 3 Hours.* Painting over computer-generated image. Painted for NASA and JPL.

2-36 A CAT-scan cross section of the brain. Different densities appear in different colors. Courtesy of Judson Rosebush Co.

senses by allowing a person to move through and interact with a computer-simulated environment by wearing special glasses and clothing or other sensors. These monitor our movements and gestures in the alternate virtual "world." Psychologist R. L. Gregory stated in his book *Eye and Brain,* "The seeing of objects involves many sources of information beyond those meeting the eye when we look at an object. It involves knowledge of objects from previous experience

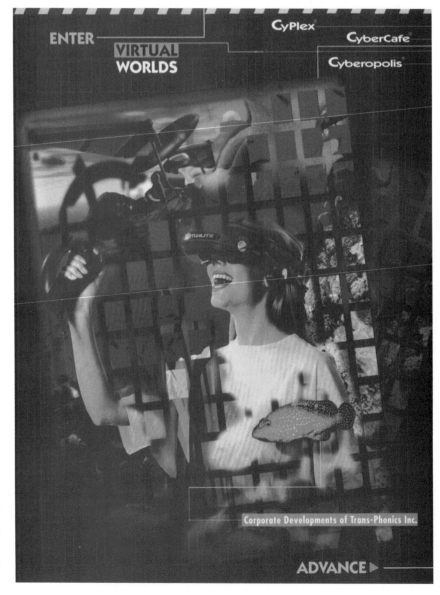

2-37 **Denis A. Dale.** Marketing, copywriting, and design for a chromatic 3-D promotional folder and inserts for Transphonics, Inc. View with Chromatek 3-D glasses for VR effect. This four-color piece with two varnishes was printed from an electronic file directly to a digital press.

and not only sight but touch, taste, smell, hearing, and perhaps also temperature or pain." What might be the impact of virtual reality on design and communication (Figure 2-37)?

As we move into a new century, it is interesting to remember the important developments at the turn of the last century. It will be an exciting and challenging future for designers who are intent on maintaining an emphasis on issues of values and content while learning and using a proliferation of new media (Figure 2-38).

# PROJECT

In consultation with your instructor, select and research a contemporary designer mentioned here or elsewhere in the text. Prepare a paper and classroom presentation based on your research. Describe the designer's work, philosophy, and background. Shoot slides of the work, or prepare to present visual materials in another fashion (Figures 2-39*a* and 2-39*b*).

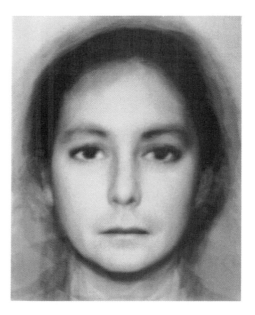

2-38 **Nancy Burson** with **Richard Carling** and **David Kramlich.** *Androgyny.* 1982. The photograph is a composite image of twelve faces (six men and six women).

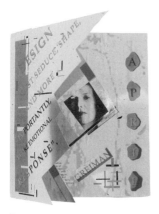

a

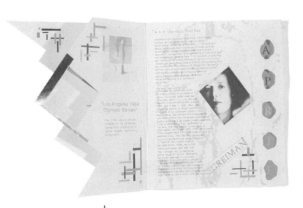

b

2-39a, 2-39b **Ada Jardin.** Comprehensive for an eight-page brochure about designer April Greiman. Written and designed in response to an assignment concerning a design history presentation.

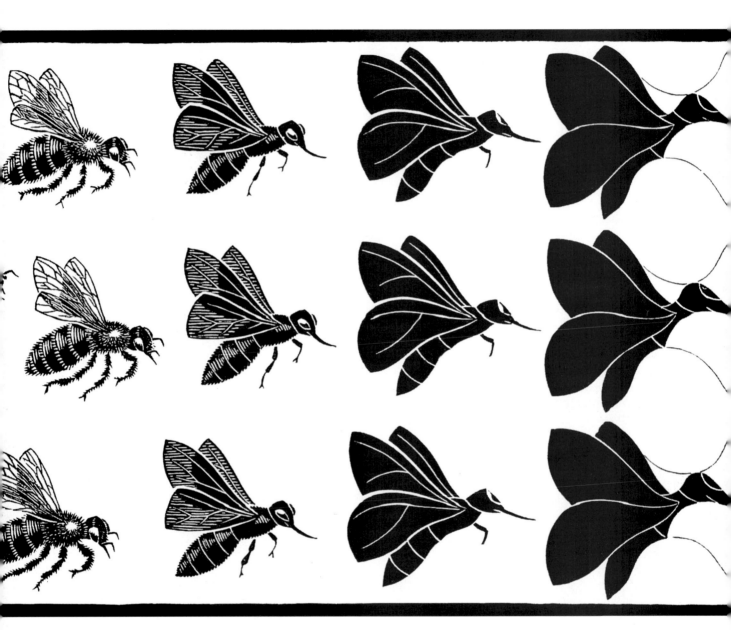

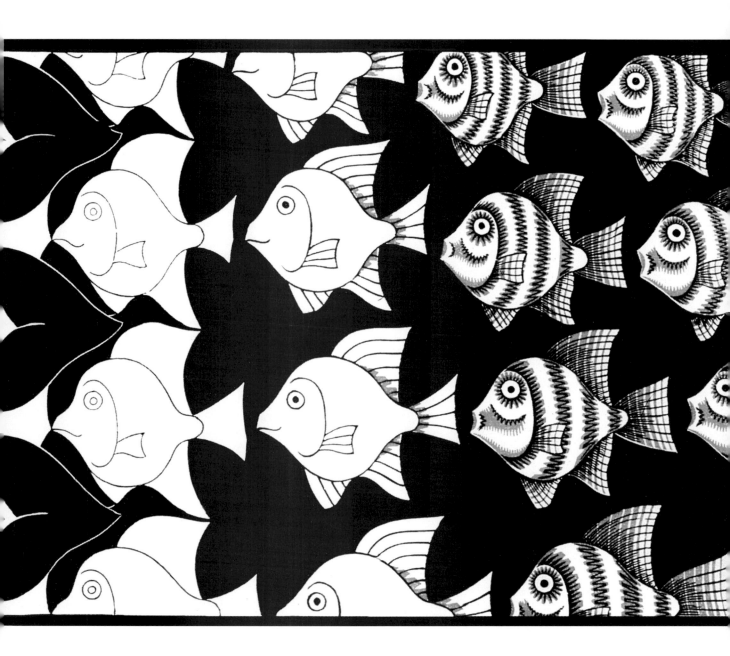

THREE

PERCEPTION

# SEEING AND BELIEVING

Graphic designers do more than decorate a surface. They work with the fundamental principles of perception. When we look at a printed page, whether it is covered with type, an illustration, or a photograph, there is more than meets the eye. The brain is sifting and cataloging the images. We carry a load of experiences, innate responses, and physiological considerations that interact with those images. Designs that effectively use that process have the creative strength of sight itself on their side.

As soon as the first mark is made on a blank sheet of paper, it is altered by the eye. We cannot see only a flat mark on a flat piece of paper. Our past experience, our expectations, and the structure of the brain itself filter the information. The visual illusions created through this process are a real part of perception. *Realism in art and design is not an absolute but a convention that our culture and personal background create from visual data.*

## SEARCH FOR SIMPLICITY

The Gestalt psychologists have investigated the way humans process information from a two-dimensional surface. There is an interplay of tensions among shapes on a flat surface because the appearance of any one element or shape depends upon its surroundings. These elements and surroundings are interpreted by an active eye that seeks the simplest satisfactory explanation for what it sees.

Any mark drawn on paper stimulates this active, interpretive response from eye and brain: We finish uncompleted shapes, group similar shapes, and see foreground and background on a flat surface. Their experiments led Gestalt psychologists to describe the basic law of visual perception: Any stimulus pattern tends to be seen as a structure as simple as conditions permit. This law is similar to the principle of parsimony known to scientists, which states that when several hypotheses fit the facts, the simplest one should be accepted.

Elegance and success result from explaining a phenomenon with the minimum number of steps. A similar elegance can be achieved on the printed page. A great deal may be happening on a page although few marks exist. In fact, adding *more* marks without understanding their effect can often make *less* happen. That is poor design.

The manner in which the Gestalt psychologists believe our brain interprets and groups the images on a flat surface will be discussed in following chapters. It is generally recognized as a useful prescription for designing visual images so they will be comprehended as we want. No single theory, however, explains all there is to visual perception. Most of what there is to know has yet to be discovered.

## INTERPRETATIONS

The lines in Figure 3-1 demonstrate our busy interaction with simple marks drawn on a page. These interpretations are influenced by the culture in which

3-1

a                 b                 c                 d                 e

we live. We accept the black mark in *a* as nearer than the white field it occupies although they both exist on the same physical plane on the surface of the page. Adding a second mark of a larger size (*b*) causes another interpretation. The larger mark seems closer in space than the smaller one. A line placed vertically that divides the space (*c*) will not disturb the two-dimensional quality. However, a line set at an angle surrounded by a white field (*d*) will seem to recede in space. Add a second line (*e*) and suddenly the eye sees the perspective of a road or railroad tracks running into the distance.

Perception, and thus communication, is always colored by interpretation. Context, personal experience, and culturally inculcated systems of signs and symbols play a strong role in perception. Later chapters discuss this phenomenon from varying perspectives. Semiotics is the study of this influence on our perception.

## FIGURE/GROUND

If we are aware of how the eye and brain organize marks on a flat surface to give them meaning, we will be much more successful in showing what we mean. The most fundamental organizational principle of sight for an artist working on a flat, two-dimensional surface is figure/ground. It is sometimes called positive/negative space. An ability to see and structure both areas is crucial to the designer.

Whenever we look at a mark on a page we see it as an object distinct from its background. This distinction is the fundamental, first step in perception. A thing (figure) is only visible to the extent that it is seen as separate from its background (ground). This theory has application in every area of perception. A

3-2 **David McLimons.** Madison, WI. "What Makes Italy a Major Black Market in Art?" Illustration created for *The New York Times.*

tree, for example, can only be seen in relation to the space around it, the "not-treeness." Figure 3-2 shows this figure/ground relationship.

We are able to look at the shapes and lines of a photograph and recognize a "picture" because of figure/ground grouping. Figure 3-3 is a playful and effective use of this grouping. We are able to recognize and read words because we organize the letters into a figure lying against a ground. *At its best, design becomes inseparable from communication. Form becomes content.*

## CATEGORIES

Every figure seems to lie at some location in front of the ground. Designing well depends upon handling both areas. Many beginning artists concentrate only on the mark they make and are not aware of the white space surrounding it. Remember that this space or "ground" is as integral a part of the page as the "figure" placed upon it. The three main categories in figure/ground shaping are stable, reversible, and ambiguous.

3-3 Bugs! logo created for a campaign for the Minnesota Zoo by Rapp Collins Communications. Designer **Bruce Edwards** has won numerous national awards for this design, including awards from Print, Communication Arts, and Adobe Design.

3-4 **Emile Preetorius.** *Licht und Schatten* {Light and Shadow}. 1910. Lithograph, printed in color, 11¾ x 8¾" (29.8 x 22.2 cm). The Museum of Modern Art, New York. Gift of The Lauder Foundation, Leonard and Evelyn Lauder Fund. Photograph ©1998 The Museum of Modern Art, New York.

3-5

### Stable Figure-Ground

*Each two-dimensional mark or shape is perceived in an unchanging relationship of object against background.* Aubrey Beardsley played deliberately with the tension of a stable figure/ground relationship on the verge of breaking down. Move your eye around Beardsley's work and figure/ground will reverse or become unclear, only to establish itself again. (See Figure 2-6.) This poster by Emile Preetorius also has a great deal of figure-ground tension (Figure 3-4).

### Reversible Figure/Ground

*Figure and ground can be focused on equally.* What was initially ground becomes figure. Because we cannot simultaneously perceive both images as figure, we keep switching. Many logo designs use reversible figure/ground, as you will discover in Chapter 5 (see Figure 3-3).

### Ambiguous Figure/Ground

In some puzzle pictures, one figure may turn out to be made up of another, or of several different pictures (Figure 3-5 and Figure 5-2).

## CONDITIONS

Once mastered, figure/ground grouping is an invaluable tool. It is complex and deserves study. Here are some conditions under which one area appears as figure and another as ground. Use these principles when completing the first exercise.

*The enclosed or surrounded area tends to be seen as figure; the surrounding, unbounded one as ground (Figure 3-6a).*

*Visual texture makes for figure perception. The eye will be drawn to a textured area before it is to a nontextured area (Figure 3-6b).*

*Convex shapes are more easily seen as figure than concave (Figure 3-7a).*

**3-5** Japanese symbolic picture. Nineteenth century. An example of ambiguous figure/ground.

3-6

a

b

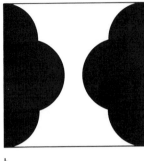

3-7

a                              b                              c

*Simplicity (especially symmetry) predisposes area to be seen as figure (Figure 3-7b).*

*Familiarity causes a shape to pull out from its surroundings. As we focus on it, it becomes figure, while the surroundings become ground (Figure 3-7c).*

*The lower half of a horizontally divided area reads as the solid figure to which gravity anchors us (Figure 3-8).*

*The smaller an area of space, the greater the probability that it will be seen as figure (Figure 3-9).*

*There also is a tendency for black to be viewed as the predominant figure more readily than white. Rotating Figure 3-8 will help demonstrate that effect.*

## LETTERFORMS

How does this figure/ground phenomenon affect letterforms, the basic ingredient of the printed page? Stop now and do Exercise 1. As you do the exercise you will realize that figure/ground affects letterforms the same as any mark on the page. Using type effectively depends on seeing both the black shapes of the letters and the white shapes between, within, and around them. You must pay close attention to the shape of the ground areas, called *counters* (Figure 3-10). This rule has direct application in logo and layout design (Chapters 5 and 7).

Because we tend to read for verbal information and not for visual information, we are rarely aware of the appearance of the type itself. We read it, but do not "see" it, unless we are dealing with contemporary designers like Neville Brody or David Carson. For the first several projects, we will be concerned with type as a pure design element while you learn to "see" it. Only display or "headline" size letterforms will be used. Look closely at the letter *A*'s shown in this chapter and study all the parts of their structure, paying close attention to the

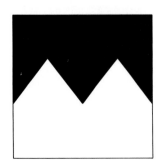

3-8  *(left)*

3-9  *(right)*

**and**

counters. Renaissance artist Albrecht Dürer constructed his own type style. His structural diagrams demonstrate the careful shaping and measurements necessary when hand-constructing letterforms (Figure 3-11).

## SHAPE

Design is the arrangement of shapes. They underlie every drawing, painting, or graphic design. It is possible for an artist to become enamored with the subject matter and forget its basic shapes. Develop the ability to see and think in terms of shapes even though those shapes look like apples or oranges or letterforms. Shape occurs both in figure and in ground.

## SHAPE VERSUS VOLUME

A shape is an area created by an enclosing boundary that defines the outer edges. The boundary can be a line, a color, or a value change. "Shape" describes a two-dimensional artwork,

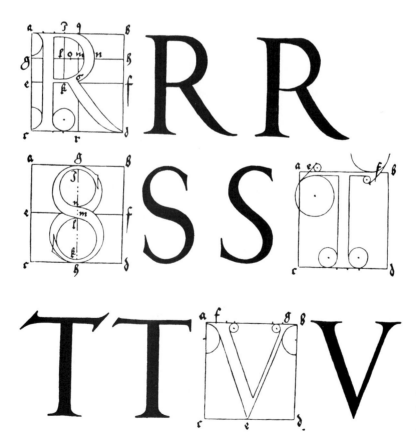

3-11 **Albrecht Dürer.**
*On the Just Shaping of Letters.* 1525.

3-12 This rectangle can be made to resemble a camera, but it is still made up of only two-dimensional shapes.

"volume" a three-dimensional work such as a ceramic piece or a sculpture. A rectangle and a circle are shapes, whereas a box and a sphere are volumes. As pictorial shapes, the former might be made to resemble a camera and an orange or a book and a ball (Figure 3-12).

## GROUPING SHAPES

Every visual experience is seen in the context of space and time. As every shape is affected by surrounding shapes, so it is influenced by preceding sights.

The normal sense of sight grasps shape immediately by seizing on an overall pattern. Research has demonstrated that grouping letters into words makes it possible to recall the letters more accurately than when they are presented alone. If it is possible to group marks into a recognizable or repeating shape, the eye will do so, because it is the simplest way to perceive and remember them.

## SHAPE VERSUS SUBJECT

For the graphic designer, the shape of a circle may represent the letter *O,* a diagram of a courtyard, a drawing of a wheel, or a photograph of a musical instrument. These objects are not linked by subject matter to any common theme. They are linked by shape. Through basic shape you can bring unity to a group of seemingly disparate objects. (As you will see, the designer works with so many disparate objects that to be blind to their shapes would result in utter chaos on the page.) Repeating similar shapes in different objects is an excellent way to bring visual unity to a design.

## THE FORM OF SHAPES

An artist may choose to represent an object or person *realistically,* by an image similar to an unaltered photograph. Actually, reality is a little more difficult to define than that. Philosophers have been working on it for centuries. We know that visual reality is a combination of the shapes on the page and the viewer's interaction with them.

An artist/designer may also represent the subject in a purposeful *distortion* or *stylization* that can bring extra emphasis to an emotional quality.

*Abstraction* is another approach. It implies a simplification of existing shapes. Details are ignored, but the subject is still recognizable. Often the pure design shapes of the subject are emphasized.

Purely *nonobjective* shapes, such as those the constructivists worked with, give structure and character to a layout. They are the basis of the invisible, underlying structure of layout design.

## LETTERFORM SHAPES

The ability to see shapes is especially important with letterforms. Ture, they are a symbol of something, but first and foremost they are pure shape, a fundamental design element. Successful layout and logo design depend upon creating unity through variations on letterform shape.

The distinction is often made between geometric shapes and curvilinear, organic shapes. Jasper Johns utilizes a free, expressive, curvilinear line. Our eye alternates among numerals as we recognize the multiple overlap in Figure 3-13.

Type styles often have different expressive qualities depending on their shapes. Those with hard, straight edges and angular corners have a colder, more reserved feeling than typestyles with graceful curves, which have a relaxed,

**3-13** **Jasper Johns.** *0–9.* 1960. Lithograph, printed in black, composition: 24 × 18⅞″ (61 × 47.9 cm). The Museum of Modern Art, New York. Gift of Mr. and Mrs. Armand P. Bartos. Photograph ©1998 The Museum of Modern Art, New York. ©1998 Jasper Johns/Licensed by VAGA, New York, NY.

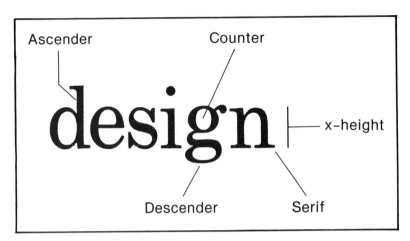

**3-14** Parts of a letter-form.

sensual feeling. What feel does the type-face used in this book convey?

To become sensitive to the shapes in a letterform, look carefully at its anatomy (Figure 3-14). Then learn the differences among type styles. Chapter 6 goes into the history and classification of type styles. Right now, however, concentrate on making comparisons among a few classic type styles (Figure 3-15).

## TERMINOLOGY

The following list of definitions will help you know what to look for when comparing shapes in letterforms.

### Counter

The white shapes inside the letter. Duplicating a letterform accurately calls for close attention to both the white and the black shapes (the figure and the ground). When drawing a letterform or designing with one, it is useful to think of yourself as drawing the white shapes.

### Serif

The stroke that projects off the main stroke of the letter at the bottom or the top. Letters without serifs are called sans serif.

### Type Size

Type size is measured by points. A 72-point type is one inch high, for example, as measured from the ascender to the descender.

### x-Height

The height of the body of a lowercase letter like the letter $x$ or $a$. It does not include ascender or descender. The x-height will vary in typefaces of the same size. Type size is measured from the top of the ascender to the bottom of the descender. Thus 10-point Garamond has a small x-height and long ascenders and descenders; 10-point Univers has a larger x-height and smaller ascenders and descenders.

### Ascender

The part of the lowercase letter that rises above the body of the letter. The letter $a$ has no ascender, but the letter $b$ does.

### Descender

The part of the lowercase letter that falls below the body of the letter. The letters $a$ $b$ $c$ $d$ $e$ have no descenders, but the letters $f$ and $g$ do.

abcdefghijklmn

abcdefghijklmnop

abcdefghijklmnopq

abcdefghijklmnop

abcdeefghijkl

3-15

**Typeface**

Style of lettering. Most typefaces vary a great deal, when you develop an eye for the differences. Each "family" of typefaces may contain variations like "italic" and "bold" in addition to regular or "roman."

**Font**

A font is a complete set of type of one size and one variation on a typeface. (Bold Century is a different font from Italic Century.)

3-16

3-17

3-18

### *Stress*

The distribution of weight through the thinnest part of a letterform. It can be easily seen by drawing a line through the thinnest part of an *o* and observing the slant of the line (Figure 3-16).

Using this terminology, look at each style and ask yourself the following questions:

How much variation is there between thick and thin strokes?

Which style has a short x-height?

Which style has a tall x-height?

Which has the longest ascenders and descenders?

What are the differences in the serifs?

Which type has the most vertical stress?

What are the similarities among letters that belong to one style?

# EXERCISES

1. Refer to the information on figure/ ground perception demonstrated in Figures 3-6 through 3-9 for this exercise.

   **a.** Group several copies of the arrow in Figure 3-17 to form an interesting and symmetrical pattern. Stress the creation of shapes in figure and in ground.

   **b.** Figure 3-18 is drawn so that it is equally possible to see the white or the black area as figure. How can you change this diagram to make one area appear to be figure?

   **c.** Place the letter **H** inside a rectangular format. Use a Helvetica type style (see Figure 6-16). Place the letter and its values so that the **H** becomes ground instead of figure. Familiarity makes this exercise difficult.

   **d.** Repeat the Helvetica letter **A** in a symmetrical pattern. What do you see as figure? Why? Can you change the figure into ground?

2. The letter *A* has been shown to you in five different typefaces (Figure 3-15). To help you recognize the shapes of different faces and learn to

**3-19  Sen Xiong.** Project on figure/ground.

3-20 **Susan Sorn.**
Project on figure/ground.

handle your tools, trace each of these letters and transfer them to drawing paper or illustration board. Reproduce them in ink or pencil so that they are "letter perfect."

When you have finished and your work has been critiqued, you will be ready to proceed with the first main project.

## PROJECT

### Figure/Ground and Letterforms

Choose two letterforms from the type styles shown in this chapter. Create a design that uses one letter as the figure and another as the ground. This relationship can be stable, reversible, or ambiguous as long as it remains possible to "read" both letterforms. Remember the importance of thumbnails. Explore a minimum of 15 possibilities.

Fit your design within an 8″ × 10″ (20 × 25 cm) format. Keep your letters "true to form" and "letter perfect." Use solid black or white shapes without outlining, crosshatching, or screening. You can (1) extend the edge of a shape, (2) overlap a form, or (3) hide an edge by placing a black letter against a black background or white against white. Do not, however, distort their basic shapes. Bring out the beauty, variety, and personality of those shapes. Figures 3-19 and 3-20 are student designs based on this project.

### Objectives

Learn to see and duplicate standard letterforms.

Use thumbnails to explore and evaluate alternative solutions.

Experiment with creating figure/ground relationships.

### For Extra Credit

Try an expressive "painting" based on letterforms.

# FOUR

# TOWARD A DYNAMIC BALANCE

# VISUAL AND INTELLECTUAL UNITY

Two kinds of unified communication occur in graphic design. Intellectual unity is idea-generated and word-dominated. The mind, not the eye, makes the grouping. Visual unity, on the other hand, is created by placement of design elements visible to the eye.

The poster in Figure 4-1 by the famous early twentieth-century designer A. M. Cassandre is unified both intellectually and visually. It is a poster for an optician, so it is intellectually unified by the slogan, the emphasis on the eyeglasses, and the bright, clear area of vision through which the eyes peer at us. It is visually unified through a complex series of events as the small type leads our eye down and into the O of "Leroy." The size of this small type echoes the serif on the larger word. The square-

ness of the typography in "Leroy" is echoed by the bright square surrounding the face.

Imagine that a designer and a writer are hanging a gallery show of a photojournalist's work. The designer is hanging photographs together that have similar value and shapes. The writer is following behind, rehanging the photos together according to subject matter: a picture of a burning building next to one of firefighters. One is *thinking* of subject matter (intellectual unity); the other is *looking* at design (visual unity).

As a design student you are learning to see the visual unity in a composition, and to create with an eye for it. Few people have this skill. Study the form of your design. Once you have mastered the visual "language," you will be able to use it to strengthen both visual and intellectual communication. Both are important and should work together.

## DESIGN AS ABSTRACTION

Abstract art drew attention to pure visual design. It was "about" color, value, shape, texture, and direction. In a painting by Mondrian (Figure 4-2) we are intrigued by the break-up of space and the distribution of value and color. There is no "picture" to distract us from the visual information. Theo van Doesburg, Mondrian, and the de Stijl movement had a tremendous influence on graphic design, as layout artists began arranging their shapes and blocks of type into asymmetrically balanced compositions.

A good graphic artist must be a good abstract artist. Figure 4-3 shows a layout by Swiss designer J. Müller-Brockmann that demonstrates a strong eye for abstract design shapes reminiscent of Mondrian's surface divisions and strong horizontal/vertical orientation. Figure 4-4 by Louisville designer Julius Friedman shows a de Stijl influence on letterhead design.

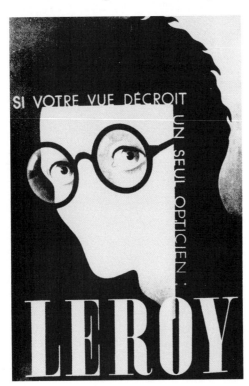

**4-1 A. M. Cassandre.**
Poster for an optician.

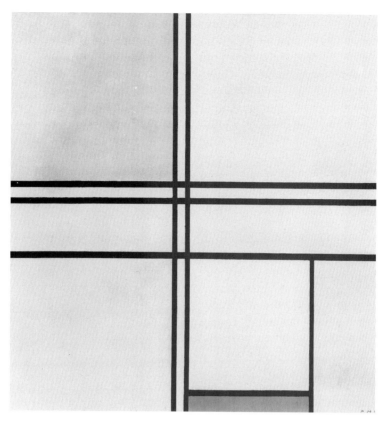

**4-2** **Piet Mondrian.**
*Composition Gray-Red.*
1935. Oil on canvas,
57.5 × 55.6 cm. Gift of
Mrs. Gilbert W.
Chapman, 1949. 518.
©1987 the Art Institute
of Chicago. All rights re-
served.

Graphic design is essentially an ab-
stract art. A work should be balanced
and compelling in its own right as well
as supportive of an idea. *Design is a vi-
sual language.*

## WORKING TOGETHER

In a design firm the visual design of a
project is given full consideration. The
ad agency, however, is often dominated
by copywriters. Many other places that
employ designers also have word people
in key positions. These people tend to be
sensitive primarily to words and ideas
(intellectual unity). They are not trained
in visual communication. For this angle
they will rely upon you. Together you
can assure, as the Bauhaus would say,
that the *form* of a design matches its
*function.*

**4-3** **J. Müller-
Brockmann.**
Poster for
Kunstgewerbemuseum,
Zurich. 1960.

**4-4  Julius Friedman,**
art director, designer.
Images design firm.
Louisville, KY.

To quote El Lissitzky, "The words on the printed page are meant to be looked at, not listened to." How do we *look* at designs, and how do we give them visual unity? The answer has to do largely with balance.

## VISUAL DYNAMICS

A ladder leaning precariously against a wall will make us tense with a sense of impending collapse. A diver poised at the top of the high dive fills us with suspense. We are not passive viewers. We project our experience into all that we see, including the printed page.

How do we project our physical experience into that flat rectangular suface? *Kinesthetic projection* (sensory experience stimulated by bodily movements and tensions) is operating, whether we deal with pictures of people or the abstract shapes of type design. Figure 4-5 by Don Egensteiner demonstrates

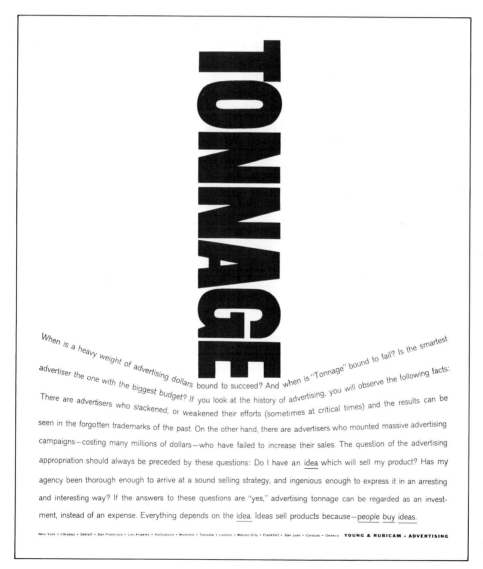

**4-5 Don Egensteiner.** (Young & Rubicam, Inc.) Ad in *Fortune* magazine. 1960.

**4-6** Self-Promotional Ad. Bartels and Company, St. Louis, MO.

the tension of the creative process to show through (Figure 4-6).

As you saw in the preceding chapter, any mark made on a sheet of paper upsets the surface and organizes the space around the mark. This dynamic tension is not contained in the paper itself, nor in the graphite, markers, or ink we use. It is created by our interaction with the image.

## TOP TO BOTTOM

We are uncomfortable with shapes clustered at the top of a page with open space beneath them. We have observed in the world around us that many more things are at rest on the ground than in the sky. There is a sense of suspense as we wait for the fall if they are not "standing" on anything. We experience a design as "top-heavy" much more quickly than as "bottom-heavy."

Milton Glaser, a contemporary designer, illustrator, and author, deliberately plays with this tension in his double portrait of dancer Nijinsky (Figure 4-7). All that anchors the dancing gravity-defying feet is the line of the baseboard under the left foot and the vertical line at the corner.

Type designers have long believed in the importance of putting extra weight at the bottom of a letterform to make it look firm and stable. The 8 and 3 in Figure 4-8 look top-heavy when viewed upside down, as here. Book designers customarily leave more space at the bottom than at the top of a page. They understand that a sense of balance cannot be achieved by placing identical margins at the top and bottom of a composition. This is the same principle that is used when matting artwork. The bottom measurement is slightly greater than the top, allowing for an optical center that is slightly different than the mathematical center.

the attraction of gravity on type. Our culture reads a page from top to bottom, a movement that matches our experience with gravity. It is harder to read a design of words or images that asks the eye to go from bottom to top.

We project emotional as well as physical experience onto the page. An illustration of a man stabbed causes discomfort due to such projection. Visual form stirs up memories and expectations. That is why visual perception is so dynamic.

Loose strokes that allow the process of construction to show through also arouse this dynamic tension. The visible brush stroke or "mark of the maker" pulls viewers into the process of creation. Many interesting and appealing printed pieces are created by allowing

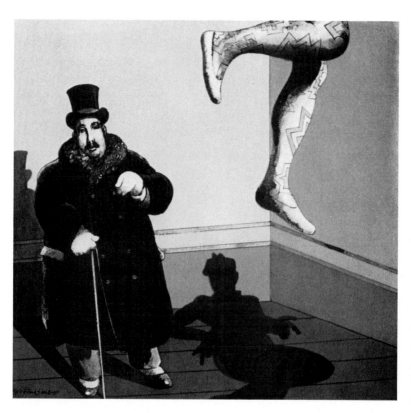

4-7 **Milton Glaser.** *Portrait of Nijinksy & Diaghilev* designed and illustrated for *Audience* magazine.

## VERTICAL AND HORIZONTAL

We find hortizontal and vertical lines stable, probably because they remind us of our vertical bodies on the horizontal earth. Milton Glaser again deliberately violates this sense of stability in Figure 4-9. As he comments, "The diagonal of this figure gives the illustration its surreal perversity."

We find diagonal lines dynamic because they seem in a state of flux, poised for movement toward the more stable horizontal or vertical. The de Stijl artist Theo van Doesburg deviated from Mondrian's horizontal and vertical compositions, stating that the modern human spirit felt a need to express a sharp contrast to those right angles found in architecture and landscape. An oblique angle is one of the quickest, most effec-

4-8 Type turned upside down looks top-heavy.

tive means of showing tension. This tension can be created by placing a single shape at an oblique angle or by placing the entire composition at an angle. Part of the delight in Figure 4-9 is the unusual and unanticipated angled figure. This kind of design solution surprises and delights the viewer.

**4-9  Milton Glaser.**
A drawing created to illustrate a story in *Audience* magazine about a man with a crooked head.

## LEFT TO RIGHT

In Western cultures we read from the left to the right side of the page, and this experience may influence the way we look for balance between those two sides of a design. The left side is the more important, emphasized by the fact that our attention goes there first. Pictorial movement from the left toward the right seems to require less effort than movement in the opposite direction. An animal speeding from the right to the left, for example, seems to be overcoming more resistance than one shown moving from left to right. You can explore this left-to-right balance by holding your de-

signs up to a mirror. They may now appear unbalanced.

## OVERALL

Every two-dimenisional shape, line, figure/ground relationship, value, color, and so on possesses visual dynamics. We have seen the dynamic value of a kinesthetic reaction, or empathy with the image. There is more to the dynamics of perception, however. We have all seen images of a supposedly moving figure that appears in awkward, static immobility. The objects of dancer or automobile can lead us to expect movement, but only skillful control of visual language

can evoke it. Successful communication requires balance, the directing and conducting of visual tensions (Figure 4.10).

## BALANCE

Every healthy person has a sense of balance. It allows us to remain upright and walk or ride a bicycle. Our eye is pleased with a balanced composition, just as we are pleased with our ability to ride a bicycle and not wobble (Figure 4-11). Lack

of balance in a design will irritate viewers and impair the communication. In isomorphic terms, we identify our physical structure with the physical layout/structure of the page and feel in danger of "falling off the bicycle." How do we create a unified, "ridable" design?

When the dynamic tension between elements is balanced, we are most likely to communicate our intended message. Otherwise, the eye is confused. It shifts from element to element, wanting to move things so that they "sit" right on the page, as we want to straighten a

4-10 **Connie McNish.** Dye sublimation print of a stamp design created on a Macintosh, using Illustrator software.

4-11 **Will Bradley.**
Poster for Victor
Bicycles. 1899. Courtesy
UW–Whitewater Slide
Library.

picture hanging crooked on a wall. The viewer so bothered will pay less attention to the quality or content of the picture.

Balance is achieved by two forces of equal strength that pull in opposite directions, or by multiple forces pulling in different directions whose strengths offset one another. Think of visual balance as a multiple rope pull where, for the moment, all teams are exerting the same strength on the rope. It is not a state of rest, but a state of equal tension (Figure 4-12).

If the simplest and quietest form of balance were always desirable, we would see dull art. However, too much predictability and unity disturbs us just as too much chaos. We are animals of change and tension. We strive for growth and life. A simple decrease in visual tension resulting in a quiet balance will not satisfy us for long. An interplay between tension-heightening and tension-reducing visual devices seems to satisfy us and match our kinesthetic and emotional experience. *We yearn for diversity as well as unity.*

4-12 Elements in
balance.

## SYMMETRY

The two basic types of balance are symmetry and asymmetry. In symmetrical balance, identical shapes are repeated from left to right in mirrored positions on either side of a central vertical axis. Figure 4-13 is a symmetrical logo design. Some symmetrical designs also repeat from top to bottom. They are often radial designs. Symmetrical balance dominated painting and architecture until the Renaissance. It dominated graphic design throughout the first centuries of the printing trade, when type was carefully set in centered, formally ordered pages. The traditional book form is a classic example of symmetry (Figure 4-14). The white areas are symmetrical, as are the areas of gray type.

Symmetrical design with its quiet sense of order is useful whenever stability and tradition are important. It uses contrasts of value, texture, and shape to relieve boredom and introduce variety.

There are a variety of nuances when dealing with symmetry. It refers to the similarity of form on either side of a central dividing line. Symmetrical balance can happen even when images are not identical on either side of this axis. Some differences may occur in shape, color, or value. The important consideration is whether the overall balance of shape, value, and color remains primarily symmetrical. That symmetry may be vertical, horizontal, radial (the elements radiate from a central point), or overall.

## ASYMMETRY

Asymmetrical design has a greater sense of movement and change, of possible instability and relative weights. It is like taking your bike through an obstacle course. You may fall off, but the effort is worth it and the audience is thrilled. It is a contemporary balance that reflects the changing times. Symmetrical design

**4-13** **Margo Chase.** Logo design for a recording company.

has a logical certainty that is lacking in asymmetrical design. In symmetrical design a two-inch square in the upper left dictates another such square in the upper right. In asymmetrical design that square could be balanced by a vast number of shapes, values, colors, or textures. It is difficult, challenging, and visually exciting.

Asymmetrical designs are balanced through contrast to achieve equal visual weight among elements. To be effective, contrast must be definitive. Shapes that are almost but not definitely different are irritating to the eye. Figure 4-15 is an asymmetrical design that uses several forms of contrast in both figures and letterforms to achieve a balanced, intriguing design.

## BALANCE THROUGH CONTRAST

Symmetry achieves balance through likeness; asymmetry achieves balance through contrast. The easiest way to achieve visual unity would be to make one shape into an overall symmetrical pattern on the page. A full book page with nothing on it but a solid block of type is visually unified, no matter what the words say. It is also visually dull. In the case of novels, this visual dullness is

## The Five Books of J.G. Lubbock

BY COLIN FRANKLIN

Mr. J.G. Lubbock, book artist, printmaker and author, lives in an obscure corner of Suffolk well protected by a confusing maze of lanes; thus there need be no fear of mass intrusion if I suggest that to know his books one should visit him. Since 1966 his surprising productions have grown among us, bearing his varied and splendid prints and his own struggling cosmic prose printed with the Cambridge taste of Will and Sebastian Carter of The Rampant Lions Press, and nobody has known quite what to make of it all. "Prints are okay," people say, "so long as you don't have to read the books." The sea comes into his writing, and he lives near an estuary. Thinking of another member of his family, Basil Lubbock, whose book *The Last of the Wind-jammers* I desired as a boy, I had imagined a blustery beard-ed sailor, talented as seamen often are with their hobbies but greatly out of depth in prose. Mostly it was rather high-flying stuff, like this from his first book:

> The process of production of the work of art is of more inter-est than the results even to the spectator, because the work must always, by virtue of the artist's imperfection as a transmitter, be inferior to the transcendent reality sensed by him.

He seemed to range rather casually over the universe, tak-ing in science or the sea as a car needs to pause at the garage. Was it all rather peculiar and pretentious?

It was not. Mr. Lubbock looks a little like portraits of James Joyce, and keeps the Cambridge diffidence of his youth. Few men preserve themselves without worldly corruption through a full span of professional life and re-turn to complete their proper artistic purpose, but he ap-pears to be achieving just that. "Art in books" had appealed to him since undergraduate years at Trinity, where varied Books of Hours and the Trinity College Apocalypse had provided an enduring wish. As an engineer and living at the edge of London, there had simply been no time for all that; the vanity and indulgence of art waited, and at his retirement burst with energy upon a sudden summer.

He works in mixed method – etching, aquatint, engrav-ing – but always with color and using one plate only. In his studio by the sloping field he was coloring a large chrome-surfaced plate which went through the etching press as he heaved spokes of the old wheel like a sailor at his helm. And out came one of the astonishing religious land-scapes, everything looking easy apart from the effort. Hand-coloring of sky and forest background occupied less than two minutes. Later, the laying of a resin-dust ground for aquatint looked simple, the brushing of acid-resist any-one's job. But the vision and energy of these prints. . . . (See illustrations, page 89.)

It has all happened fast for J.G. Lubbock, at an unusual phase of life. Raymond Lister in his book on *British Ro-mantic Art* wrote that "the fuller development and com-plete synthesis of the aesthetic possibilities of form in Na-ture have, even now, only just begun to be realized, in the work of artists like Graham Sutherland, Paul Nash, and Ivon Hitchens; but most of all in such works as some little known, but extremely beautiful engravings by J.G. Lub-bock, and Morris Cox." The link with Morris Cox and the Gogmagog Press, with comparable and complex examples of color printing, is apt, of course, and I find it entirely sympathetic, though deep differences suggest themselves if one thinks of the two together. Morris Cox has spent his life as an artist, humbly and with a single mind; Lubbock's religious art has survived a conventional career in one of the professions, showing its strength in release. The Gog-magog Press of Morris Cox makes everything, prints, binds, adapts to a table-press and by laborious improvisa-tion produces "form in Nature," as Mr. Lister phrases it.

**4-14** **Scott Walker** and **Tim Girvin.** Page design for Fine Print. 1979.

"Let's go girl, low. "But phone mumm stepped into a booth and true and well

sai firs Sh p

DeAth in The Afternoo AFTERNOON
Afternoo
CHAPTER ONE

4-15 **Michael David Brown.**
*Death in the Afternoon* from *Creativity Illustrated.* 1983. An example of asymmetrical balance.

deliberate. The reader is directed to the content of the words without distraction. In most publications and advertising design, however, this unity must be tempered with contrast if it is to attract and hold the viewer. The designer is usually working with many different elements. Most successful designs rely on a carefully juggled balance of similarities and contrasts.

There are two considerations in setting up balance through contrast: weight and direction. *Weight* is the strength or dominance of the visual object. *Direction* is the way the eye is drawn between elements over the flat surface. Balance is determined by the natural weight of an element and by the directional forces in the composition. Weight and direction are influenced by several forces.

### Location

The center of a composition will support more weight than the edges. Although a shape is most stable when in the center, it also is visually "light." Small shapes at the edges of a composition can balance large ones in the middle (Figure 4-16*a*).

### Spatial Depth

Vistas that lead the eye into the page have great visual strength. We project ourselves into the spatial illusion, so it seems to have greater presence of size (Figure 4-16*b*).

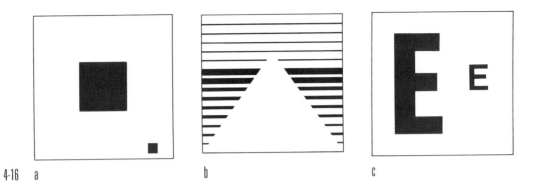

4-16    a                    b                    c

### Size

Visual weight also depends upon size (Figure 4-16c)—the larger the heavier. Size is the most basic and often used form of contrast in graphic design. The contrast between large and small should be sharp and definite without overpowering the smaller elements so that they cannot contribute their share. Most successful designs benefit from size contrast

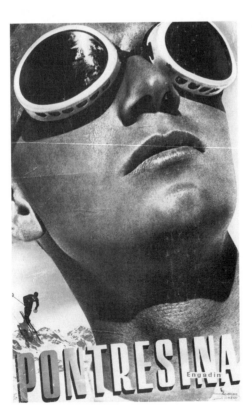

**4-17  Herbert Matter.** *Pontresina Engadin.* 1935. Gravure, printed in color, 41″ × 25⅛″ (104.1 x 63.8 cm). The Museum of Modern Art, New York. Gift of the designer. Photograph © 1998 The Museum of Modern Art, New York.

in type or in image. In layout design the contrast is often between large and small photographs and between headline and text type.

An interesting sort of size contrast is contrast in expected size. The large element is played small and vice versa, resulting in a visual double take, as in this 1935 poster depicting skiing and ski goggles (Figure 4-17).

### Texture

A small, highly textured area will contrast with and balance a larger area of simple texture (Figure 4-18a). This rule refers to visual, not tactile texture. Contrast of texture is especially useful with text type (type smaller than 14-point, used to set the body of copy).

### Isolation

A shape that appears isolated from its surroundings will draw attention to itself more quickly and have greater visual weight than one that is surrounded by other shapes (Figure 4-18b).

### Subject Matter

The natural interest of a subject matter will draw the viewer's eye and increase visual weight. It also can create directional movement as we move our eyes between lovers or follow the eye direction of a figure. Our eyes are drawn to the realistic representation of something that interests us (Figure 4-18c).

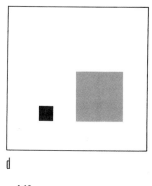

a      b      c      d

4-18

## *Value*

Areas of high contrast have strong visual weight. A small area of deep black will contrast with and balance a larger area of gray when both are placed against a white background (Figure 4-18*d*). The creation of light and dark areas in a drawing, painting, photograph, or illustration produces a dramatic play of values that delights the eye. Figure 4-19 by Toulouse-Lautrec uses both value and textural contrast to this end.

Typography also uses value contrast. The contrast of a black, heavy type against a light one helps relieve boredom and makes the page more readable. Contrasts between headings and text matter and the white areas of paper can create three distinct weights: the black bar of the heading is played against the gray, textured rectangle of the text type, both of which contrast with the white areas of the background page. Designers will sometimes alternate boldface and regular weight type for a visual pattern. Figure 4-20 is an illustration based on a poem by Paul Klee; it uses many kinds of contrast to emphasize the meaning of the words.

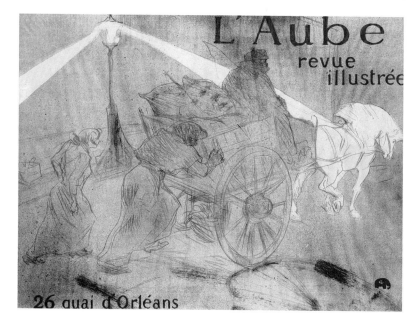

4-19 **Henri de Toulouse-Lautrec.** *L'Aube.* 1986. Color lithograph. Milwaukee Art Museum Collection. Gift of Mrs. Harry Lynde Bradley.

**4-20** Illustration based on a poem by Paul Klee.

### Shape

The shape of objects generates a directional pull along the main structural lines. Complicated contours also have a greater visual weight than simple ones. Therefore a small complex shape will contrast with and balance a larger simple shape (Figure 4-21a). One block of type might be set in a long, thin ragged rectangle while another is set in a large, square block form. Contrast in shape also works with single letterforms. You might play the round openness of an *O* against the pointed complexities of a *W* or the shape of an uppercase *A* against a lowercase *c* (Figure 4-21b).

### Structure

In type design structure refers to the contrasting characteristics of type families. It is a kind of contrast of shape. Compare the *G* in Helvetica with the *G* in Baskerville (Figure 4-21c). They are the same basic shape, but their differences are important in typography. Their structures—thick/thin, serif/sans serif—are different. The logo design in Figure 4-22 plays with both contrast and similarity.

### Color

The brighter and more intense the color, the heavier. A large dark blue shape will

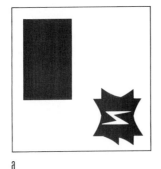

**4-21**    a                              b                              c

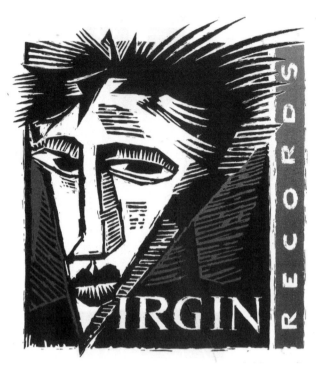

**4-22 Margo Chase.**
Margo Chase Design, Los
Angeles. Logo design for
Virgin Records.

be balanced by a small bright red shape. A small, bright, intense green will contrast with and balance a large, toned-down, low intensity green. In graphic design each additional color costs money, so it must be used wisely. A second color can be used to enliven a magazine from cover to cover, or only on those pages that are cut from the same printed signature. Remember that in one-color design, that color need not be black. It can be a rich gray, a deep green, or any color you can envision.

## EXCERCISES

1. Do some sketches on full-sized separate sheets of paper to experiment with the statements listed below. It is a good idea to use letterforms for these sketches in order to become better acquainted with them before you try images. What design dynamics are influencing each of these situations?

   a. A shape placed in a corner is protected by the two sides of the rectangle. Place the same shape farther out into the space around it, and it seems more vulnerable.

   b. Two shapes placed side by side will look less lonely than one.

   c. Two shapes (an *e* or an *a* works well) placed back to back will appear uncommunicative, unfriendly.

   d. A point placed against a soft curve will cause a sensation of discomfort. (An *A* and an *e* again work well.)

2. Using cut and paste and/or computer software such as Freehand or Illustrator, select letterforms or simple shapes to demonstrate the following principles. (It might be interesting to try doing this exercise with both the

**4-23  Julieanne Asma.**
Word illustration,
"Mirror."

hand method and via computer to compare results.)

  **a.** A single shape can balance several shapes.

  **b.** A large shape can be balanced by a group of smaller shapes.

  **c.** Shapes can be balanced by negative space.

  **d.** A dark shape can be balanced by a larger, lighter shape.

  **e.** A large flat shape can be balanced by a smaller, textured shape.

**3.** Prepare a classroom presentation based on a critique of a poster, advertisement, or illustration. Describe how it achieves or fails to achieve visual and intellectual unity.

## PROJECT

### *Word Illustration*

This project asks you to concentrate on placement, contrast, and kinesthetic projection to create a balanced and interesting design. Figures 4-23 and 4-24 are student designs based on this project.

    Choose a word to illustrate. Practice on those listed below. Then find your own word from class discussion or your own research. A dictionary can be useful. Do a minimum of 15 thumbnails. Base these thumbnails and your project upon existing type styles. Search for an appropriate one. Do not use pictures or distort your letterforms into pictures to tell your story. Let the letterforms communicate their message *visually* through size, color, value, shape, structure, texture, placement, and kinesthetic projection. Tell visually what the word says intellectually. Be able to describe the tensions and balancing forces.

    Execute your design so that it fits with an 11″ × 14″ (28 × 36 cm) format. Use black and one shade of gray if it will strengthen your design. If you use a

**4-24  Becky Kliese.**
Word illustration,
"Movement."

computer-generated solution, stay within the same design limitations of size and color. Do not allow the seductive nature of the software to lure you into distorting the basic shape of the letterform. Enjoy it for its clarity and beauty of design.

## Objectives

Learn to create a visually balanced design.

Explore the personalities of varying type styles.

Increase your control of media and tools and your respect for precision.

## Practice Words

| | |
|---|---|
| Black and White | Allover |
| Elephant | Black and Blue |
| Headache | Wrong Font |
| Divide | Alone |
| Direction | Repeat |
| Invisible | |

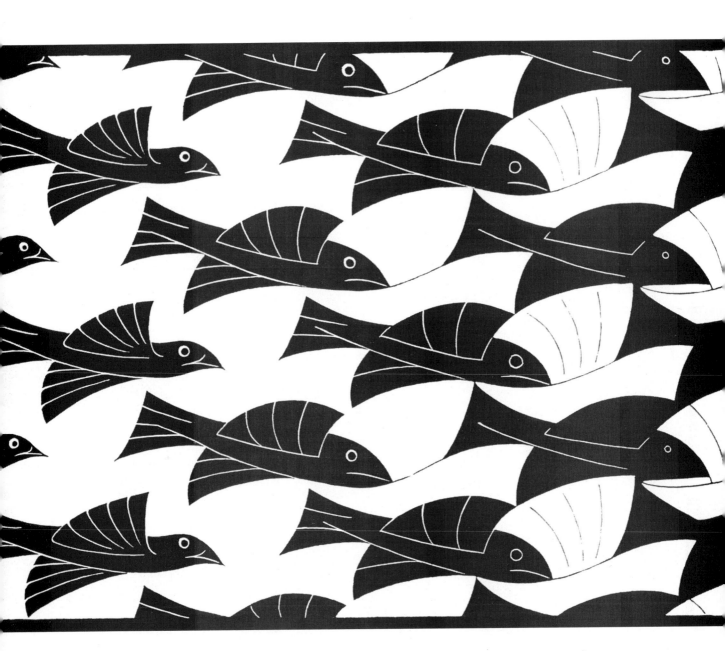

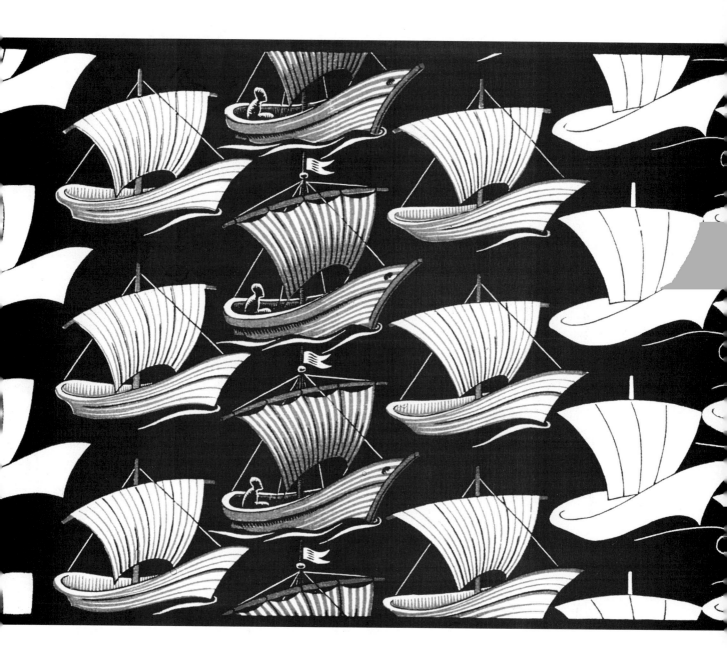

"GOOD" GESTALT

**5-1** *(left)*

**5-2** *(right)* **Guiseppe Arcimboldo**. Sixteenth century.

5-2

## THE WHOLE AND THE PARTS

The Gestalt school of psychology, which began in Germany around 1912, investigated how we see and organize visual information into a meaningful whole. The conviction developed that the whole is more than the sum of its parts. This whole cannot be perceived by a simple addition of isolated parts. Each part is influenced by those around it.

### WHOLE

As you read the word above, you are perceiving the whole word, not the individual letterforms that make it up. Each let-

ter can still be examined individually, but however you add it up, the *word* is more than the sum of those separate letterforms (Figure 5-1).

When you sew a shirt, you begin with pieces of fabric that are cut into parts. When the parts have been assembled, a new thing has been created. The collar, the facing, and the sleeve still exist, but they have a new "whole" identity called a shirt.

**5-3** **Julius Friedman** and **Walter McCord**, co-designers. Logo for Images design firm.

Giuseppe Arcimboldo, a painter from the sixteenth century, demonstrates the principle clearly in this portrait. A close examination reveals the separate parts that make up this head (Figure 5-2). A similar example is this contemporary alphabet made up of objects (Figure 5-3).

The early Gestalt psychologists and many other researchers into visual perception have discovered that the eye seeks a unified whole or gestalt. Knowing how the eye seeks a gestalt can help you analyze and create successful designs. By knowing what connections the eye will draw for itself, you eliminate clutter and produce a clearly articulated design.

## GESTALT PRINCIPLES

A designer works not simply with lines on paper, but with perceptual structure. Learn these gestalt perceptual principles and you can take advantage of the way object, eye, and graphic creation interweave. A powerful and beautiful example can be found in Plate 1.

## SIMILARITY

When we see things that are similar, we naturally group them. Grouping by sim-

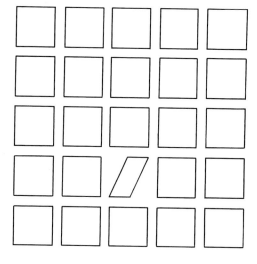

5-4

ilarity occurs when we see similar shape, size, color, spatial location (proximity), angle, or value. All things are similar in some respects and different in others. In a group of similar shapes and angles, we will notice a dissimilar shape or angle (Figure 5-4).

Similarity is necessary before we can compare differences. In the photograph by Gordon Baer (Figure 5-5), we are attracted

5-5 **Gordon Baer.** Freelance photographer, Cincinnati, OH. *Two Old Men.*

5-6 *(left)* **Saul Bass.**
Trademark for ALCOA.
Courtesy, Aluminum
Company of America.

5-7 *(right)* **Margo Chase.**
Logo for Esprit woman,
a romantic line, made
up of figures and hearts.

**ALCOA**

by a similarity of sleeping forms. It is
useful for the designer to know that the
eye will notice and group similarities
while separating differences. The symbol
and logotype created for Alcoa by Saul
Bass, a renowned American designer, re-
lies on similarity of shape. Count the tri-
angles in Figure 5-6. In Figure 5-7, de-
signer Margo Chase uses a similarity of
line quality to create a dynamic, unified
logo for Esprit.

## PROXIMITY

Grouping by similarity in spatial location
is called proximity, or nearness. The
closer two visual elements are, the more

likely it is that we will see them as a
group (Figure 5-8). The proximity of
lines or edges makes it easier for the eye
to group them to form a figure.

## CONTINUATION

The viewer's eye will follow a line or
curve. Continuation occurs when the

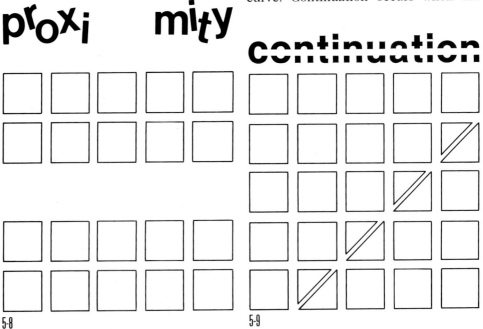

5-8                5-9

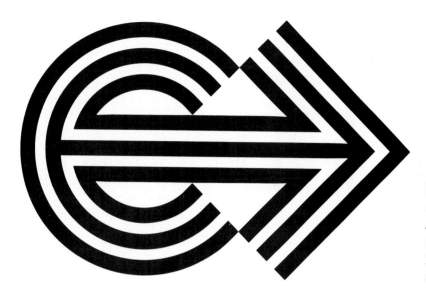

5-10 **George Jadowski,** designer, **Danny C. Jones,** art director. Symbol for the U.S. Energy Extension Service.

eye is carried smoothly into the line or curve of an adjoining object (Figure 5-9).

The eye is pleased by shapes that are not interrupted, but form a harmonious relationship with adjoining shapes. The symbol of the U.S. Energy Extension Service (Figure 5-10) uses continuation to emphasize the moving, dynamic nature of energy. Continuation can also be achieved through implied directional lines.

## CLOSURE

Familiar shapes are more readily seen as complete than incomplete. When the eye completes a line or curve in order to form a familiar shape, closure has occurred (Figure 5-11). This step is sometimes accompanied by a reaction, "Oh, now I see!" Figure 5-12 is a symbol created by the 1 + 1 Design Firm. Do you see the plus sign created by the figure/ground relationship? Part of the closure in this example includes a sudden connection with the name of the firm. This sort of connection is especially useful in trademark design.

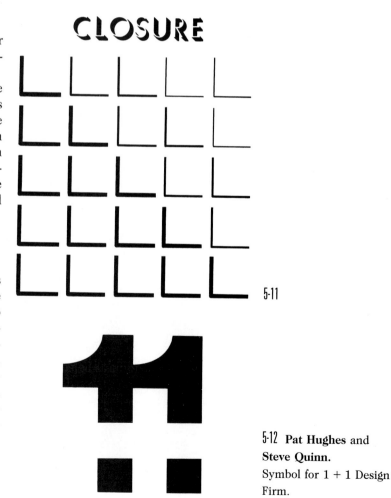

5-11

5-12 **Pat Hughes** and **Steve Quinn.** Symbol for 1 + 1 Design Firm.

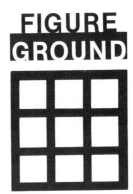

5-13

When closure happens too soon, without participation from the eye and mind of the viewer, the design can be boring.

## FIGURE/GROUND

The fundamental law of perception that makes it possible to discern objects is the figure/ground relationship. The eye and mind separate an object (figure) from its surroundings (ground). As you read this page, your eye is separating out words (figure) from ground (paper). Many times the relationship between figure and ground is dynamic and ambiguous, offering more than one solution to the searching eye (Figure 5-13).

Sometimes referred to as positive and negative space relationship, this principle is crucial to shaping a strong design. The designer must be aware of creating shapes in the "leftover" ground every time a figure is created. Figure 5-14 uses this fact in an entertaining way, similar to the work of M. C. Escher. Figure 5-15 is an illustration that also uses the figure/ground relationship as an inherent part of its structure.

In Figure 5-16, the logo for Case Equipment Company, the figure/ground relationship is remarkably strong.

## TRADEMARKS

The interplay of gestalt principles occurs in all areas of design but is clearest in

5-14 **Whitney Sherman,** illustrator; **Martin Bennett** and **Mary Pat Andrea,** designers. North Charles Street Design Organization. This poster announces an upcoming move to a new location.

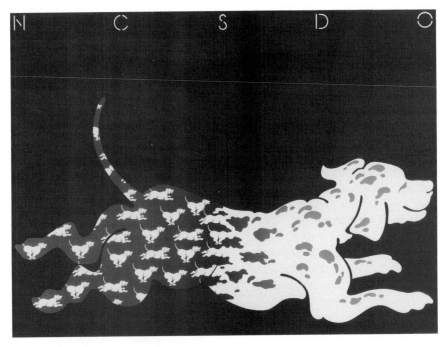

the creation of logo and symbol trademarks. Here, form and function are closely related. We have examined form. Now we will consider function. The project in this chapter will require you to relate these two considerations.

## FUNCTIONS

Symbols and trademarks have served many functions in history. The early Christians relied on the symbol of the fish to identify themselves to one another secretly. In the Dark Ages family

trademarks were used. No nobleman in the same region could wear the same coat of arms. These "arms" came to mark the owner's possessions, while peasants used simpler "housemarks," which were especially useful because few people could read (Figures 5-17 and 5-18). Also, each medieval craftsman inscribed a personal mark on his products and hung out a sign showing his calling. During the Renaissance, the three golden balls of the Medici family symbolized moneylending. The Medici mark can still be seen today, pirated by modern pawnbrokers. More recently, in the western United States, each cattle rancher had a brand or mark. Many still do.

Today, trademarks are widely used by corporations. The trademark is any unique name or symbol used to identify a product and to distinguish it from others. These unique marks can be registered and protected by law. Their primary use is to increase brand recognition

5-15 *(left)* **David McLimons.** "Helping Children Learn," an illustration for *The Progressive* magazine.

5-16 *(right)* Lippincott and Margulies, Inc. Trademark for Case Corporation. The company adopted a new logo design in 1994.

5-17 *(left)*

5-18 *(right)*

and advertise products and services. The use of trademarks, or logos, is growing as individuals identify themselves on letterheads, résumés, and homepages. Consumers come to rely on the quality associated with a trademark and are willing to try new products that are identified with that recognized trademark.

## MAKING "MARKS"

Unlike other forms of advertising, the modern trademark is a long-term design. It may appear on letterhead, company trucks, packaging, employee uniforms, newsletters, and so on. Designers often spend months developing and testing one trademark. Only a strong design with a simple, unified gestalt will stand the test of repeated exposure.

Keep several other points in mind when developing a "mark":

1. You are not just "making your mark on the world"; you are making a mark to symbolize your client and your client's product. It must reflect the nature and quality of that product to an audience. Research the company, product, and audience. As designer Paul Rand said, "A trademark is created by a designer, but *made* by a corporation. A trademark is a picture, an image . . . of a corporation."

2. The mark is often reproduced in many different sizes, from the company vehicle to a business card. Your design must remain legible and strong in all circumstances.

3. Because this mark may be reproduced in newspaper advertising or with severely limited in-house duplicating facilities, it must reproduce well in one color.

4. Many trademarks are seen in adverse viewing conditions, such as short exposure, poor lighting, competitive surroundings, and lack of viewer interest. Under such conditions, simplicity is a virtue. A simple, interesting shape with a good gestalt is easier to remember than a more complex design.

5-19 **Michael Vanderbyl.** Symbol proposed but not adopted for the California Conservation Corps.

5-20
**Roger Cook** and **Don Shanosky** (Cook and Shanosky Associates). Department of Transportation pictograms prepared by the American Institute of Graphic Arts (AIGA).

Some designers refer to all trademarks as "logos," whereas others have a complex system of subtle categories. The two most common categories of trademarks, however, are symbol and logo.

## SYMBOLS

*Webster's Ninth New Collegiate Dictionary* says a symbol is "something that stands for or suggests something else by reason of relationship, association, convention, or accidental resemblance, especially: a visual sign of something invisible. A printed or written sign used to represent an operation, element, quantity, quality, or relation." Historically important symbols include national flags, the cross, and the swastika.

The symbol is a type of trademark used to represent a company or product. It can be abstract or pictorial, but it does not usually include letterforms. It represents invisible qualities of a product, such as reliability, durability, strength, or warmth.

A symbol has several advantages, including:

1. Original construction
2. Simple gestalt resulting in quick recognition
3. A wealth of associations

Figure 5-19, a symbol proposed for the California Conservation Corps, demonstrates all three qualities.

A pictogram is a symbol that is used to cross language barriers for international signage. It is found in bilingual cities, such as Montreal, for traffic signs. It is also found in airports and on safety instructions inside airplanes. It is pictorial rather than abstract (Figure 5-20).

## LOGOS

The second category of trademark is called logo or logotype. The logo is a unique type or lettering that spells out the name of the company or product. It may be handlettered, but is usually constructed out of variations on an existing typeface. Historically, it developed after the symbol, because it requires a literate audience.

When you create a logo, it is extremely important to choose type that

A READER'S DIGEST
PUBLICATION

**5-21** *(left)* **Herb Lubalin.** Trademark created for *Reader's Digest.* Assigned to Military Family Communication, publisher of *Families* magazine.

**5-22** *(right)* Logotype for Ditto Corporation. The Ditto trademark is a federally registered trademark of Starkey Chemical Process Co. of LaGrange, IL.

suits the nature of your client and audience. A successful, unique logo is often more difficult to design than a symbol, because it entails both visual and verbal communication. Figure 5-21 was created for *Reader's Digest* by one of the most respected and influential logo designers, Herb Lubalin. The clean, bold type style makes it easy to see the play on similar shapes that creates the "family connection" hidden in the word. Figure 5-22 was created for Ditto Company, a duplication products manufacturer. Compare this type style with the one before. Each is distinctively suited to its use.

The advantages of a logotype include

1. Original construction
2. Easy identification with company or product

A combination mark is a symbol and logo used together. These marks are difficult to construct with a good gestalt because of their complexity. They are often used, however, because they combine the advantages of symbol and logo.

In all these marks, gestalt principles help to create a unified and striking design. With "good" gestalt, form and function interweave in a powerful whole.

## EXERCISES

Figure 5-23 is a student design based on some of the following exercises. This assignment is best done with graph paper, or you may want to use a computer program to generate it quickly and cleanly.

1. Select a circle 1½″ (4 cm) in diameter (or slightly more) and practice overlapping two of them to create new and varied shapes. Then try three circles. Do not use line, only shape and black and white values. Reverse one out of another for more interesting effects.
2. Place a circle in various positions within a square. Do not use line. Use black and white shapes. Experiment with size and border violations.
3. Set up a series of vertical lines so that the white lines gradually grow small

 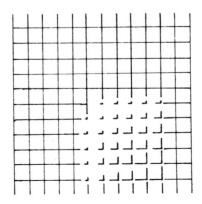

**5-23  Tom Yasitis.** Grid and circle variations.

while the black lines expand. Start by making a series of vertical lines ¼″ (5 mm) apart. Each line can then be thickened.

4. Create a break or anomaly in a series of vertical lines.

5. Examine the illustrations in this chapter and identify the unifying gestalt features in each mark.

6. Use one or more of these exercises to develop an appropriate symbol for a company of your choice.

# PROJECT

### *Combination Mark*

Design a combination mark for a company described below. You may combine logo and symbol into one image, or present them as two images, carefully placed together. Experiment with many alternatives in your thumbnail sketches. Incorporate each of the gestalt principles discussed in this chapter into your thumbnail investigation.

Begin with an existing type style and make careful alterations. Spend time looking through typebooks. Experiment with fonts, finding which are appropriate for the company you have selected. List the name of the font next to your pencil sketch.

After consultation with the instructor, select two thumbnails to enlarge to full-size roughs for final review. Execute the strongest within an 8″ × 10″ (19 × 25 cm) format. Use only one color. Execute in either paint, ink, cut paper, or computer program. Again, Freehand or Illustrator is a good choice, although many programs will work well.

Keep your design visually strong and uncluttered. Be prepared to discuss the gestalt principles involved during the critique. Use at least two of them in your final trademark. Also consider the audience your trademark will be reaching.

What will appeal to them? Consider the company. What will be an accurate and positive image? Be prepared to discuss the function of your trademark and why the design suits it.

Figures 5-24 and 5-25 are student designs created for a similar project.

### *Companies*

#### Manard
A national heavy-equipment manufacturer that specializes in tractors, end loaders, and so on.

#### Antique Oak
A trendy eatery located on Chicago's North Side that caters to young professionals.

#### Aurora
Manufacturer for retail sales of hiking clothing, tents, and camping equipment.

5-24 **Lynette Schwartz.** Combination mark for a "yuppie" men's clothing store. How many forms of similarity can you find?

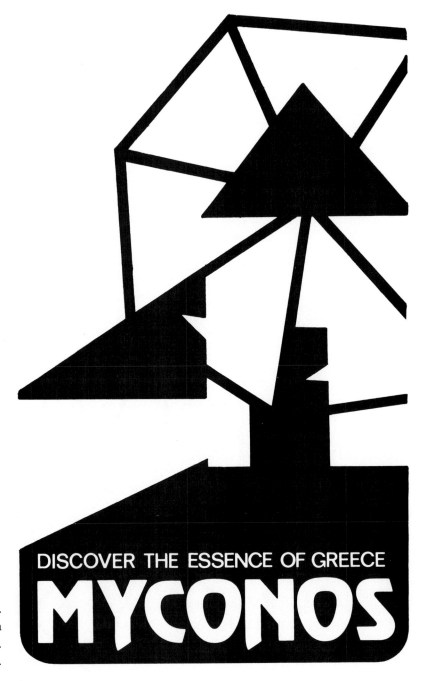

5-25 **Sophia Asimomitis.**
Combination mark for a
Greek vacation spot.
Count the triangles.

**Quadrata**

An interior design firm that specializes in corporate accounts.

### Objective

Communicate the nature of a company with a design that appeals to a particular audience.

Apply gestalt principles to develop a trademark that is more than the sum of its parts.

### Variations

Let your instructor invent new corporations or assign existing ones that need a new trademark design.

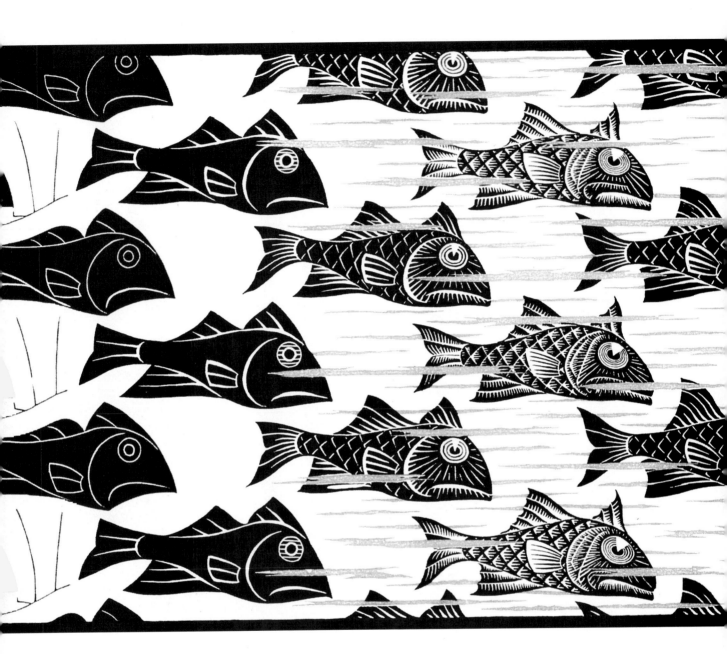

# USING TEXT TYPE

# THE DEVELOPMENT OF WRITTEN COMMUNICATION

Since the first person made a mark in the sand for another to find, we have been communicating with a visual language. The earliest forms of visual communication were pictorial drawings of everyday objects, such as weapons and animals. As the desire to communicate grew, these pictures were combined to convey thoughts and ideas.

With visual language, it became possible to "conquer" time. An individual's mark could be seen and understood after the maker had moved on or even died. Civilization developed along with our visual record of the spoken language. So did the importance of the individual.

## ALPHABETS

The first systematized alphabet was created by the Egyptians. It was partly abstract symbols and partly pictures. The Phoenicians added consonants around 1600 B.C. A nation of merchants, they needed an efficient, condensed language for business transactions. This need led to a significant breakthrough: Symbols were used to represent not objects, but the sounds of speech. A different symbol

stood for each recognizable spoken sound. It was a much shorter and more efficient system of written language.

The Greeks adapted the Phoenician system, and around 1000 B.C. the Romans modified the Greek alphabet. Our alphabet is derived from the Roman version. The Romans devised a total of 23 letters. The letter J was added to our alphabet only 500 years ago (Figure 6-1).

As designers working with the letters of the alphabet, we have thousands of years of history behind us. The shape of letters has been largely determined by the tools used to create them. The Egyptians used reeds for writing on papyrus. This method created a pattern of thick and thin strokes. The Greeks used a stylus on tablets, whereas important Roman inscriptions were chiseled into stone. These forms developed with few curved lines, because curves were difficult to carve. The Greek and Egyptian alphabets had no serifs. They evolved with the Roman alphabet, perhaps to make inscriptions seem to sit better optically when chiseled in stone. Medieval handwritten scrolls kept the alphabet alive during the Middle Ages. These scrolls gradually evolved into folded manuscript books, produced by religious orders. Our most common typefaces are imitations of early handwriting or modifications of early typefaces modeled

6-1 The Phoenician, Greek, and Roman alphabets.

**1.** Phoenician alphabet

**2.** Greek alphabet

**3.** Roman alphabet

after the lettering in manuscript books. From the invention of the first printing press in 1440 until the eighteenth century, type designs were based on handwriting. The rounded style favored by Renaissance artists is the inspiration for our modern roman style. Computers now make it possible to develop variations on existing styles quickly. Specialized software makes the creation of new styles simpler and more accessible than ever before. Whatever tools are used, the eye of the designer remains the most important factor.

## TYPE CATEGORIES

Like the alphabet, type has undergone a long development. A brief look at its history will help you assemble types with similar attributes. History provides a key to proper use.

The type category we refer to as *old style,* with gently blended serifs leading into thick and thin strokes, was created in 1470 by Nicholas Jenson, a Venetian printer. The French typographer Claude Garamond built his type style "Garamond" on Jenson's design. This classic remains in use today. A modern revival of fifteenth-century Italian types occurred in Europe and the United States around 1890. Englishman William Morris produced a type called "Golden" that recalled the spirit of the fifteenth century (see Figure 2-6).

Most roman types have variations available called italics. They are a slanted form that relates to the original type style but does not duplicate it. Venetian printer Aldus Manutius is credited with developing italics in 1501 as a method of fitting more characters on a line to save space. For about 40 years italic was simply another style of type, until an italic was consciously developed from an upright roman mold. Today most roman types have "matching" italics as well as several other variations.

Roman faces with strong contrast between thick and thin strokes and with thin serifs were developed in the eighteenth century. These faces are generally classified as *transitional.* They were more precise because they were designed for the printing industry. A widespread interest in copperplate engraving at that time helped the development of types that incorporate a very fine line.

Bodoni and Didot imitated the engraver's tool with precise hairline strokes. The term *modern* is used to describe this eighteenth-century type, confusing many a student.

In the nineteenth century, many new faces were developed, with a wide variety of looks. The sans serifs and the Egyptians are among them. A revival of the old classic typefaces, such as Jenson, occurred at this time. Printers, such as Ben Franklin and William Morris, contributed to the history of typography during this time, creating some handsome typefaces.

Since the early nineteenth century, serif and sans serif types have alternated in popularity. A great interest surrounded sans serif in the mid-twentieth century. Bauhaus designers in Germany during the 1920s began designing sans serif faces such as Futura. In the 1950s Helvetica became the dominant typeface used by design professionals. Its dominance lasted over a decade, due to a clean precision and understated elegance of line. The horizontals are cut along a common line. Univers and Folio are sans serif type styles developed during this period. Figure 6-2 is a layout by contemporary designer Paula Scher that uses sans serif type to evoke an earlier era. Today's designers choose from a rich array of old and new type styles. In fact, there is such an extensive array of fonts available on computer that selecting one can be quite difficult. A basic familiarity

**6-2  Paula Scher.** Layout design for *The Magic Mountain* in "Great Beginnings" brochure.

# abcdefghijklmn
# opqrstuvwxyz
# ABCDEFGHIJK
# LMNOPQRSTU
# VWXYZ$12344
# 567890 (.,"""-;:!)?&

**6-3** Garamond Book, a revised old style face. (See p. 92 for Figure 6-5, Garamond in different point settings.)

with typography will help you develop a discerning eye.

## TYPE STYLES

### Old Style

Characteristics of old style faces (Figure 6-3) include thick and thin stroke serifs that seem to merge into the main strokes. This feature is called bracketing. Garamond and Caslon are examples. Garamond was originally credited to Claude Garamond who died in 1561. It was recently discovered that Jean Jannon, a French printer, designed this face based on Claude Garamond's work. Created in 1617, it was the first typeface designed to appear uniformly "printed" rather than hand-lettered. It remained the principal type for over 200 years, with many derivatives.

### Transitional

A blending of old style and modern, the transitional has emphasis on thicks and thins and gracefully bracketed serifs (Figure 6-4). It is lighter than old style and has a more precise, controlled character. It is less mechanical and upright, however, than the modern faces.

Baskerville was designed in 1757 by John Baskerville, an amateur printer. The transitional Baskerville has straighter and more mechanical lines than the old style typefaces, with flatter serifs that come to a fine tip. Increased contrast between the thick and thin strokes of the letterforms and the rounded brackets give it more delicacy than old style faces such as Caslon.

John Baskerville introduced several technical innovations that affected the appearance of his type. He passed printed sheets through heated copper cylinders to smooth out the rough texture of the paper then in use. This smooth surface made it possible to reproduce delicate serifs clearly. Figures 6-5 and 6-6 show text-size Garamond and Baskerville fonts.

abcdefghijklmnop
qrstuvwxyzAB
CDEFGHIJKLM
NOPQRSTUV
WXYZ$1234567
890(.,""''-;:!)?&

6-4 Baskerville, a transitional face. (See p. 93 for Figure 6-6, Baskerville in different point settings.)

## Garamond Book

Since the first person made a mark in the sand for another to find, we have been communicating with a visual language. The earliest forms of visual communication were pictorial drawings of everyday objects such as weapons and animals. As the desire to communicate grew, these pictures were combined to convey thoughts and ideas. With visual language, it became possible to "conquer" time. An individual's mark could be seen and understood after the maker had moved or even died. Civilization developed along with our visual record of the spoken language. So did the importance of the individual.

8/9

Since the first person made a mark in the sand for another to find, we have been communicating with a visual language. The earliest forms of visual communication were pictorial drawings of everyday objects such as weapons and animals. As the desire to communicate grew, these pictures were combined to convey thoughts and ideas. With visual language, it became possible to "conquer" time. An individual's mark could be seen and understood after the maker had moved or even died. Civilization developed along with our visual record of the spoken language. So

8/10

Since the first person made a mark in the sand for another to find, we have been communicating with a visual language. The earliest forms of visual communication were pictorial drawings of everyday objects such as weapons and animals. As the desire to communicate grew, these pictures were combined to convey thoughts and ideas. With visual language, it became possible to "conquer" time. An individual's mark could be seen and understood after the maker had moved or even died. Civilization de-

8/11

Since the first person made a mark in the sand for another to find, we have been communicating with a visual language. The earliest forms of visual communication were pictorial drawings of everyday objects such as weapons and animals. As the desire to communicate grew, these pictures were combined to convey thoughts and ideas. With visual language, it became possible to "conquer" time. An individual's mark could be seen and understood after the maker had moved or even died. Civilization de-

9/10

Since the first person made a mark in the sand for another to find, we have been communicating with a visual language. The earliest forms of visual communication were pictorial drawings of everyday objects such as weapons and animals. As the desire to communicate grew, these pictures were combined to convey thoughts and ideas. With visual language, it became possible to "conquer" time. An individual's mark could be seen and understood

9/11

Since the first person made a mark in the sand for another to find, we have been communicating with a visual language. The earliest forms of visual communication were pictorial drawings of everyday objects such as weapons and animals. As the desire to communicate grew, these pictures were combined to convey thoughts and ideas. With visual language, it became possible to "conquer"

9/12

Since the first person made a mark in the sand for another to find, we have been communicating with a visual language. The earliest forms of visual communication were pictorial drawings of everyday objects such as weapons and animals. As the desire to communicate grew, these pictures were combined to convey thoughts and ideas. With visual language, it became possible to "conquer" time. An individu-

10/11

Since the first person made a mark in the sand for another to find, we have been communicating with a visual language. The earliest forms of visual communication were pictorial drawings of everyday objects such as weapons and animals. As the desire to communicate grew, these pictures were combined to convey thoughts and ideas. With visual language,

10/12

Since the first person made a mark in the sand for another to find, we have been communicating with a visual language. The earliest forms of visual communication were pictorial drawings of everyday objects such as weapons and animals. As the desire to communicate grew, these pictures were combined to convey thoughts and ideas. With visual language,

10/13

Since the first person made a mark in the sand for another to find, we have been communicating with a visual language. The earliest forms of visual communication were pictorial drawings of everyday objects such as weapons and animals. As the desire to communicate grew, these pictures were

12/13

## Baskerville

Since the first person made a mark in the sand for another to find, we have been communicating with a visual language. The earliest forms of visual communication were pictorial drawings of everyday objects such as weapons and animals. As the desire to communicate grew, these pictures were combined to convey thoughts and ideas. With visual language, it became possible to "conquer" time. An individual's mark could be seen and understood after the maker had moved or even died. Civilization developed along with our visual record of the spoken language. So did the importance of the individual.

8/9

Since the first person made a mark in the sand for another to find, we have been communicating with a visual language. The earliest forms of visual communication were pictorial drawings of everyday objects such as weapons and animals. As the desire to communicate grew, these pictures were combined to convey thoughts and ideas. With visual language, it became possible to "conquer" time. An individual's mark could be seen and understood after the maker had moved or even died. Civilization developed along with our visual record of the spoken

8/10

Since the first person made a mark in the sand for another to find, we have been communicating with a visual language. The earliest forms of visual communication were pictorial drawings of everyday objects such as weapons and animals. As the desire to communicate grew, these pictures were combined to convey thoughts and ideas. With visual language, it became possible to "conquer" time. An individual's mark could be seen and understood after the maker had moved or even died. Civili-

8/11

Since the first person made a mark in the sand for another to find, we have been communicating with a visual language. The earliest forms of visual communication were pictorial drawings of everyday objects such as weapons and animals. As the desire to communicate grew, these pictures were combined to convey thoughts and ideas. With visual language, it became possible to "conquer" time. An individual's mark could be seen and understood after the maker had moved or even died.

9/10

Since the first person made a mark in the sand for another to find, we have been communicating with a visual language. The earliest forms of visual communication were pictorial drawings of everyday objects such as weapons and animals. As the desire to communicate grew, these pictures were combined to convey thoughts and ideas. With visual language, it became possible to "conquer" time. An individual's mark could be seen and

9/11

Since the first person made a mark in the sand for another to find, we have been communicating with a visual language. The earliest forms of visual communication were pictorial drawings of everyday objects such as weapons and animals. As the desire to communicate grew, these pictures were combined to convey thoughts and ideas. With visual language, it became possible to

9/12

Since the first person made a mark in the sand for another to find, we have been communicating with a visual language. The earliest forms of visual communication were pictorial drawings of everyday objects such as weapons and animals. As the desire to communicate grew, these pictures were combined to convey thoughts and ideas. With visual language, it became possible to "con-

10/11

Since the first person made a mark in the sand for another to find, we have been communicating with a visual language. The earliest forms of visual communication were pictorial drawings of everyday objects such as weapons and animals. As the desire to communicate grew, these pictures were combined to convey thoughts and ideas.

10/12

Since the first person made a mark in the sand for another to find, we have been communicating with a visual language. The earliest forms of visual communication were pictorial drawings of everyday objects such as weapons and animals. As the desire to communicate grew, these pictures were combined to convey thoughts and ideas.

10/13

Since the first person made a mark in the sand for another to find, we have been communicating with a visual language. The earliest forms of visual communication were pictorial drawings of everyday objects such as weapons and animals. As the desire to communicate grew,

12/13

6-6

93

### Modern

The modern styles evolved from transitional types. They have still greater variation between thicks and thins. Modern typefaces are characterized by thin serifs that join the body with a stiff unbracketed corner. There is strong vertical stress to the letters. The serifs are hairline thin.

Bodoni (Figure 6-7) is the best known of this category. It was created in the late 1700s by Firmin Didot, a Frenchman who also gave Europe a fully developed type measurement system. It is sometimes attributed to Giambattista Bodoni, an Italian typographer.

### Egyptian

The first slab-serif type style was introduced in 1815. The category was dubbed "Egyptian" because Egyptian artifacts and Egyptian travel were in vogue. Napoleon's conquest of Egypt aroused great enthusiasm for that country. During this period type design became less predictable and more eclectic. The characteristics were mixed and recombined, producing many variations. The heavy square serifs in this category often match the strokes in thickness. There is less difference between thicks and thins than in the modern and transitional periods. Clarendon and Century are examples of this group.

The popularity of square slab-serif type decreased greatly in the early twentieth century, but has now revived somewhat. Lubalin Graph (Figure 6-8,), designed in 1974 by Herb Lubalin, Tony Di Spigna, and Joe Sundwall, has the characteristics of Egyptian type styles. Figures 6-9 and 6-10 show text-size Bodoni and Lubalin Graph fonts.

### Sans Serif

In the fifties the available type styles were analyzed and found wanting. Weight changes were not subtle enough, and the various weights and widths in a type family often lacked coherency. This disorder was natural, because they were often designed by different people. A young Swiss type designer named Adrian Frutiger developed a sans serif style called Univers. He created a complete family of types in all possible weights and widths.

Several classic sans serif typefaces were designed at the German Bauhaus (see Chapter 2). Influenced by the Bauhaus, the Swiss firm Haas worked with the German Stempel foundry to produce Helvetica (Figure 6-11, p. 98). It is still considered by many designers to be the perfect type—versatile, legible, and elegant. Figure 6-12 (p. 99) shows text size Helvetica font.

### Miscellaneous Faces

Many type styles do not seem to belong to any category. They are often experimental, ornamental styles of limited application. These eccentric types are almost never suitable for text type, but do sometimes find appropriate usage in display headings (Figure 6-13, p. 100).

It is possible to use specialized, ornate styles in display headlines and not hamper readability too greatly. In large amounts of body copy, however, every subtle variation has a cumulative effect that can seriously hinder readability. A classic, all-purpose type style will remain legible and unobtrusive as body type. Selecting an appropriate, legible text type calls for a sensitive, educated eye. Figures 6-14, 6-15 and 6-16 (pp. 100–102) show a few of the all-purpose styles.

## TYPE FAMILIES

The five categories of type we have discussed are filled with type families, such as Bodoni and Baskerville. Each family

abcdefghijklmnopq
rstuvwxyzABCDEFG
HIJKLMNOPQRST
UVWXYZ$12345678
90(.,"'"''"-;:!)?&

6-7 Bodoni, a modern face. (See p. 96 for Figure 6-9, Bodoni in different point settings.)

abcdeefghijkl
mnopqrstuvwx
yzABCDEFGHI
JKLMNOPQRST
UVWXYZ$123
4567890(.,""-,;!)?&

6-8 Lubalin Graph, an "Egyptian" slab-serif face. (See p. 97 for Figure 6-10, Lubalin Graph in different point settings.)

## Bodoni

Since the first person made a mark in the sand for another to find, we have been communicating with a visual language. The earliest forms of visual communication were pictorial drawings of everyday objects such as weapons and animals. As the desire to communicate grew, these pictures were combined to convey thoughts and ideas. With visual language, it became possible to "conquer" time. An individual's mark could be seen and understood after the maker had moved or even died. Civilization developed along with our visual record of the spoken language. So did the importance of the individual.

8/9

Since the first person made a mark in the sand for another to find, we have been communicating with a visual language. The earliest forms of visual communication were pictorial drawings of everyday objects such as weapons and animals. As the desire to communicate grew, these pictures were combined to convey thoughts and ideas. With visual language, it became possible to "conquer" time. An individual's mark could be seen and understood after the maker had moved or even died. Civilization developed along with our visual record of the spoken language. So did the impor-

8/10

Since the first person made a mark in the sand for another to find, we have been communicating with a visual language. The earliest forms of visual communication were pictorial drawings of everyday objects such as weapons and animals. As the desire to communicate grew, these pictures were combined to convey thoughts and ideas. With visual language, it became possible to "conquer" time. An individual's mark could be seen and understood after the maker had moved or even died. Civilization developed along

8/11

Since the first person made a mark in the sand for another to find, we have been communicating with a visual language. The earliest forms of visual communication were pictorial drawings of everyday objects such as weapons and animals. As the desire to communicate grew, these pictures were combined to convey thoughts and ideas. With visual language, it became possible to "conquer" time. An individual's mark could be seen and understood after the maker had moved or even died. Civilization developed

9/10

Since the first person made a mark in the sand for another to find, we have been communicating with a visual language. The earliest forms of visual communication were pictorial drawings of everyday objects such as weapons and animals. As the desire to communicate grew, these pictures were combined to convey thoughts and ideas. With visual language, it became possible to "conquer" time. An individual's mark could be seen and understood after the

9/11

Since the first person made a mark in the sand for another to find, we have been communicating with a visual language. The earliest forms of visual communication were pictorial drawings of everyday objects such as weapons and animals. As the desire to communicate grew, these pictures were combined to convey thoughts and ideas. With visual language, it became possible to "conquer" time. An

9/12

Since the first person made a mark in the sand for another to find, we have been communicating with a visual language. The earliest forms of visual communication were pictorial drawings of everyday objects such as weapons and animals. As the desire to communicate grew, these pictures were combined to convey thoughts and ideas. With visual language, it became possible to "conquer" time. An individual's

10/11

Since the first person made a mark in the sand for another to find, we have been communicating with a visual language. The earliest forms of visual communication were pictorial drawings of everyday objects such as weapons and animals. As the desire to communicate grew, these pictures were combined to convey thoughts and ideas. With visual language, it

10/12

Since the first person made a mark in the sand for another to find, we have been communicating with a visual language. The earliest forms of visual communication were pictorial drawings of everyday objects such as weapons and animals. As the desire to communicate grew, these pictures were combined to convey thoughts and ideas. With visual language, it

10/13

Since the first person made a mark in the sand for another to find, we have been communicating with a visual language. The earliest forms of visual communication were pictorial drawings of everyday objects such as weapons and animals. As the desire to communicate grew, these pictures were

12/13

## ITC Lubalin Graph Book

Since the first person made a mark in the sand for another to find, we have been communicating with a visual language. The earliest forms of visual communication were pictorial drawings of everyday objects such as weapons and animals. As the desire to communicate grew, these pictures were combined to convey thoughts and ideas. With visual language, it became possible to "conquer" time. An individual's mark could be seen and understood after the maker had moved or even died. Civilization developed along with our visual record of the spoken language. So did the importance of the individual.

8/9

Since the first person made a mark in the sand for another to find, we have been communicating with a visual language. The earliest forms of visual communication were pictorial drawings of everyday objects such as weapons and animals. As the desire to communicate grew, these pictures were combined to convey thoughts and ideas. With visual language, it became possible to "conquer" time. An individual's mark could be seen and understood after the maker had moved or even died. Civilization de-

8/10

Since the first person made a mark in the sand for another to find, we have been communicating with a visual language. The earliest forms of visual communication were pictorial drawings of everyday objects such as weapons and animals. As the desire to communicate grew, these pictures were combined to convey thoughts and ideas. With visual language, it became possible to "conquer" time. An individual's mark could be seen and understood

8/11

Since the first person made a mark in the sand for another to find, we have been communicating with a visual language. The earliest forms of visual communication were pictorial drawings of everyday objects such as weapons and animals. As the desire to communicate grew, these pictures were combined to convey thoughts and ideas. With visual language, it became possible to "conquer" time. An individual's mark could be seen and understood after the

9/10

Since the first person made a mark in the sand for another to find, we have been communicating with a visual language. The earliest forms of visual communication were pictorial drawings of everyday objects such as weapons and animals. As the desire to communicate grew, these pictures were combined to convey thoughts and ideas. With visual language, it became possible to "conquer" time. An individu-

9/11

Since the first person made a mark in the sand for another to find, we have been communicating with a visual language. The earliest forms of visual communication were pictorial drawings of everyday objects such as weapons and animals. As the desire to communicate grew, these pictures were combined to convey thoughts and ideas. With visual language, it became possible to "conquer" time. An individu-

9/12

Since the first person made a mark in the sand for another to find, we have been communicating with a visual language. The earliest forms of visual communication were pictorial drawings of everyday objects such as weapons and animals. As the desire to communicate grew, these pictures were combined to convey

10/11

Since the first person made a mark in the sand for another to find, we have been communicating with a visual language. The earliest forms of visual communication were pictorial drawings of everyday objects such as weapons and animals. As the desire to communicate grew, these pictures were combined to convey

10/12

Since the first person made a mark in the sand for another to find, we have been communicating with a visual language. The earliest forms of visual communication were pictorial drawings of everyday objects such as weapons and animals. As the desire to communicate grew, these pictures were combined to convey

10/13

Since the first person made a mark in the sand for another to find, we have been communicating with a visual language. The earliest forms of visual communication were pictorial drawings of everyday objects such as weapons and animals. As the desire to com-

12/13

6-10

comes in a variety of weights and sizes. A family is all the variations of a particular typeface. Helvetica, for example, now comes in a series of variations described as light condensed, medium condensed, bold condensed, ultra light, ultra light condensed, ultra light italic, light, medium, regular, medium light, bold, bold italic, and bold extended. Figure 6-17 (p. 103) illustrates the Helvetica family.

A specific variation in a specific size is called a font. For example, 18-point Helvetica italic is a font. A great variety of shapes exist in a single font. There are 26 capitals, 26 lowercase letter forms, and assorted numerals and punctuation marks. These various shapes can be successfully combined into a unified design because of the similarities in width, brackets, serifs, and x-height. A well-designed type font is an excellent example of the interplay of repetition and variety that makes for good design (Figure 6-17).

Computerized layout gives the designer the ability to make a wide variety of changes in these carefully designed fonts. Vector programs allow type to be mirrored, scaled with varying horizontal and vertical values, and otherwise manipulated for effect. The pre-computer, hot type technology was based on actual physical pieces of metal shaped into letterforms. These couldn't be stretched or set to overlap unless the sheet was printed twice and the font recast. Now that everything is possible, an enthusiasm for exploration needs to be tempered by respect for the subtle and complex beauty of a font.

## SELECTION

How does the designer select which style of type to use? What factors are involved in designing with text type? Selecting the type for a given layout means making decisions in six interrelated areas: type size, line length, type style, leading, spacing, and format.

Designers now often set their own type as they develop a layout design. But

6-11 Helvetica, a sans serif face. (See p. 99 for Figure 6-12, Helvetica in different point settings.)

## Helvetica

Since the first person made a mark in the sand for another to find, we have been communicating with a visual language. The earliest forms of visual communication were pictorial drawings of everyday objects such as weapons and animals. As the desire to communicate grew, these pictures were combined to convey thoughts and ideas. With visual language, it became possible to "conquer" time. An individual's mark could be seen and understood after the maker had moved or even died. Civilization developed along with our visual record of the spoken language. So did the importance of the individual.

8/9

Since the first person made a mark in the sand for another to find, we have been communicating with a visual language. The earliest forms of visual communication were pictorial drawings of everyday objects such as weapons and animals. As the desire to communicate grew, these pictures were combined to convey thoughts and ideas. With visual language, it became possible to "conquer" time. An individual's mark could be seen and understood after the maker had moved or even died. Civilization developed along with our visual record of the spoken

8/10

Since the first person made a mark in the sand for another to find, we have been communicating with a visual language. The earliest forms of visual communication were pictorial drawings of everyday objects such as weapons and animals. As the desire to communicate grew, these pictures were combined to convey thoughts and ideas. With visual language, it became possible to "conquer" time. An individual's mark could be seen and understood after the maker had moved or even died. Civi-

8/11

Since the first person made a mark in the sand for another to find, we have been communicating with a visual language. The earliest forms of visual communication were pictorial drawings of everyday objects such as weapons and animals. As the desire to communicate grew, these pictures were combined to convey thoughts and ideas. With visual language, it became possible to "conquer" time. An individual's mark could be seen and understood after the maker had moved or even died.

9/10

Since the first person made a mark in the sand for another to find, we have been communicating with a visual language. The earliest forms of visual communication were pictorial drawings of everyday objects such as weapons and animals. As the desire to communicate grew, these pictures were combined to convey thoughts and ideas. With visual language, it became possible to "conquer" time. An individual's mark could be seen and

9/11

Since the first person made a mark in the sand for another to find, we have been communicating with a visual language. The earliest forms of visual communication were pictorial drawings of everyday objects such as weapons and animals. As the desire to communicate grew, these pictures were combined to convey thoughts and ideas. With visual language, it became possible to

9/12

Since the first person made a mark in the sand for another to find, we have been communicating with a visual language. The earliest forms of visual communication were pictorial drawings of everyday objects such as weapons and animals. As the desire to communicate grew, these pictures were combined to convey thoughts and ideas. With visual

10/11

Since the first person made a mark in the sand for another to find, we have been communicating with a visual language. The earliest forms of visual communication were pictorial drawings of everyday objects such as weapons and animals. As the desire to communicate grew, these pictures were combined to convey thoughts and ideas. With visual

10/12

Since the first person made a mark in the sand for another to find, we have been communicating with a visual language. The earliest forms of visual communication were pictorial drawings of everyday objects such as weapons and animals. As the desire to communicate grew, these pictures were combined to convey thoughts and ideas. With visual

10/13

Since the first person made a mark in the sand for another to find, we have been communicating with a visual language. The earliest forms of visual communication were pictorial drawings of everyday objects such as weapons and animals. As the desire to communicate grew, these

12/13

6-12

6-13 *(right)* "Abramesque," an ornate, experimental type style.

6-14 *(below)* Some good type styles for body copy as well as display type. See also Figures 6-15 and 6-16.

| American typewriter light | Benguiat medium cond | Beton light | ITC Bookman light italic |
|---|---|---|---|
| ABCDEFGHIJ KLMNOPQRR STUVWXYZØ abcdeefghijkl mnopqrstuv?! wxyzæceø12 34567890£¢$ | ABCDEFGHIJKL" MNOPQRSTUVW XYZÆŒÇØabcd efghijklmnopqrs tuvwxyzæœeçø1 234567890ß£$¢ ?!&%§()/«‒–‿‿‗‴⁎‥ | ABCDEFGHIJKL MNOPQRSTUV WXYZabcdefghi jklmnopqrstuvwx yz 1234567890 Æ ŒÇØæœeçøß £$ ¢&%?!()«»/⁎;∘⌃‿∼ | ABCDEFGHIJKLMNO PQRSTUVWXYZ AB ABCDEFGHIJK LMNOPQRR STU VVWWXYZÇ Th ÆŒØabcdefghijklm nopqrstuvwxyzefiñç fihKmnopqr tæœ ß1234567890 1234567 890£$¢&%?!$@#![(̃̃̃̃;̃/)] |
| American typewriter med | Benguiat medium cond | Beton bold | Bookman |
| ABCDEFGHIJ! KLMNOPQRŒ STUVWXYZØ ÆÇabcdefghij klmnopqrstu? vwxyzæœeçøß 1234567890£ $¢&%§(«»:;‾⁎/) | ABCDEFGHIJKL MNOPQRSTUV*;: WXYZÆŒÇØab cdefghijklmnop» qrstuvwxyz æœ çø1234567890ß £$¢?!&%§()/«‒–‿⌃ | ABCDEFGHIJK LMNOPQRST() UVWXYZabcd efghijklmnopq, rstuvwxyz1234! 567890ÆŒÇØ? æœeçøß£$¢&%. | AA ABBCDDEF EFGHIIJJKKL LMMNNOPQR PRSTUUVVWX WXYYZÆabcde fghijklmnopqrr stu vwxyyzæœøç1234 567890ÆŒØÇB&! ?@&$(/̃̃;:) |
| American typewriter bold | Benguiat bold cond | Beton extra bold | Bookman italic |
| ABCDEFGHI JKLMNOPQ RSTUVWX? YZ!abcdeefg hijklmnopq rstuvwxyz1 234567890❧⁎ | ABCDEFGHIJKL" MNOPQRSTUVW XYZÆŒÇØabcd efghijklmnopqr stuvwxyzæœeçø⁎ 1234567890 ß£$ ¢?!&%§()/«‒–‿‿;: | ABCDEFGHIJ KLMNOPQR STUVWXYZ? abcdefghijkm lnopqrstuvwx yzæœeçø:1234 567890ÆŒØ! £$¢%&ß(ãñ÷¡) | AAA ABBCCD DEEFFGGHII HJJKKKLLMM MNNNOPQR PRRR SSTTU! UVVVWWXYZa bcdefghhijkklmnn opqrrsStuvwwxyz 1234567890&Th&̈̈ |

6-15

| Caslon antiqua medium | Cheltenham book | Futura light | Futura extra bold |
|---|---|---|---|
| ABCDEFGHI JKLMNOPQ RSTUVWX YZabcdefghijk lmnopqrstuvw xyz123456789 0&ß?!%$£¢(≈≈×+) | ABCDEFGHIJ KLMNOPQRS TUVWXYZ a bcdefghijklmn opqrstuvwxy zæl1234567890 ŒØ&ß$£¢%⌢ | ABCDEFGHIJKL! MNOPQRSTUV WXYZÆŒØ abcdefghijklmno pqrstuvwxyzæ? œçø 12345678 90ß£$¢&%(¦)«»⸴⸲ | ABCDEFGHIJK LMNOPQRST¢ UVWXYZ ÆŒ ÇØabcdefghij! klmnopqrstuv wxyzæœçøßl 234567890£ $&%?(«»⸲.; ⸗⸱*) |
| Caslon italic | Cheltenham book italic | Futura medium | Futura extra bold italic |
| ABCDEFGHI JKLMNOPQR STUVWXYZ Œabcdefghijkln mopqrstuvwxyz 1234567890Æ? &%ß$£¢!0(⁂⁎⁑) | ABCDEFGHIJ KLMNOPQRS TUVWXYŻŒ abcdefghijklm nopqrstuvwxy zæl1234567890 ØÆ&ß$£¢%?! | ABCDEFGHIJK LMNOPQRSTU VWXYZ abcde fghijklmnopqrst uvwxyzø12345 67890ŒÆØ& %ß?!£$(≈ñ:/:«»⸳) | ABCDEFGHIJK LMNOPQRSÆ TUVWXYZŒÇ Øabcdefghijk lmnopqrstuv? wxyzæœçøßl 234567890$ £&%!(«»⸲.; ⸗⸱*) |
| Caslon modern | Cheltenham ultra | Futura demi bold | Futura extra |
| ABCDEFGH IJKLMNOPQ RSTUVWXZ Yabcdefghijkl mnopqrstuvw xyzœæøçl1234 567890ÆŒß &%$£?!0(⁙⁘⁙) | ABCDEFGHI JKLMNOPQ RSTUVWXY Zabcdefghij klmnopqrst uvwxyz1234 567890 ŒØ& | ABCDEFGHIJK LMNOPQRSTU VWXYZabcde fghijklmnopqrs tuvwxyz-1234 567890ŒÆ £ $Ø&%ß?!(«ñ;/) | ABCDEFGHIJK LMNOPQRSTU VWXYZÆŒØÇ abcdefghijkln mopqrstuvwx yzæl12345678 90!?&£$ß(«»⸲) |

whether you set the type yourself or send it our for someone else to prepare, you will need to design and specify the six characteristics mentioned earlier. It is important to develop a fine, critical eye for type quality, watching for problems such as uneven letterspacing and low resolution. Oftentimes the type printed on a desktop laser printer at 300 dpi (dots per inch) is unsuitable for reproduction, especially if the type is reversed and in a small serif font (Figure 6-18).

## SIZE

Text type is any type that is under 14 points in size. A point is a unit of measurement based on the pica. There are 12 points in a pica and approximately 6 picas in an inch, so there are 72 points

6-16

| Goudy old style | Optima | Palatino | Times new roman |
|---|---|---|---|
| ABCDEFGHIJ KLMNOPQRS TUVWXYZa bcdefghijklmn! opqrstuvwxyz1 234567890ÆØ Œ&ß?!$£¢%«»·* | ABCDEFGHIJKL MNOPQRSTU VWXYZabcd! efghijklmnopqr stuvwxyz1234 567890ÆŒÇ? Øæœçøß£$¢; | ABCDEFGHIJK; LMNOPQRST? UVWXYZabcd! efghijklmnopqrs tuvwxyz123456 7890ÆŒØæœo £$¢&%()/·°~·.·~ | ABCDEFGHIJK LMNOPQRSTU VWXYZÆŒÇ? Øabcdefghijklmn opqrstuvwxyzæœ çøß1234567890 £$¢&%!(«‹›»÷.;·/*) |
| Goudy bold | Optima semi bold | Palatino italic | Times bold |
| ABCDEFGHIJ KLMNOPQR! STUVWXYZ abcdefghijklm? nopqrstuvwxy zæø1234567890 ŒÆØ&·$£¢%·· | ABCDEFGHIJ! KLMNOPQR? STUVWXYZa bcdefghijklm nopqrstuvwx yz123456789; 0£$¢&%()/* | ABCDEFGHIJK LMNOPQRST» UVWXYZÆ£ ŒÇØabcdefghijkl- mnopqrstuvwxyzæ œçø1234567890ß;: $¢%&§?!()/«·^~·°· | ABCDEFGHI JKLMNOPQ RSTUVWXY Zabcdefghijkl mnopqrstuvwx yz1234567890 ŒÆ$£&?!%,·»·· |
| Goudy heavyface | Optima black | Palatino black | Times bold italic |
| ABCDEFGHIJK LMNOPQRSTU VWXYZÆŒÇ Ø abcdefghijkl mnopqrstuvw xyzæœçø1234 567890£$¢ß&·% ?!;::()/·*-·····~+«·» | ABCDEFGHIJ* KLMNOPQRS TUVWXYZ ab cdefghijklmno pqrstuvwxyz1 234567890Æ& ŒØæœø£$¢? %!()/;·°^·~·· | ABCDEFGHIJ; KLMNOPQRS TUVWXYZabc defghijklmnop qrstuvwxyz123 4567890ÆŒÇ Øæœçøß$c&/* %?!«»·°·-··~ | ABCDEFGHI JKLMNOPQ RSTUVWXY Zabcdefghijkl mnopqrstuvwx yz1234567890! Œ£$&%?ß(·&·!·) |

Helvetica LIGHT CONDENSED

**Helvetica** MEDIUM CONDENSED

**Helvetica** BOLD CONDENSED

Helvetica ULTRA LIGHT

*Helvetica* ULTRA LIGHT ITALIC

Helvetica LIGHT

**Helvetica** MEDIUM

**Helvetica** REGULAR

*Helvetica* MEDIUM ITALIC

**Helvetica** BOLD

***Helvetica*** BOLD ITALIC

**Helvetica** BOLD EXTENDED

HELVETICA OUTLINE

This is an example of a reversed,
9 point serif font printed on a
300 dpi laser printer

*(left)*
6-17 The Helvetica family.

6-18 *(right)*

6-19 This pica rule gives
measurements in points,
picas, and inches.

in an inch (Figure 6-19). The point sys-
tem of measurement was introduced in
the eighteenth century because the
small sizes of text type called for a mea-
suring system with extremely fine in-
crements.

Type size is measured in points un-
til it reaches about 2″ (5 cm) high. It is
available from 5 points to 72 points on
most typesetting systems and desktop
computer menus, or larger sizes can be
specified (Figure 6-20). When measuring
type size by hand, include the ascender

6-20 Type is measured in
points until it reaches
about 2″ (5 cm) high.

| | | | | | | | | | | | | | |
|---|---|---|---|---|---|---|---|---|---|---|---|---|---|
| 5 | 6 | 8 | 10 | 12 | 14 | 18 | 24 | 30 | 36 | 45 | 54 | 60 | 72 |
| points | points | points | points | points | points | points | points | points | points | points | points | points | points |

and descender in the measurement. The easiest way to measure type without a computer is by comparing it with a type specimen book and matching the size visually.

When choosing a type size, keep the audience in mind. Type that is smaller than 10 points is often difficult for older people to read.

Type size can be difficult to judge on the computer monitor, since the screen image may not be the same size as your final printed page. Also, the vertical, backlit quality of a monitor is a very different medium than the printed page, and we interact with it differently. Students have a tendency to choose sizes that are too large when they first begin designing with type on the computer.

## LINE LENGTH

Line length also is measured by the pica system. It is the length in picas of a line of text type. When laying out a page and marking copy for the typesetter, use pica measurements. The dimensions of the page itself, however, are usually expressed in inches (or centimeters). For example, an 8-point type may be set in a 22-pica line length on an 8½″ × 11″ (22 × 28 cm) page format.

The length of a line is closely related to the size of type. A small point size such as 6 point or 8 point on a line 44 picas long is difficult to read. The type seems to jump around along the midsection of the line, and the eye must search for the beginning of each new line. This trouble is worse when there is insufficient space between lines. Usually you want the reader's eye to move smoothly, never being forced to slow down or lose its place. The standard line length and point size ratio for optimal legibility is a line of 50 to 70 characters long (Figure 6-21). To remember this ratio, keep in mind that line length should be approximately double the point size.

An 8-point type sits well on a 16-pica line. Variations on this theme can be used purposely to slow the reader down.

## STYLE

When you choose text type, legibility is a prime consideration. Although there are many beautiful, elegant, and accessible styles, stay away from styles with an excess of ornamentation when selecting text type.

Next, seek a type that is appropriate to the audience, the publication, and your own sense of aesthetics. Sans serif has a modern feel and is highly legible in the limited amounts of copy used in most annual reports, newsletters, and so on. The serif types are generally more traditional and classical in feeling. They are easier to read in large amounts. Many of the newest styles strive to combine the virtues of serif and sans serif type.

Trends arise in type, just as in music, clothes, and lifestyles. Notice how they change from year to year. Use the ones you consider appropriate and aesthetic.

The printing process can help to determine type selection. Delicate, hairline serifs are not appropriate when a heavy ink coverage is required, because the ink will block up the serifs and result in a blotchy look. Heavily textured paper will also make a delicate serif unadvisable. The texture of the paper will cause the finely inked serifs to break up.

Beginning designers often combine several type styles in a typographical layout. They choose each for its own beauty and interest, but forget the effect of the whole design. Diverse styles usually refuse to combine into an organized whole and have an undisciplined and chaotic look. Many experienced designers prefer to work within one type family, drawing upon its bold, italic, and roman faces (Figure 6-22). They achieve a look of variety without risking going outside one family. This course is certainly the "safest" for a new designer.

The length of a line is an important factor in legibility. If you prefer that no one read the text, choose a small point size on a long line length. 8 point set 30 picas long is nearly impossible to read. As a designer and typographer however, your intent will usually be to insure that the reader's eye moves smoothly, never being forced to slow down or lose its place. The standard line length and point size ratio for optimal legibility is a line 50 to 70 characters long.

8 point GARAMOND

The length of a line is an important factor in legibility. If you prefer that no one read the text, choose a small point size on a long line length. 8 point set 30 picas long is nearly impossible to read. As a designer and typographer however, your intent will usually be to insure that the reader's eye moves smoothly, never being forced to slow down or lose its place. The standard line length and point size ratio for optimal legibility is a line 50 to 70 characters long.

9 point GARAMOND

The length of a line is an important factor in legibility. If you prefer that no one read the text, choose a small point size on a long line length. 8 point set 30 picas long is nearly impossible to read. As a designer and typographer however, your intent will usually be to insure that the reader's eye moves smoothly, never being forced to slow down or lose its place. The standard line length and point size ratio for optimal legibility is a line 50 to 70 characters long.

10 point GARAMOND

The length of a line is an important factor in legibility. If you prefer that no one read the text, choose a small point size on a long line length. 8 point set 30 picas long is nearly impossible to read. As a designer and typographer however, your intent will usually be to insure that the reader's eye moves smoothly, never being forced to slow down or lose its place. The standard line length and point size ratio for optimal legibility is a line 50 to 70 characters long.

11 point GARAMOND

The length of a line is an important factor in legibility. If you prefer that no one read the text, choose a small point size on a long line length. 8 point set 30 picas long is nearly impossible to read. As a designer and typographer however, your intent will usually be to insure that the reader's eye moves smoothly, never being forced to slow down or lose its place. The standard line length and point size ratio for optimal legibility is a line 50 to 70 characters long.

12 point GARAMOND

6-21 Line length should be proportional to point size.

| Helvetica ultra light | Helvetica medium | Helvetica bold | Helvetica medium outline |
|---|---|---|---|
| ABCDEFGHIJ KLMNOPQRS TUVWXYZØa bcdefghijklmno pqrstuvwxyzæ 1234567890&! ?$£%ßŒÆ | ABCDEFGHI JKLMNOPQ RSTUVWXY Zabcdefghijk lmnopqrstuv wxyz123456 7890ß&?!( | ABCDEFGHIJ KLMNOPQRS TUVWXYZab cdefghijklmn opqrstuvwxy zæœøç12345 67890ÆŒØ? !£$¢%ß&( | ABCDEFGH IJKLMNOP QRSTUVW XYZ123456 7890ÆŒ&! %?£$¢Ø( |
| Helvetica ultra light italic | Helvetica bold italic | Helvetica light | Helvetica light cond |
| ABCDEFGHIJ KLMNOPQRS TUVWXYZabc defghijklmnopq rstuvwxyzæœ 1234567890$ £&%?!ßÆŒØ | ABCDEFGHIJ KLMNOPQRS TUVWXYZab cdefghijklmn opqrstuvwxy zæœç:12345 67890ÆŒØ! ?&%£$¢ß( | ABCDEFGHIJ KLMNOPQRS TUVWXYZab cdefghijklmno pqrstuvwxyz1 234567890?! %$£&ßØ( | ABCDEFGHIJKL MNOPQRSTUVW XYZÆŒØabcde fghijklmnopqrstu vwxyzæœç1234 567890ŒÇØÆ¢ £$ß%?!&/( |
| Helvetica medium italic | Helvetica bold extended | Helvetica regular | Helvetica medium cond |
| ABCDEFGHIJ KLMNOPQRS TUVWXYZØa bcdefghijklmn opqrstuvwxyz 1234567890?! ß&£$%Œ( | ABCDEFGH IJKLMNOP QRSTUVXY WZÆŒÇØ abcdefghik jlmnopqrst uvwxyzç12 34567890 ß$£&?!%( | ABCDEFGHI* JKLMNOPQ? RSTUVWXY- ZÆØabcdef! ghijklmnopqr stuvwxyzæø 1234567890 £$&%(«»:;/) | ABCDEFGHIJKL MNOPQRSTUVW XYZabcdefghijkl mnopqrstuvwxy zæ1234567890! ?&%£$ßÆŒ( |

6-22 One type family can offer a great deal of variety.

The most exciting layouts, however, often do mix distinctively different type-faces. Mixing takes sensitivity to how the styles affect one another and contribute to the whole. A good rule of thumb when mixing type families is to make certain they are very different. The composition will work if there is either deliberate similarity or definite variety. It can confuse and displease the eye if the distinctions are muddy. Figures 6-23 and 6-24 are two successful designs that combine type styles. The MacPros layout uses typography to achieve an overlapping visual texture. Contemporary designers have many more choices of typefaces and design effects.

## LEADING

Leading (pronounced like the metal lead) describes the vertical spacing between lines of type. The historical origin of the term goes back to hot-metal type-

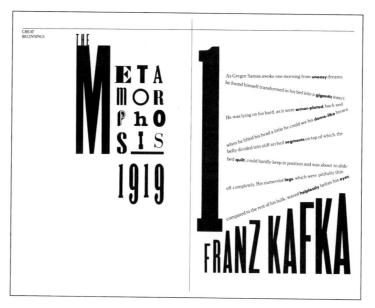

**6-23 Paula Scher.**
Layout design for *The Metamorphosis* in "Great Beginnings" brochure.

setting, when a thin strip of lead was inserted as a spacer between lines of metal type. This type and leading were locked together into a galley, inked, and printed. Leading strongly affects the look and readability of the layout. Type is considered to be set "solid" when there is no space inserted between the descender of the top line and the ascender of the bottom line. A 10-point type set on a 10-point leading is an example of solid leading. Sample leadings are shown in

Figures 6-5, 6-6, 6-9, and 6-10. How much leading you use is important. Several factors affect that decision. Among those factors are type size, line length, and type style.

### Type Size

Leading must be proportionate to the size of the type. Although there is no standard, correct leading for any certain type size, one often finds 10-point type set on 12-point leading. An extra 2 points

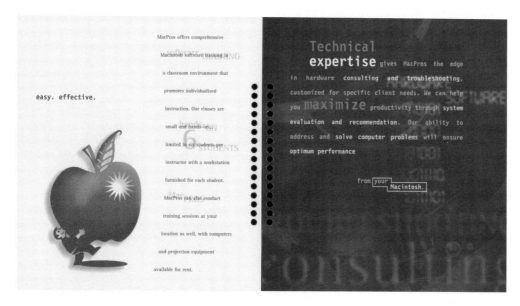

**6-24** This brochure for MacPros plays with overlapping typography, as well as changes in size and style in order to get a point across. It takes full advantage of the flexibility possible when designing with computerized typography.

of space have been inserted between the lines of type. A larger or smaller type size will require less extra leading. A 14-point type might need only 14- or 15-point leading, for instance. It is rare to find minus leading, or a 10-point type set on a 9-point leading. Current typesetting technology makes it possible to set one line of type on top of another and to weave entire paragraphs over each other for visual texture. The important criteria is always "is it appropriate" and "is it good design"? Does form follow function? Figures 6-23 and 6-24 show a rich visual texture created with typography.

### Line Length

Line length is an important factor in determining leading. The longer the line, the more leading is appropriate. With longer line lengths, the eye has a tendency to wander. If there is insufficient space between lines, you will find yourself reading the line above or beneath and having difficulty finding the beginning of each line.

### Type Style

Three aspects of the type style also affect leading: x-height, vertical stress, and serif versus sans serif. The x-height, as you know, refers to the size of the body of the letter, without its ascender and descender. The x-height of Helvetica is much greater than the x-height of an older type such as Garamond. Consequently the Helvetica would probably require more leading. It does not have lots of extra white space packed around its body, so the lines of type appear closer together.

The vertical stress of a type style affects leading because the stronger the vertical emphasis, the more the eye is drawn up and down instead of along the line of type. Hence, the greater the vertical stress, the more leading required. A type style such as Baskerville has a strong vertical stress and requires more leading than Garamond.

A serif helps to draw the eye along in a horizontal direction, so serif type is generally considered to be easier to read than sans serif type. Sans serif type usually requires more leading than the serif style to keep the eye moving smoothly along.

## SPACING

Letterspacing is the amount of space between letters of a word (Figure 6-25). A good figure/ground relationship between letterforms is as important with text type as with display type. If the letters are spaced too far apart, the eye must "jump" between letters, and reading becomes strained.

Whether designing with text type or display type, keep an eye out for the creation of equal volumes of white space between individual letterforms "Kerning" is a term that describes the specific adjustment of space between individual letterforms. An "IH," for example, will require a different spacing than an "MN" (Figure 6-26).

The amount of space between words is called word spacing. If it is too great, it is difficult for the eye to move quickly along the line of type. There is a tendency to pause between individual words. The reader should be unaware of the space between words, and aware instead of their content.

Word spacing usually is not a problem with text type, unless the type is being set in a justified format (flush left and flush right edges). To make the lines come out even, the computer will insert extra space between words. If the line length is long, with many words, this addition is not noticeable. However, if the line length is short, great white holes seem to appear in the copy (Figure 6-27). Look at your local newspaper, and squint. Often rivers of white will appear in the columns of text type as a result of poor word spacing.

**Typography**
TOUCHING

**Typography**
VERY TIGHT

**Typography**
TIGHT

**Typography**
NORMAL

**Typography**
TV SPACING

6-25 There is a great deal of difference between tight and loose letterspacing.

# FORMAT

Format design refers to the arrangement of lines of type on the page (Figure 6-28). There are two basic categories: justified and unjustified. In justified type the lines are all the same length, so that the left and right edges of the column of type are straight. This format is commonly used in newspaper layout and text and trade books. It is appropriate when speed and ease of reading are the primary considerations. Justified copy is considered slightly easier to read than unjustified copy. The straight, squared-off columns of type give an orderly, classical feeling to the page.

Unjustified copy can be arranged in a variety of ways: flush left, flush right, centered, and asymmetrical.

6-26 Spacing between letterforms must vary to please the eye.

The head of the nation's military, Gen. Fidel Ramos, warned Thursday of a possible plot by disaffected officers. His office said he had "warned any military adventurers against embarking on such a rash course of action because it could be bloody and destabilizing."

**6-27** *(right)* Justifying copy in a short line length will cause white holes to appear.

**6-28** *(far right)* Variations in format.

### Flush Left

The flush left format calls for a straight left edge and a ragged right edge. Typewritten copy is usually flush left. This format is commonly used in annual reports, brochures, identification lines under photographs, and any time when a slightly more informal look is desired than can be achieved with justified type. One of the benefits of this format is that it is possible to avoid hyphenated words. Page layout software programs will usually allow the user to set parameters for hyphenation. A designer can specify how many can happen in succession and just how ragged the right or left edge can become.

### Flush Right

The flush right format is unusual and consequently difficult to read. It has a ragged left edge and is used for design effect in special situations. It is difficult for the eye to search out the beginning of each new line without a common starting point.

### Centered

Centered copy is often found in headlines or invitations, but rarely in standard copy. It is a slow-reading, classical format that encourages the reader to pause after each line. It is important to make logical breaks at the end of each line. This format has a pronounced irregular shape and packs a lot of space around itself. The white space and irregular outline can draw the eye strongly. Consider the content of your material, how rapidly it should be read, and the overall look of the page before deciding on a centered format.

### Asymmetrical

Asymmetrically arranged type can put across the point of a poem or an important statement. Asymmetry is also used in display type to achieve better balance

among letterforms. Contour type is a form of asymmetry that fits the shape of an illustration, following its contour. Type that is set around the squared edge of a photo is called a runaround. Occasionally type will be set in the shape of a contour itself.

The ancient Egyptians and Greeks originally experimented with this format. It was used early this century by the poet Apollinaire and more recently yet by contemporary designers.

## STYLE AND CONTENT

Typography sets a visual tone depending on the variables we have just examined. The style, the leading, and the format all contribute to a nonverbal communication that has a great deal to say. This visual communication, or visual language, affects the image of the client. It is a function of the choices the designer has made partly as a personal preference, partly in response to the client's needs, and partly in response to contemporary design trends.

Specific type styles are associated with historical periods. Type styles can be susceptible to fashion trends; thus, it is possible to evoke the mood of an era just through careful type selection. The twentieth century in the United States has seen several styles come into vogue and then fade out.

Wood display type was widely used in the 1800s. By the latter part of the century, these wooden type styles became elaborate, beautifully decorative designs. Type styles and trends continued to change, reflecting the sensibilities and technology of the time. Broadway type style was popular in the 1930s, while the sans serif styles of Helvetica and Univers were widely used in the 1950s and 1960s. Today's styles show a return to the serif and an eclectic willingness to experiment with unusual

graphic effects, as digital typesetting encourages stylistic innovation.

With the advent of digital typography, special effects with type and layout design are easier to achieve than ever before. Experimentation is good, especially when tempered by a firm knowledge of traditional typographic design principles.

## SOME PROBLEMS

Once the format for the layout is selected and the type is set, some awkward accidents may occur. If you are aware of these problems, you can avoid them.

Widows and orphans are romantic names designating isolated line endings and dangling words. A widow is a short line that ends a paragraph and appears at the top or bottom of a printed column. An orphan is a single word that also appears in the isolated position and is most distressing when it appears at the top of a new page.

Hyphenation can also become a problem, especially if the line length is short and the format is justified. Too many hyphenated words will interfere with legibility. Hyphens should always fall at syllables, and they should not chop the word into unrecognizable segments.

## A DESIGN SUMMARY

Good design is a delicate thing. It relies upon so many interrelated variables that it cannot be reduced to a simple formula. Here, however, are a few summary comments.

When choosing type styles, remember that it's easier to either mix very different fonts or to stay within the same type family. For example, two different serif fonts will be more difficult to use together than a serif and a sans serif.

A combination of two (or more!) fonts with strong personalities and highly distinctive styles are difficult to use together because they both call for attention.

The design principles of proximity, similarity grouping, and focal point are all important considerations in layout design. Variations in point size and font style function like a code to guide a reader. The headings and subheadings in this text, for example, are carefully chosen to visually group information topics and to separate out new topics. These headings should be physically grouped in closer proximity to the information they introduce than to the unrelated paragraph above.

Decide what kind of speed you want from your reader. A justified format is the quickest read, while ragged right takes a little more intimate involvement on the part of the reader. A centered format is a very slow read, presenting itself line by line rather than as a grouped paragraph. Mixing these formats can be done to visually clue the reader about the content. The running text in a chapter may be justified, for example, while the photo captions are all ragged right.

Every element that goes onto a page is important. Every element contributes to the whole. Take nothing for granted.

**6-29** Indicating type with chisel-point pencil or marker.

# EXECUTION

## COMPING TYPE

In order to visualize a layout before the final typesetting, the designer may make an actual size rough. The headlines are indicated letter by letter, while the text type is often suggested by a procedure called "comping" (see Figure 6-29). The width of each line should match the x-height of the proposed type. Type can be indicated by using a chisel-point pencil or gray marker or by drawing two lines that indicate the top and bottom of each line of type. Figure 6-30 shows comped type on an ad layout. A more polished form of comping calls for "greeking," available in sheets of transfer type. Greeking has actual letterforms, but not recognizable words (see Figure 6-31). Many designers simply set the copy on a computer, since format and style changes can be easily made. The danger with immediately turning to typeset copy is that it can look finished before enough thought has been given to design. Use the computer to generate a rich range of possible solutions.

## SPECIFYING COPY

If the designer is not doing the typesetting, but is sending the copy to someone else, the next step is to "spec" the copy. When you "spec" copy, you provide all the information necessary to set the type from the typewritten copy: type style, size, leading, format, line length, sometimes letterspacing, and special instructions.

The copy should be double-spaced, typed on one side only, with a wide margin on all sides for instructions. Always keep a duplicate for the files. The deadline for delivery must be established as well as the cost of the original typesetting and corrections. Most design firms, advertising agencies, and art departments have their own procedures.

6-30 **J.P. Sartori.** (UW–Whitewater design collection). Ad layouts using comped text and "greeking" to indicate typography.

After the copy has been typed, draw a horizontal line to and above the first line of the copy. Above this line write all the information about the type style, such as size, family name, family structure, and caps or caps and lowercase. Below the line indicate the information about the format of the copy, such as column width, centered, justified, ragged right, and letterspacing. The copy will probably have several changes in this information. Each change is indicated by hooking another line above the copy with the new information (Figure 6-32).

6-31 (see 6-30)

```
                    42 pt. BASKERVILLE BOLD C, LC
SPECIFYING COPY
              10/12 BASKERVILLE MED.
              X21 JUSTIFIED
       After the copy has been typed, draw a horizontal line

       to and above the first line of your copy.  Above this line

       place all the information about the type style, such as

       size, family name, family structure, caps or caps and

       lowercase.  Below the line indicate the information

       about the format of the copy, such as column width,

       centered, justified, ragged right, and letter

       spacing.      + 6 pts

10/12        The copy will probably have several changes in this
X18
RAGGED       information.  Each change is indicated by hooking
RIGHT
             another line above the copy with the new information.
```

**6-32** An example of "speccing" type.

Extra space may be inserted between areas of copy, with the symbol (#), which means an extra line space of the current leading. More subtle spacing changes are indicated with "+6 pts," or "+3 pts," and so on. The depth of the copy should correspond to the depth of the area allowed on the layout. If it does not, adjustments must be made to the type size, the leading, or on rare occasion, the typeface.

Often certain words or phases must be set in a special typeface within a type family. This fact is indicated by underscoring the word and abbreviating the special face in the margin (Figure 6-33).

# MAKING CORRECTIONS

Almost always some corrections are needed in typeset copy, due to last-minute revisions or errors. Proofreading is an easier job now, with the spell check available on layout programs. Use it always, realizing that the computer can spell but it can't read. If this last sentence said, ". . . but it can't red," the spell check on your computer wouldn't object.

You will need to know proofreader's marks to make corrections from a design point of view, such as damaged copy, poor breaks in words, or incorrect font. The standard proofreader's marks are shown in Figure 6-34. It is a good idea to use one color for corrections. The color that you choose will come to be a

**6-33** Marking for special typefaces.

| | |
|---|---|
| Delete ℓ⁄ | Close up ⌒ |
| Insert here ∧ | Elevate a word ⌐⌐ |
| Move to left [ | Move to right ⌐ |
| Lower a letter ⌐⌐ | Insert an Em space □ |
| Insert 2 Em spaces ⬚⬚ | Broken type, please reset ✗ |
| New paragraph ¶ | No new paragraph ₙₒ ¶ |
| Open up a space # | Close up a space |
| Restore to original *stet* | Wrong font *wf* |
| Transpose ∩ | Set in caps and lower case |
| Set in all caps | Set in small caps |
| Set in **boldface** | Set in ⟨roman⟩ *rom* |
| Set in *italics* | Change to lower case *lc* |
| Insert period ⊙ | |

6-34 Proofreader's marks.

visual symbol signaling your corrections (Figure 6-35).

matches the value of the actual typeset copy. How can it be improved? Are the x-height and leading accurate?

# EXERCISES

1. Study various magazines, newspapers, and other publications for samples of the different formats. Which are successful, and which are flawed?
2. Choose two of your less effective samples for analysis. Determine their line length, leading, point size, and type style. Recommend specific changes.
3. Practice comping a page of type from this book. Then stand back, squint, and ask yourself if your comping

# PROJECTS

### *Typographical Illustration of a Poem*

Select a poem or an interesting and emotive piece of prose that is no longer than 20 lines. Set it twice, using the typesetting equipment available to you. The first time, follow the standard guides for type design to enhance legibility and pay close attention to leading, line length, spacing, and format. Select one type

---

**CORRECTED PROOF**

This paragraph is marked for correction using the proofreader's marks shown above. if you are in doubt about which mark to use, write the instructions in the margin, or cross out the line and write in a new one.

¶ Paragraph indentations are not always necessary, but it is important to the keep layout consistent. Exercises

6-35 Corrected proof.

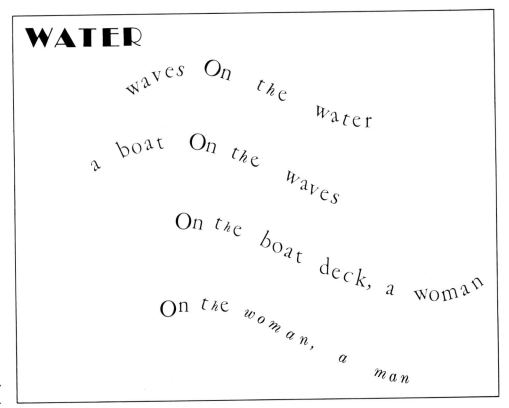

**6-36 Ann Ladich.**
Poem illustration.

**6-37 Roberta Fiskum.**

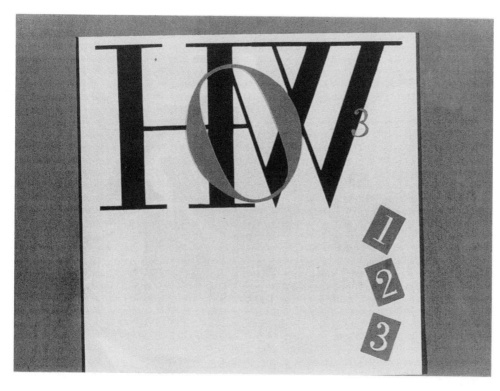

6-38  **Roberta Fiskum.**

family, limit the fonts, and restrict the point size variation.

Set it again, breaking as many rules as you wish, while creating an effect appropriate to the piece and your feelings about it. Experiment with complexity and diversity. Freehand, Illustrator, Quark, or Pagemaker are good programs for these projects (Figure 6-36).

### Layouts Using Text Type

Create four separate layout designs on 8″ × 8″ (20 × 20 cm) format. Arrange the elements so that you are using similarity, eye direction, figure/ground shaping, and continuation. Choose a single topic or theme to unite this assignment, and feel free to experiment with color. If your output is on a laser printer, try the many colored and textured laser papers available. Figures 6-37 and 6-38 are based on this assignment.

1. Combine one large letterform, one paragraph of type, and one bar into a design (Figure 6-37).

2. Combine one large word (paying attention to letterspacing), a comped version of your paragraph from part A, and one bar (Figure 6-38).
3. Combine one word, one paragraph of type, one photograph, and one bar. The type style and format must illustrate the mood or tone of the photograph.
4. Throw out the rules and do an interpretative piece related to your theme. Feel free to incorporate ambiguity or to experiment with incorporating seemingly disparate elements.

### Objectives

Learn to apply gestalt unit-forming principles to layout design.

Learn to integrate text and display type, while carefully orchestrating eye direction.

Learn to integrate typography and image to express a mood.

SEVEN LAYOUT

# THE BALANCING ACT

Layout is a balancing act in two senses. First, it relates the diverse elements on a printed page in a way that communicates and has aesthetic appeal. Ideally, the form enhances the communication (Figure 7-1).

Second, as in all design, every element on the page affects how the other elements are perceived. Layout is not simply the addition of photographs, text type, display type, or artwork. It is a careful balancing of elements.

The layout artist must select from the vast array of available typefaces one that is appropriate. The format, size, and value contrast of the typographical elements must be closely related to accompanying photographs and illustrations. Layout may be the most difficult balancing act a designer is ever called upon to perform.

Everything you have studied so far about creating a balanced visual gestalt holds true for layout design. A good relationship between figure and ground is essential. The careful shaping of the white ground of the page gives cohesion and unity to the figures or elements placed upon it. There should be no "left-over" space that is unshaped, undesigned. Open white space functions as an active, participating part of the whole design. Page design can be symmetrically or asymmetrically balanced. In either case, careful figure/ground grouping will enhance the readability of the page.

A careful balancing of contrast can give the page dynamic, unpredictable energy that will draw the reader's eye. Chapter 4 discussed contrasts in size, shape, value, and texture. A combination of similarity and contrast creates a balanced and successful layout.

# SIZE AND PROPORTION

This difficult balancing act calls for sensitivity to proportion—the organization of several things into a relationship of

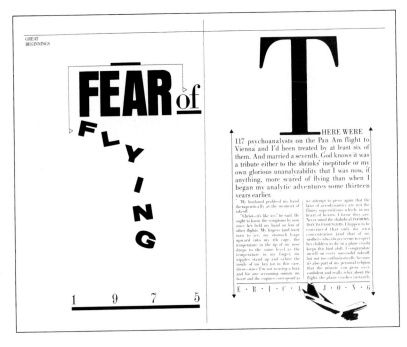

**7-1** **Terry Koppel.** (Koppel & Scher, New York.) Layout for *Fear of Flying* in "Great Beginnings" brochure. Courtesy of the designer.

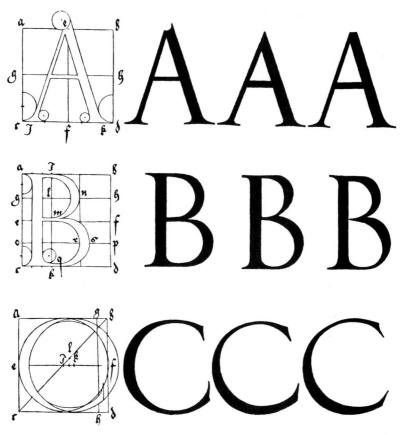

7-2 Alphabet by **Albrecht Dürer**. Fifteenth-century type design based on the "golden section."

size, quantity, or degree. Artists have understood the importance of size relationships for centuries. The Parthenon expressed the Greeks' sense of proportion. It was based on a mathematical principle that came to be known as the "golden section." Albrecht Dürer used the golden section in the fifteenth century to analyze and construct his alphabet (Figure 7-2). Ultimately, however, no mathematical system can take the place of an intuitive feeling for proportion or a sense of tension and energy in contrast. When the contrast between elements is too great, however, harmony and balance are lost.

*The division of a page into areas in harmony with one another is at the heart of all layout design* (Figure 7-3). The relationships between type sizes,

between printed and unprinted areas, and between various values of gray must all be proportionate.

When we refer to size, we usually use words like "big" or "small." These terms are meaningless, however, unless we have two objects to compare. A 36-point word in a page with a lot of text type will be large. On a spread with a 72-point headline, it will be relatively small. An element large or bold in proportion to other elements on the page makes an obvious visual impact and a potentially strong focal point (Figure 7-4). Do not be afraid to use an element really LARGE, as in Figure 7-1, where the letter *T* makes a bold graphic statement. Several magazines use a larger format than is standard. This is another example of size contrast. Next to other magazines on

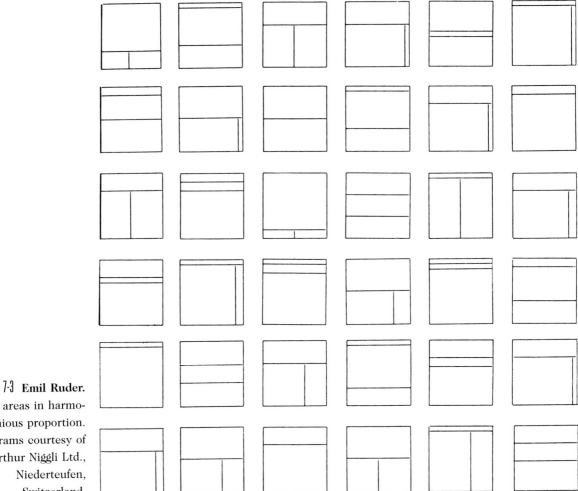

**7-3 Emil Ruder.**
Page areas in harmonious proportion.
Diagrams courtesy of
Arthur Niggli Ltd.,
Niederteufen,
Switzerland.

the newsracks, they have the impact of a comparatively large and impressive display.

Another way of determining size is to have a standard expected size in mind. If we refer to a large household cat, "large" means over 12 inches (30 cm) high. If we refer to a large horse, we have a different size in mind. Deliberately violating this expectation can create a dynamic, unusual effect. Mixing up standard relative sizes creates strong tension and compelling interest.

Another approach to confusing our sense of size and scale is by showing objects larger than life. On the printed page, viewers have come to expect things

to be shown smaller than they really are. We have no problem accepting a photograph in which the Empire State Building appears 3″ (8 cm) high; but magnify a tiny object, and we get a visual jolt that makes us pay attention. Imagine the photograph of a common housefly 20 times actual size. Figure 7-5 is a wonderful play on size by freelance designer Karen Roehr.

## VISUAL RHYTHM

Another important consideration in layout design is visual rhythm. Life itself is based upon rhythm. There is a rhythm to the passing days and seasons. The

7-4 Ad layout courtesy of Apple Computer. **Gavin Milner,** art director; **Harold Einstein,** writer; **Edward Adler,** producer; stock photography; prepared by BBDO, Los Angeles, CA.

"tempo" of our days may be fast or slow. The growth and gradual decline of all natural life forms has a rhythm. Cities have particular pulsing rhythms. Different periods in our history have seemed to move to various beats. Our current age has an eclectic/quickened tempo compared with 100 years ago.

Visual rhythm is based upon repetition of shapes, values, colors, and textures. Recurrences of shapes and the spacing between them set up a pattern or rhythm. It can be quick and lively, with small closely placed shapes, or solemn and dignified, with large solo shapes. Rhythm is crucial in the work of many visual artists.

7-5 **Karen Roehr.** "Good Things Come in Small Packages" direct mail self-promotional design. The accompanying note suggests the recipient call to see the "bigger book."

There are many ways to use rhythm in typography. Within a single word, a rhythmic pattern of ascenders and descenders and curves and lines is created. The rhythm might be symmetrical

**tempo o tempo**

**_t e m p o_**

**7-6** Letterspacing affects tempo.

or asymmetrical in character. Letter and word spacing can set up a typographical movement of varying tempos, as can changes in value and size (Figure 7-6).

The total layout of the page is another opportunity to form a rhythmic pattern. The lines of type can form a rhythm of silent pauses and rests, of leaps, of slow ascents and descents. Endless rhythms can be created this way (Figure 7-7).

The spacing and size of photographs can intermingle with typography. An alternating visual rhythm may reserve every left-hand page for a full-page pho-

tograph, while the right-hand page is textured with smaller units of text and other elements.

Another form of rhythm is progressive rhythm. The repeated element changes in a regular fashion. Text type might be used in changing values from regular to bold to extra bold and back again. A photograph might be repeated, each time with more of the image displayed. This rhythmic movement can take place on one page or on successive pages. Change in regular manner is at the heart of a progressive rhythm.

## GRID LAYOUT

A sense of pacing and rhythm can be set up throughout an entire publication with

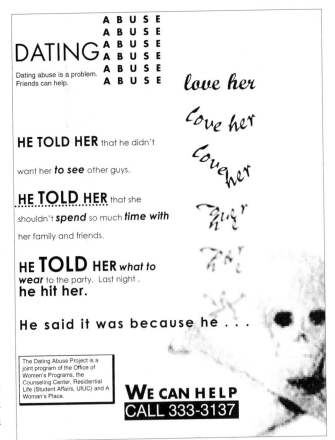

**7-7 Erik Peterson.** This layout uses visual rhythm to deal with a difficult topic.

7-8

## KEEPING THE BEAT

A musical composition has a timing or beat that pulses beneath all the long and short notes. In a visual composition, this beat is often kept by a grid. Just as a four-beats-to-the-measure musical score would not be cut off at 3.5 beats, a grid layout that has four sections across will not end at 3.5. Whether the fourth unit is filled with an element or left as a white ground, it gets its full count and full visual weight. Within these four musical counts might be a mixture of quarter notes, half notes, or whole notes. The four-unit grid might hold one large four-unit element, two half-unit elements, or four quarter-unit elements. The beauty in any composition, whether visual or auditory, comes once the structure is set up, and the variations in pacing, timing, and emphasis begin.

## PLAYING THE THEME

An underlying musical theme, like the one in Beethoven's *Sixth Symphony* (the "Pastoral"), will appear over and over in different guises, tying the symphony together into a whole. An underlying visual theme will accomplish the same for a visual composition. A layout for a publication unfolds through time, just as a musical concert does. Each page must be turned before the next is revealed. It cannot be seen and grasped at one viewing like a painting, an advertisement, or a poster. Unifying it requires a theme. Often this theme will include both a purely visual *design* theme and an editorial *content* theme (Figures 7-9 and 7-10).

The editorial theme could be the repetition of quotations on a particular topic. It could be a contrast of "then and now," a set of interviews—anything that seems to tell an interesting story related to a common topic. Advertising campaigns are usually based upon an

7-8 Design Studio 45, a student design agency at UW–Whitewater, created this series of publications promoting an upcoming theatre season. A grid layout integrates the various pieces.

the aid of a grid. A grid is an invisible structure underlying the page that is used as a guide for the placement of layout elements.

When and why is it appropriate to use a grid? Large publications usually require one to keep order. Grids are sometimes used in single-page designs such as advertisements and posters. They are also used to bring continuity to the separate pieces of a design series (Figure 7-8). A grid is most useful when it brings an organized unity not only to a single page, but also to facing pages, an entire publication, or a series of publications.

Layout design that utilizes a grid is as flexible and creative as its designer. The grid has been accused of bringing a boring conformity to page design. Grids, however, can help generate distinctive, dynamic images. They allow for experimentation with all the forms of contrast. A grid functions like a musical instrument. A piano, for instance, has a limited number of keys of fixed tone and position. It is possible, however, to play many different musical compositions through placement, rhythm, repetition, and emphasis.

**7-9, 7-10** Layouts for self-promotional brochure by 12Twelve Design, a division of Terry Printing. **Mary Hakala,** art director; **Dennis Dooley,** photographer.

editorial theme. Specialty publications such as annual reports, which revolve around one company, may also use an editorial approach.

A visual theme almost always accompanies the editorial theme. It might be the repeated use of a single thematic photograph on several pages throughout the publication. It could be a particular repeated arrangement of typography—or the grid itself. Many people consider the most creative activity of the layout artist is in the highly conceptual activity of establishing a visual and sometimes an intellectual theme (Figures 7-11 and 7-12).

## GRIDS IN HISTORY

The grid is by no means a new invention. It has been used for centuries by various cultures to design ornamental screens and textiles (Figure 7-13). It has been the basis for quilt design, architecture, and navigation. It has been used by Pakistanis, Native Americans, isolated African tribes, contemporary designers, and a host of others. The squared grid, in which each of the four sides of the unit is equal to the others, is the simplest variation; but it is capable of yielding sophisticated results (Figure 7-14).

Renaissance artists developed a method of examining a subject through a grid network of strings and drawing onto a paper similarly divided into sections. In the twentieth century, the grid became of interest to artists as a shape in itself. Frequently drawings, illustrations, and paintings allow the grid structure to show through, just as Bauhaus architects insisted that the structure of their buildings show through.

**7-11, 7-12 Erik Peterson.** These comprehensives are printed on a dye sublimation printer and are part of a series of 12 calendar pages promoting Raleigh bikes. They make use of a similarity in layout to unite the various images.

7-13 An ornamental grid design.

Many layouts today that have a strong grid structure trace their origins to the de Stijl movement. Van Doesburg and Mondrian were both using dark lines to divide their canvases into asymmetrical patterns by 1918 (Figure 4-2).

A more recent figure associated with the grid layout is Swiss designer J. Müller-Brockmann. He had tremendous influence on the structure and definition of graphic design. "The tauter the composition of elements in the space available, the more effectively can the thematic idea be formulated," he stated. Copy, photographs, drawings, trade names are all subservient to the underlying grid structure in what is called "Swiss design" (Figure 4-3).

Grid design is incorporated into our current technology. Page layout programs on your computer do an excellent job of accommodating a grid-based layout. QuarkXpress and Pagemaker both allow the designer to construct an individually designed grid and specify type to fill the columns.

## CHOOSING A GRID

Grids are as different as the minds that create them. They vary from the familiar three-column format, to a Swiss grid based on overlapping squares, to an original creation.

The first consideration when choosing a grid is the elements it will contain. Consider the copy. How long is it; how long are the individual segments; how many inserts and subheads? If the copy is composed of many independent paragraphs, the underlying grid should break the page area up into small units. On the other hand, if the copy is a textbook of long unbroken chapters with few visuals, a complex grid is wasted; most of its divisions will be seldom used.

Now consider the art. A publication that uses many photographs will call for a different grid than one that is copy-heavy. Whenever many elements need to be incorporated into a layout, a more complex grid, broken down into many small units, is the most useful. It will give more possibilities for placing and sizing photographs.

You can create your own grid that corresponds to the number of elements and size of your page. The tinier the grid units, the more choices will need to be made about placement. The more placement options there are, the greater the chance that the underlying unity will be lost. In other words, sometimes a simple grid is the best choice.

Both the vertical and the horizontal divisions in a grid are important. The vertical dividers determine the line length of the copy. Both the vertical and

horizontal lines determine the size of photographs or artwork. Remember from Chapter 6 to relate line length and type size to make it easy for the eye to read and keep its place. Forcing large type into small grid units makes for slow, difficult reading.

## CONSTRUCTING THE GRID

The vertical divisions of the grid are usually expressed in picas or in inches, as is the line length of copy measured for typesetting. The horizontal divisions are most frequently measured in points, as is leading. A 10-point type, for example, with 2 points of leading between lines would be set on 12-point leading. This type could be specified at a 21-pica line length or 3.5-inch line length. The column width would correspond. The structure is usually sounder if the elements themselves align with the grid edges and merely suggest the presence of the grid. With precise alignment, our eyes

will draw an invisible line of "continuation" between elements that is a much stronger bond than the physical, inked line.

Grid structure gives results similar to another approach, the "path" layout. Both depend on the eye and mind detecting such unit-forming factors as repetition and continuation, tempered with a deliberate contrast or variation for effect.

## PATH LAYOUT

The path layout assumes no underlying, unifying structure. Rather, the designer begins with a blank white sheet of paper and attempts to visualize the elements on it in various arrangements. This complex approach can yield tremendously varied results. The underlying unity comes from a direct reliance on unit-forming factors. This reliance is sometimes unconscious, but beginning

7-14 **Julius Friedman/ Walter McCord,** designers; **Craig Guyon,** photographer. Quilts: Handmade Color.

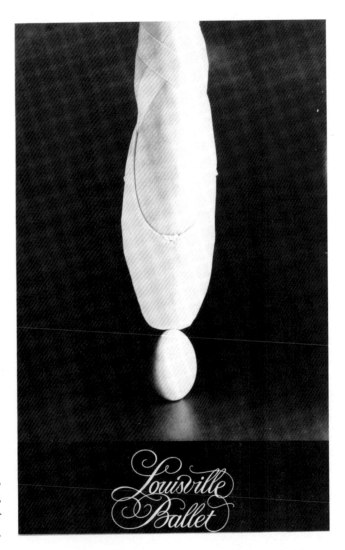

**7-15** **Julius Friedman,** designer; **John Lair,** photographer. Poster for the Louisville Ballet.

designers should learn it on a conscious level. It will lead to excellent results.

The word "path" describes this less structured, more spontaneous approach because the designer is attempting to set up a path for the eye. The goal is to guide the eye skillfully through the various elements. In order to do so, there usually is a clear entry point or "focal point" and a clear "path" to the next element and the next.

## FOCAL POINT

The focal point, or the point of entry into a design, is the first area that attracts attention and encourages the viewer to look further. If at first glance, our eye is drawn equally to several different areas, visual chaos results and interest is lost. A focal point can be set up in many different ways, but they all have to do with creating difference or variety. Whatever

disrupts an overall visual field will draw the eye. These differences could affect the focal point:

A heavy black value set down in a field of gray and white.

A small isolated element in a design with several larger elements in close proximity to one another.

An irregular, organically shaped element set next to geometric ones.

A textured element set next to solid areas. Text type can often function in this manner.

A pictorial image or word that is emotionally loaded.

The focal point should not be so overwhelming that the eye misses the rest of the composition.

## PATH

The eye is guided from element to element through eye direction, continuation, the echoing or repetition of a shape, angle, or color, as well as through the carefully balanced contrast of size and value. A simple path layout is used effectively in Figure 7-15, a poster design for the Louisville Ballet by designer Julius Friedman.

## PHOTOGRAPHY IN A LAYOUT

An important element in layout design is the photograph. Learn what makes a good photograph and how to use it to best advantage. (Chapter 8 will help you do so.) Copywriters, photographers, and designers depend on one another's skills. Poor page design can make a beautiful photograph lose all its impact and appeal. Sometimes, also, a poor photograph may be strengthened by a good design.

Dynamic photos strong in design and human interest can look lifeless with certain design mistakes. One is the paper. If it is too absorbent, it will ink poorly, so the value contrast in the reproduced photos will be muddy. Another common mistake is with size contrast. Photos of similar sizes compete for attention; the eye will be drawn to none. Other elements on the page may also point away or detract.

Figure 7-16 shows some different ways of placing a photograph on a grid layout. Practice some variations yourself, attempting to establish a visual pacing.

## CROPPING

Many photographs can be improved by careful cropping. Cropping is eliminating part of the vertical or horizontal dimension of a photograph to focus attention on the remaining portion. Cropping is also used to fit a photograph into an available space by altering its proportions. When cropping to fit a space, use discretion.

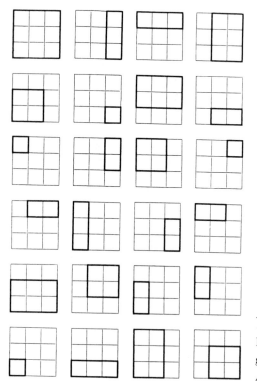

**7-16 Emil Ruder.** Photo placements on a grid. Design courtesy Arthur Niggli Ltd.

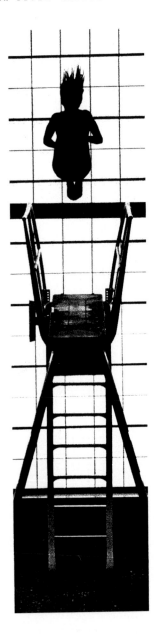

**7-17 Gordon Baer** (Louisville, KY). Pepsi-Cola Diving Competition.

Cropping too tightly will destroy the mood of the image.

Sometimes a photograph, like an overwritten paragraph, can be improved by deleting excess information. The format is fixed in a camera, but the action that is being photographed might be taking place within a compact square area or a long thin vertical. Trimming away the meaningless part of the image on the sides will improve the impact (Figure 7-

17). It can also enhance a feeling of motion, as shown in this same photograph.

Sometimes cropping a photograph makes it dramatic. If you wish to emphasize the height of a tall building, for example, cropping in on the sides to make a long, thin rectangle will increase the sense of height. Cropping the top and bottom of a long horizontal shot will increase the sense of an endless horizon.

Cropping causes us to focus on the dramatic part of the image in Figure 7-18, a poster for the Cincinnati Ballet Company. The feet present a theme on repetition and variation.

## RESIZING

There are three ways to figure out the new proportions of a photo to be resized—a simple algebraic equation, a proportion wheel, or a visual aid. A metric ruler has an advantage since the units are smaller. This is also true of the point/pica measurement system since there is no need to convert fractions of an inch to decimals for resizing calculations.

The algebraic formula is

$$\frac{\text{original height}}{\text{original width}} = \frac{\text{new height}}{\text{new width}}$$

or

$$\frac{x}{y} = \frac{x^{\text{new}}}{y^{\text{new}}}$$

One new dimension is unknown. Cross-multiply and divide to find it. Dividing the new width or height by the old one will give the percentage of enlargement or reduction.

A proportion wheel is shown in Figure 7-19. Following the directions printed on the wheel will give you the same information without any mathematical computations on your part.

Layout artists sometimes leave the percentage calculations to the printer and instead only figure visually whether the proportions of a resized photo will fit

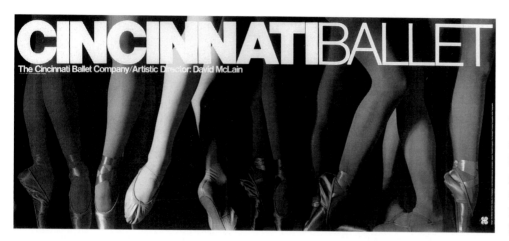

7-18 **Dan Bittman,** designer; **Corson Hirschfeld,** photographer; and the Hennegan Company, lithography. Poster for the Cincinnati Ballet Company.

the layout. Simply draw a diagonal from a lower corner to an upper corner of the cropped photograph. Then select either the vertical or horizontal dimension as the given new measurement. Draw a line from that edge to the diagonal. Then draw a line at right angles to the intersection. The resulting rectangle has the proportions of a correctly resized photo.

Occasionally the designer is called upon to resize a group of images, often portraits, that all need to be reproduced at the same size. In this case, remember to crop and rescale so that the heads, not simply the picture, end up with the same measurements. Remember those medieval paintings where the most important person is the largest?

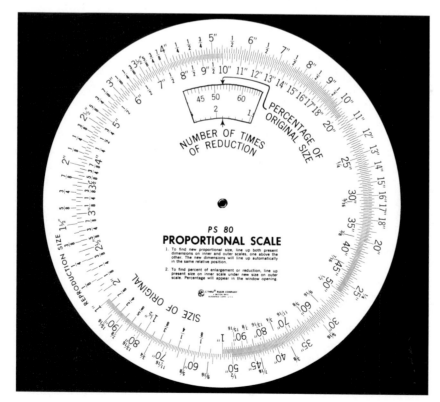

7-19

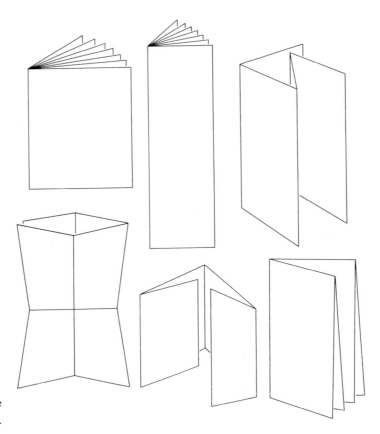

**7-20** Brochure construction.

All of these resizing methods are becoming less important, as designers are increasingly resizing, cropping, and experimenting with results on the computer. The important thing to understand is the concept of ratio. The designer must maintain the integrity of the original photograph, without expanding or distorting images to fit a space. Always maintain the original height-to-width ratio when rescaling a photograph.

## SELECTING

A designer may be given the photographs to work with or have the opportunity to order specific photos shot. You might also elect to shoot them personally. It is a wise idea for anyone considering a career in graphic design to take a course in photography.

Choose photographs for your layout on three grounds: *the quality of the print, the merit of the design, and the strength of the communication.*

Photo retouching programs make it easier to correct problems with print quality. It is helpful to understand what are good reproduction qualities in a photograph, in order to recognize and/or achieve them. Some of these qualities are dependent upon the form of output (see the sections in Chapters 8 and 10 on digital photography). Generally, however, watch for good contrast between darks and lights, a full tonal range, sharp focus (where appropriate), and lack of scratches, dust spots, and other imperfections.

## MULTI-PANEL DESIGN

Folders and brochures present a slightly different layout problem than magazines or books. A brochure is actually more a

three-dimensional construction than a two-dimensional layout. Nevertheless, a grid may be used. Contrast of size and visual rhythm remain important.

The additional element of the fold complicates matters. Brochures may fold and unfold into unusual shapes (Figure 7-20). They may unfold several times, and at each successive unfolding present a new facet of the design. Use this opportunity to tell a story. Each panel can give additional information, with the front panel acting as a "teaser." Never give your punch line on the front panel. Lead up to it. A successful front panel will lure the reader inside. The next panel will build interest and develop a theme, while the inside spread will hold the bulk of the information (Figure 7-21). If the brochure is a self-mailer, address and stamp are placed directly on the back.

Other special decisions go into a multipanel design: the size of the piece, the number of folds and their direction, and the flexibility of the paper. Usually when preparing a comprehensive, the

7-21 **Erica Green.**
Brochure for the YMCA of Milwaukee.

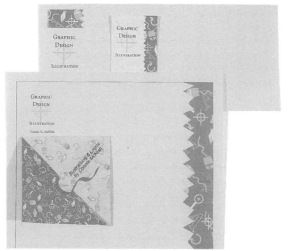

b

**7-22a, b, c  Connie McNish.**
This unified series includes a letterhead, envelope, business card, and a promotional brochure with an unusual and creative fold.

a                                                    c

designer will try to execute it on the same paper it will be printed on. Then the client can hold and unfold the design.

The brochure or flyer will often be part of a unified publication series. Then you must sustain the visual and intellectual theme of the series (Figures 7-22a, 7-22b, and 7-22c).

## LAYOUT STYLES

During the discussion of design history presented in Chapter 2, you learned that the European-influenced modern style was imported to the United States during the 1940s. Characterized by sans serif typography and the belief in a universally shared aesthetic, the modern style saw order as the spirit of a modern, rational, technological civilization. The development of the grid system seen in the work of Swiss designer Joseph Müller-Brockmann, Emil Ruder, and others fit into this perception of design as a wedding of science and aesthetics in a rational world.

Design in the 1960s became more eclectic and inclusive. The 1970s saw a questioning of the rational "Swiss design" approach that led to the development of "New Wave" or "postmodern" graphic design. April Greiman's work shows the exuberance of this inclusive, eclectic style that celebrates complexity and diversity (Figure 2-31). History is a great visual resource for appropriation where all styles are potentially meaningful. Art nouveau, art deco, pop art, Swiss modernism, and personal intuition may all be combined to generate the postmodern design.

Technology contributes greatly to the changing face of design. The widespread use of computers in design during the 1980s was dominated by the IBM PC and Apple Macintosh. The computer brought a great deal of flexibility and made easy shifts of type size, shape, and style accessible to designers. Graphics are now generated and prepared for pre-press with software programs that encourage complexity and reflect our society's complex mix of information. Electronic mail, facsimile transmissions, and low-volume desktop publishing decentralize information processing. Typesetting, design, and production are much more flexible and accessible to the designer today (Figure 7-23).

**7-23** Ad layout courtesy of Apple Computer. **Dennis Lim,** art director; **Grey Ketchum/John Dullaghan,** writers; **Karen Zimmerman,** producer; **G. Gorman/ G. McGuire,** photographers; prepared by BBDO, Los Angeles, CA.

## CONCLUSION

Layout is a balancing act that creates unity among the diverse elements on a page. An underlying grid can unite the many pages of a large publication. When combining copy, illustration, and photography, unity can also be established by finding similar shapes, angles, values, and type styles. Like a musical composition, a layout needs pacing, rhythm, and theme. This problem-solving approach stems from an understanding of visual language developed by 20th-century modernism.

Variety or contrast is important, too. Many kinds of contrast—visual texture, value, shape, type style, and size—can create a focal point or visual path in a layout. A combination of contrasting historical styles is currently used to provide a rich, visually complex design. Multiple layers of communication created with this approach are a feature of postmodern style.

Whatever the style, your layout should do justice to the intentions of the copywriter, photographer, illustrator, client, and yourself.

## EXERCISES

1. Use the sample grids in Figures 7-24, 7-25, and 7-26 (pp. 138–140) to do several rhythmic layouts. If you choose to use old magazines, cut out photographs, cropping where necessary and adding comped type. If you use a computer, try using Quark or Pagemaker to establish grids and rectangles to insert typography and to indicate photographs.
2. Select several magazines or annual reports and figure out their grid structure. Can you find one with an interesting complexity and nuance? Look for stylistic influences.
3. Save samples of brochure designs that appeal to you and study them for future inspiration. Look for interesting multipanel folders that unfold the message in sequential steps.

## PROJECT

### A *Two-Page Layout*

Redesign into a two-page spread one of the unsuccessful layouts you found while doing the exercises. You need not include everything from the original. Each

page of your redesign should be 8½″ × 11″ (20 × 28 cm). It should include a headline, three to five photographs and/or illustrations, and a minimum of 4″ (10 cm) of body copy. All elements must be resized and cropped, as necessary. Establish a grid that suits your copy. Establish another grid and do a complete layout using each grid structure. Figure out the percentage of enlargement or reduction of your photos. After doing several roughs, choose the most successful. Prepare a "comprehensive" using any method you prefer.

### A Small Book

In consultation with your instructor, choose a short story, myth, or fable. Select a visual and conceptual theme appropriate to your story. Incorporate original imagery (Figures 7-27, 7-28).

Create a multi-page book, which can be bound in a variety of methods.

### Objectives

Learn to chose an appropriate grid and fit layout elements to it.

Practice resizing photographs and typography.

Use all the information studied so far on balance, rhythm, unity, and contrast to create a dynamic and compelling layout.

7-24, 7-25, 7-26  Sample grids.

7-26

7-27 Natalie Krug. "Heart" is a path layout integrated with a water-color illustration that addresses the multiple meanings of the word heart.

7-28 Ming Ya Su. "Nymph" is a beautifully integrated grid layout with an air brush illustration. It makes a strong use of figure/ground relationships.

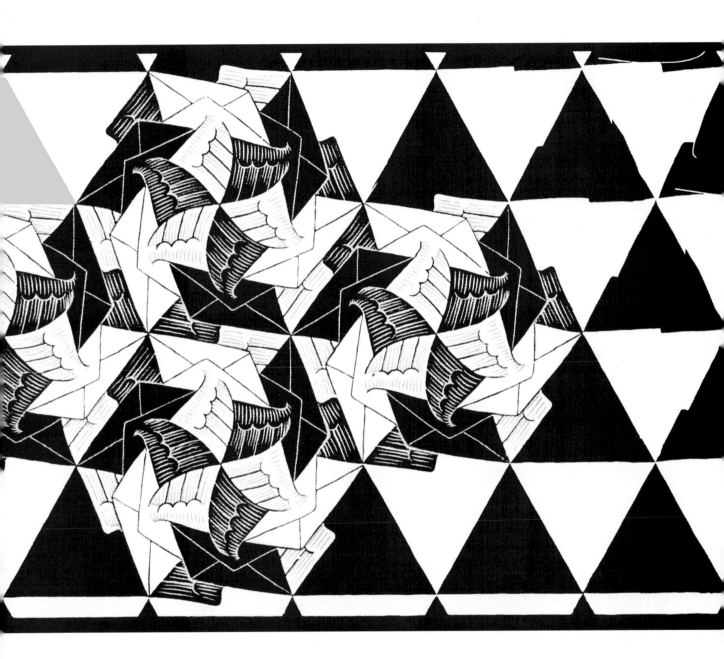

# ILLUSTRATION AND
# PHOTOGRAPHY IN DESIGN

Oftentimes the graphic designer is called upon to create or to acquire illustration and photography. The boundaries between these three disciplines are less rigid than in the past, especially as electronic media make photographic manipulation, drawing tools, and typography available to a broad range of professionals. It is advisable for every graphic designer to be familiar with the basics of image generation and utilization.

# THE DESIGNER/ILLUSTRATOR

Illustration is a specialized area of art that generally uses nonphotographic images, usually representational or expressionist, to make a visual statement. Illustration is created for commercial reproduction. Otherwise, many drawings and paintings done as illustrations look and function as fine art and are exhibited and collected as such. Many painters have worked as illustrators at some point in their careers. Edward Hopper earned his living as an illustrator for the first half of his career. Pablo Picasso and William Blake illustrated books.

Some designers never actually do an illustration themselves; instead, they purchase freelance illustrations. Many illustrators are freelance artists who maintain their own studios and work for a variety of clients (Figure 8-1). Some studios have illustrators who do nothing but illustration, working with other designers who are in charge of typography, photography, layout, and art direction. But often the field has a need for illustrators who design and designers who illustrate.

Some people feel that editorial illustration is the highest and most artistic form of design. Nevertheless, however much an illustration may resemble a painting, the restrictions an illustrator

8-1 **Dugald Stermer,** illustrator/designer.

*(left)*
**8-2  Linda Godfrey.** "Fish Out of Water." An illustration created with collage, using photographic textures and strong design elements.

*(right)*
**8-3  Robb Mommaerts.** An illustration based on an early painting by John Singleton Copley. Created with Illustrator software.

works under are similar to those in other areas of graphic design. The illustrator works with the guidance of an art director, must be concerned about how the work will be reproduced, has to meet a deadline, and is responsible for satisfying a client and a defined purpose. There are several beautiful illustrations in this chapter that meet these standards.

## WHY ILLUSTRATION?

Illustration may be chosen instead of photography for several reasons. It can show something about the subject that cannot be photographed, such as detailed information about how photosynthesis works. Also, by enhancing details, illustration can demonstrate certain particulars more clearly than a photograph can. For example, it can enlarge tiny engine parts that are difficult to see or photograph and label them. Illustration can also eliminate misleading and unnecessary details that confuse an image, thereby forcing the eye to focus on im-

portant characteristics. Finally, it is a most effective way to present highly emotional material.

Although photography is capable of creating surreal and strongly emotive images, illustration is still more flexible. It is capable of turning out images of pure fantasy (Figure 8-2). The hand-generated quality of illustration is considered by many to have a warmer, more personal quality than that of a photograph. Finally, sometimes an illustrator is allowed where a photographer and camera may be prohibited, as in some courtrooms.

## TYPES OF ILLUSTRATION

Throughout this book you will see many examples of illustration. It has a variety of looks, depending on the medium, the style of the illustrator, and the purpose of the illustration. The artwork can be drawn, painted, or assembled with a mixed-media collage, as in Figure 8-2. It may also be computer-generated, as in Figure 8-3. It can be three dimensional,

*(left)*
**8·4 David McLimons.** "Helping Children Learn," an illustration for *The Progressive* magazine.

*(right)*
**8·5 Margo Chase.** Logo/Icon for hair care products signifies modern beauty. This is a three-color design using muted tones of green, blue, and gold.

as in Plate 10. The illustrator may use a revived art deco style, a New Wave or postmodern look, a personalized style, or a highly informational, descriptive rendering technique. In recent years, illustrators have become freer to experiment with various personal directions. Some have become identified with an emotive style much like the painting movement called neoexpressionism. It is important for an illustrator to develop a distinctive, personal style.

If the field of illustration is varied in medium and style, it also is varied in intent. The purpose for an illustration may be to present a product, tell a story, or demonstrate a service. The following section lists these varied purposes. For detailed information about contracts, trade practices, and pricing, consult the Graphic Artists Guild *Handbook on Pricing and Ethical Guidelines.* This book is a valuable reference that is updated yearly.

# ADVERTISING AND EDITORIAL ILLUSTRATION

Advertising illustration is intended to sell a product or a service—almost anything that can be offered to a consumer.

Commonplace objects must be shown with style and often enhanced with dramatic highlights and textures. In the field of advertising illustration, illustrators work with art directors, account executives, and copywriters. Their work may need to please many people of varying opinions. The best prices for illustration are paid in the advertising field.

In editorial illustration, the artist may concentrate on the communication of emotion through an expressive treatment of line, shape, and placement. Editorial illustration often offers the freedom to experiment with media and to obscure details in favor of mood (Figure 8-4). Some of the varied uses for both advertising and editorial illustration follow.

## FASHION ILLUSTRATION

This is a specialized area of advertising. A strictly literal drawing will lack the appeal of a drawing that presents the garment in a romantic, stylized manner. As a result, fashion illustration does not always simply convey information about the garment. If often attempts to persuade the viewer with the mood of the illustration. An important and interesting drape or texture of the garment or accessory, as well as the model's height, pose, and curves, are often emphasized for effect. Fashion photography shows a

similar concern. A fashion illustrator draws from either a live model or a photograph of a model wearing clothes furnished by the client. The growth in the beauty and cosmetic areas, including related package illustration, has kept this field alive (Figure 8-5).

# RECORDING COVERS AND BOOK ILLUSTRATION

Creative packaging for recordings is an area that made extensive use of illustrators. Many album covers have become collector's items, and several books have been published on this area. CD covers will undoubtedly fare as well. Payment varies widely, depending on the recording company, the recording artist, the complexity of the job, and the renown of the illustrator.

The book-jacket illustration is a vital part of the promotion and sale of a book. Publishing is a growing field, with an increasing number of titles published in recent years. The prices for this form

of illustration have risen accordingly. Some publishers give very specific instructions with detailed notes from the art director. The illustrator may be asked to read a lengthy manuscript. Pricing varies depending on these considerations, as well as whether the work is done for a trade book or textbook, in paperback or hardcover. Figure 8-6 is a cover by the well-known illustrator Dugald Stermer, who incorporates hand-drawn and airbrushed letterforms. When the illustrator also does the headline and type treatment, it is often well integrated with the artwork.

Artists who work on interior illustration add an important ingredient to the value of the book. A children's book often requires illustration throughout. The fee for illustration will vary between a flat fee for books in which the illustrator's contribution is less than the author's, to a royalty contract when the illustrator is responsible for a major part of the book's impact and content. Children's book illustration is a rich field because such books are illustrated throughout, unlike most adult novels. Artwork for young children must tell much of the story, with little reliance on the text. It is responsible for generating excitement and advancing the plot

(left)
8-6 **Dugald Stermer,** illustrator/designer.

(right)
8-7 **Genevieve Meek.** Unpublished drawing to a children's Halloween story by Joy Hart titled "Halloween Haunts." The drawing's title is "Halloween Bear." Pen and ink medium.

**8-8  Arthur Rackham.**
A children's book illustration from the turn of the century called "The Golden Age of Illustration."

(Figure 8-7). One of the many excellent children's book illustrators from the turn of the century is Arthur Rackham (Figure 8-8).

## MAGAZINES AND NEWSPAPERS

Magazines depend on illustration to set a tone and pique a reader's interest (Figure 8-9). A single full-page image will often be expected to carry all the visual information for the accompanying story. It is important that the designer responsible for layout integrate the illustration into the overall layout. Treatment of the headline and text should reinforce the art through repeated shapes, angles, and careful placement.

**8-9  Kunio Hagio.**
Magazine illustration. Reproduced by special permission of *Playboy* magazine. Copyright © 1976 by Playboy.

**8-10** **David McLimons.** Line art illustration for the March 1991 issue of *The Progressive* magazine, accompanying an article on American political policy during the war in the Persian Gulf.

Sometimes small spot illustrations are dropped into a page of text to enliven the visual presence. They are often black and white and are executed in pen and ink.

Newspapers also use a great deal of black-and-white art in editorial sections. Many different kinds of illustration can be found as you search through the sections of a newspaper. Fashion, sports, editorial, product, and technical illustration of charts and graphs are all there. The newspaper will often use color only on the front pages of each section or for special feature articles. Newsprint does not reproduce details and nuances in tonal quality well, and the newspaper industry does not pay as well as some other fields of illustration.

Often payment is not the driving reason people become artists and illustrators. This illustration by artist David McLimans accompanies an article in *Progressive* magazine. Writers, artists, and the art director for this publication are primarily concerned with political activism (Figure 8-10).

## ILLUSTRATION FOR IN-HOUSE

Educational institutions, governmental agencies, corporations and businesses, and not-for-profit entities hire illustrators to generate material targeted at internal audiences. The assignment often calls for editorial illustration, that is, the communication of a concept. Annual reports, corporate calendars, brochures, posters, and an array of materials are produced to communicate the nature of the institution to its employees and constituents. Fees for illustration are relative to the size of the institution and the complexity of the job. Often, in-house staff designers are asked to provide these illustrations as a part of their regular job.

Greeting cards, fashion illustration, as well as medical and technical illustration are other markets where there is a call for illustration. The *Artist's & Graphic Designer's Market,* published by F&W Publications, is a book that lists over 2,500 companies looking for design and illustration.

## GREETING CARDS AND RETAIL GOODS

Artwork in this category includes retail products, such as apparel, toys, greeting cards, calendars, and posters. The major greeting card companies publish cards created by staff artists, but do commission some outside work as well. Seasonal cards and everyday cards are the two categories. The new direction for growth is expected to be cards targeted at specific "lifestyle" audiences, such as working women and seniors. Illustration for cards and retail goods may be paid on the basis of flat fees or royalties.

## MEDICAL AND TECHNICAL ILLUSTRATION

Medical illustrators are specially trained artists who often have a master's degree in the field, with a combined pre-med and art undergraduate degree. The accuracy of information as well as the clarity and effectiveness of presentation are vital in this field. The artist must be better than a camera in his or her ability to simplify, clarify, and select only what must be shown for complete communication. Illustrators should have a knowledge of the human body and a background and interest in science and medicine.

Technical illustrators create highly accurate renderings of scientific subjects, such as geological formations and chemical reactions, as well as machinery and instruments. They often work

**8-11** **Dugald Stermer,** illustrator/designer. *Vanishing Creatures.*

closely with scientists or technicians in the field, and they produce art for a wide variety of publications, advertisements, and audiovisuals.

## STYLE AND MEDIUM

Illustrators use a wide variety of techniques, such as mixed media collage, cut paper, pen and ink, gouache or other painting mediums, sculptural constructions, and computer-generated work. On the computer level, Illustrator and Freehand programs on the Macintosh get a lot of usage while professional computer systems dedicated to illustration come with their own specialized software programs. Computer-generated and photographic work are not replacing hand-created illustration, however, because many people feel that hand-created illustrations are appropriate when a warmer, more human image is desired.

Many illustrators specialize in one particular style or subject matter for

which they have become known (Figure 8-11). Others deliberately offer versatility. Some combine an unusual variety of materials to generate their particular "look." Illustrators must be aware of all of the technical information concerning color separations and printing methods. Oftentimes the illustrator provides the separations as a part of a two- or three-color job. Die cuts, embossing techniques, and specialty inks may all be a part of the final product.

## GETTING IDEAS

The illustrator goes through the same planning and visualizing procedures that are described in Chapter 1. The first step is getting to know the assignment. This research might call for reading a manu-script or understanding how a product functions.

Next comes the idea stage. It's a good idea to look at illustrations by other artists. Many annuals and periodicals show the most current illustrations. *Step by Step Graphics* and *How* present both illustrational ideas and techniques. The *CA Illustration Annual* and the *Graphic Artists Guild Directory of Illustration* are good sources.

Classics from the history of illustration can also provide food for visual thought. Great artists from Dürer to Goya to Magritte have provided inspiration for illustrators. Look through books of photography, both "fine art" and simple descriptive photography, for subjects related to your project. Figures 8-12 and 8-13 show this process in reverse. Artist Roy Lichtenstein used art by D.C. Comics illustrators Tony Abruzzo and Bernard Sachs as material for his painting.

*(lower left)*
8-12 Panel from "Run for Love," in *Secret Hearts*, 83 (November 1962). **Tony Abruzzo,** artist; **Ira Schnapp,** lettering. ©1962 D.C. Comics. Renewed 1983. Used with permission. All rights reserved.

*(lower right)*
8-13 **Roy Lichtenstein.** *Drowning Girl,* 1963. Oil and synthetic polymer paint on canvas, 67⅝″ × 66¾″. Collection, The Museum of Modern Art, New York. Phillip Johnson Fund and gift of Mr. and Mrs. Bagley Wright.

**8-14** Copyright-free clip art is available from a variety of sources for reference and reproduction.

Thumbnail sketches should explore the subject from every angle, high and low, as well as tightly cropped and at a distance. Imagine different kinds of spatial treatment from a Western perspective to isometric to surrealistic. Sketch these ideas, trying them in different media. Exploration is especially valuable to student illustrators who have not yet developed a particular style. As you progress from sketches to roughs, additional reference materials may be needed.

## REFERENCE MATERIALS

Drawing from life means using an actual object, landscape, or human model. Drawing from life is most practical when using a still-life setup or a landscape. Models can get tired, and they can also get expensive. However, there is an immediacy and vitality to life models that may give illustrations a different quality than can be achieved from working with photographs.

Drawing from a photograph is convenient for many reasons. The camera has already converted the subject into a two-dimensional language. Cropping is easily visualized by dropping a few pieces of paper around the photo edges. The subject never gets tired.

Reference materials can add authenticity to your work. An excellent source of photographs is the public library. Most major libraries keep picture collections. Once the source photo(s) is (are) obtained, it is important to adapt it to the particular situation. It is a good idea for all designers and illustrators to begin a clip file of their own with images of many different subjects. Old magazines are a great source. You may be able to organize magazines by categories instead of cutting out the photographs. *Life, People,* and *Newsweek* magazines would fit into a "people" category, whereas the *Smithsonian, National Geographic,* and *Audubon* would fit into a "nature" category.

When working with photographs, respect the photographer as an artist. Do not duplicate a photograph exactly unless it has been shot specifically for you or by you. Copyright infringement laws for the use of photographs has gotten increasingly tight in recent years. The source photograph must be substantially altered before it will be legal to reproduce it as your own artwork. "Clip art" denotes copyright-free images that can be used as is or altered to suit your needs. Books of electronic and traditional clip art are available from many publishing sources (Figure 8-14). Dover is the best.

There can be disadvantages to working with clip art or relying too closely on photos. The pre-existing image makes many decisions about composition, lighting, and size. The photograph can also provide only one kind of spatial representation. These limitations can be overcome by remembering to use the clip art or photo as a source, not as an answer.

Remember that reference sources need not be taken literally but interpreted creatively. Find an interpretation that suits your personality and the job.

# CONTEMPORARY VISION

The invention of offset lithography brought an explosion of illustration in the late 1800s. Coming into the twentieth century as a vital force, and aided by new advances in printing technology, illustration retained its ability to draw inspiration from the fine arts. Painters in the early twentieth century followed an investigation begun by Cezanne, and their art reflected the relativity of space, time, point of view, and emotional coloring. Discoveries in science, psychology, and technology supported their depiction of reality as changeable. It could shift, alter, and be processed in the human brain in a variety of ways. The artist could interact and help to shape it.

Much of the art of the twentieth century deals with picture plane space—the construction of a flat pattern on the flat surface of the paper or canvas. There is less illusion to this work; it does not attempt to deny the flat surface it exists upon. Constructivism and the de Stijl movement worked with picture plane space. Cubism presented reality from multiple points of view. An object might be portrayed simultaneously from the top, the front, and the sides. There is a similarity here to Egyptian art, but a different purpose. This picture plane space is a strong influence in contemporary illustration. Designers and illustrators have always been aware of the flat surface because they have also worked with typography, which encourages flat patterning. The representation of space is a varying cultural convention that contemporary illustrators draw upon (Figures 8-15*a,* 8-15*b,* 8-15*c*).

**8-15a, b, c  Michael Vanderbyl.**
Three self-promotional posters in conjunction with the publication of *Seven Graphic Designers* by Takenobu Igarashi. Printed in Japan by Mitsumura Printing Company.

a

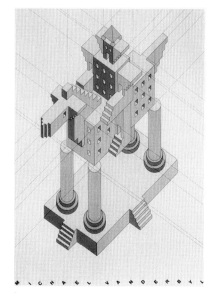

b

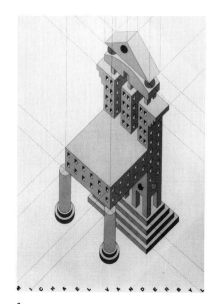

c

The fauves and the German expressionists in the early twentieth century also emphasized the flat patterning of the surface with bright, flat colors and with images that were personal and highly emotional. This expressive quality appears currently in editorial illustration in various forms. The emotionally charged image in Figure 8-16 matches the topic of violence with a violent treatment of line and surface. It becomes what it represents. This union is what illustration is about.

An interest in other forms of spatial representation began to appear in the mid-twentieth century. Trompe l'oeil artists revived an interest in life-size images inside a space that looks only inches deep. A French term meaning "fool the eye," trompe l'oeil works extremely well as an illusion of spatial reality. Our culture will probably never lose its admiration for this sort of "reality." Mainstream illustration has always been pictorial in nature.

There are more artists, designers, and illustrators than ever before in history. We have the benefit of a mass communications network to keep us informed on what is happening now in art. We have a documented history of previous art and design movements, and our influences are more numerous than ever. Designers and illustrators are combining

8-16 **Alan E. Cober.** Illustration for the *Dallas Times Herald.* Courtesy the artist.

many materials and styles to produce a rich variety of images and techniques today.

## DIGITAL ILLUSTRATION

The computer has an important impact in the field of illustration, especially for the designer/illustrator. Programs like Freehand and Illustrator are vector graphics (object oriented) programs that allow the creation of clean, precise, editable images. Painter is a bitmapped program that gives a more intuitive feeling to the process of creating an image. Whatever program you choose to use, computer graphics allow an ease of editing that cannot be ignored. When the client says, "I want more color," or "Can you make this change?" the answer is "yes" when it's a digital image (Figure 8-17).

## THE IMPACT OF PHOTOGRAPHY

Paul Delaroche, a French painter commenting on the invention of photography, exclaimed that "From today painting is dead!" While some artists shared that fear, others embraced the new medium as a tool and an opportunity. From its beginning, illustrators have used photographs as aids. The illustrator Alphonse Mucha carefully posed models amid studio props and photographed them for reference in his poster designs (Figures 8-18 and 8-19). Such well-known twentieth-century illustrators as Maxfield Parrish and Norman Rockwell have also relied heavily upon posing and photographing models for visual reference in later paintings. Photographer Eadweard Muybridge (1830–1904) is

**8-17** **Robb Mommaerts.** This student designer digitized the image of a bronze statue from the nineteenth century. He used it as a base layer to create this illustration for his portfolio, using Illustrator software.

**8-18** **Alphonse Mucha.** Poster design based on Figure 8-19.

well known in the design community for his photographic series documenting the movement of people and animals. His books remain a valuable resource to illustrators today (Figure 8-20).

# THE DESIGNER/PHOTOGRAPHER

Oftentimes the designer is called upon to create, or locate, and integrate photography into a layout design. A working

**8-19  Alphonse Mucha.** Studio photograph of model.

knowledge of how to evaluate photographs is very useful.

Photography is a strong, expressive tool with which to prove a point, explore a problem, or sell a product. Most people believe that the camera does not lie. They believe that an illustrator can change things around and make people or situations out to be better than they really are, but they fail to realize that a camera also represents a point of view. It is this suspension of disbelief that makes the camera such an effective tool for persuasion and communication. It is also this belief in the "photograph as document" that is threatened by the computer.

People want to know if they are looking at a manipulated image. In February 1982, the staff working on a cover for *National Geographic* magazine had difficulty getting a photograph of the Egyptian pyramids to fit the magazine's format. Since the information was stored digitally on a computer, it was a simple matter to move one pyramid over. When that photo manipulation became known (it was widely reported), our faith in photographic reality was badly shaken.

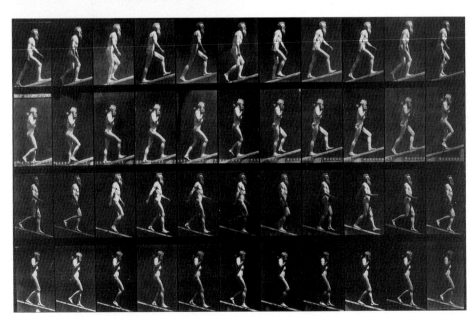

**8-20  Eadweard Muybridge.** Excerpt from *Animal Locomotion.* 1887.

No photograph is truly candid. It is selected, framed, and shot by an individual who is interacting with the environment. Moreover, a situation will change just because a camera is introduced. Another editing and selection process occurs when the contact prints are viewed. Darkroom and computer manipulation may influence the last stages. All of these processes place photography firmly in the camp of an interpretative art. A photograph can tell the truth, but that truth is filtered through the eye and intent of the photographer (Figure 8-21).

## DIGITAL PHOTOGRAPHY

The advent of digitized, computer-manipulated images makes this issue even more pertinent. Once the analog, continuous-tone photograph is translated into digital data, it can be accessed, manipulated, and transformed with incredible speed and efficiency. Digital cameras are available that skip the analog stage entirely. The image in Figure 8-22 was created by artist/educator Susan Ressler by digitizing original objects for a complex and rich series of manipulations.

Multiple variations of a single image can be generated when the image is digital, and color editing and retouching can be easily accomplished. Mistakes are never fatal, since the original is stored

**8-21** *(left)*
**John Heartfield.** "The Meaning of Geneva." Photomontage, 1932. Copyright 1998 Artists Rights Society (ARS), New York/VG Bild-Kunst, Bonn.

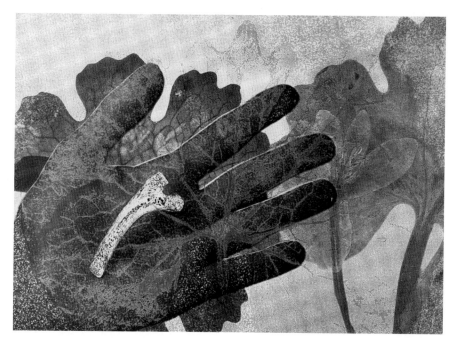

**8-22** **Susan Ressler,** electronic artist. From Stone to Bone. 1991.

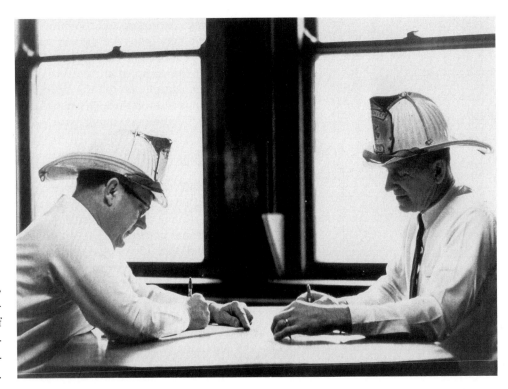

8-23 **Gordon Baer,** a Cincinnati photographer, shot this piece of photojournalism searching for the "right" candid feeling.

on disk. The final image can be output on film and printed as an analog image using traditional darkroom techniques or output on a laser printer. Materials intended for the offset press can be sent directly to film after retouching on a computer system. The impact of digital imaging on photography is tremendous. See color plates 13, 14, and 15.

A video camera can be cabled to a desktop computer and the resulting image captured as still data or as a manipulated live recording that will later be edited. It is increasingly necessary to honor and understand copyright issues. Appropriating photographers' images without payment or authorization infringes on their livelihood.

The most important aspect of photography remains in the eye and mind (and perhaps heart) of the artist. The concept, the design, the element of communication, and, finally, the output determine the quality of a photographic image.

## CANDID VERSUS STAGED

Photos fall into two general categories: "candid" and staged. Most photojournalism is candid. It is not shot in a studio or with hired models. Photojournalism attempts to capture a news event on location with immediacy and honesty. When a feature story is run in a newspaper, an art director or editor may ask for a picture essay that will illustrate a feature story with a sequence of images that give a sense of movement, establish a narrative, or set an emotional tone. Figure 8-23 by Gordon Baer is an attempt by the photographer to tell the story visually of an election for Cincinnati fire chief. This photo was the final solution and shows both the written nature of the competition and the fact that these are men competing for fire chief.

Staged photographs are often used in advertising and product photography. They are tightly directed and require

elaborate studio lighting. Hired models can make shooting time expensive. Product photographers are usually less concerned with "truth" telling than the photojournalists and more concerned with presenting a product in the most favorable light. The photographic illustrator is relying increasingly on computer-generated effects and less on darkroom technique.

Designers use photographs and work with photographers throughout their careers. A photograph may be needed to document an event, illustrate a story, sell a product, or put across a point of view. In all cases, the photograph must be evaluated in terms of print quality, design quality, and ability to communicate. The fashion photos in Figures 8-24 and 8-25 evoke an atmosphere through design and soft, grainy texture. It is advisable to study good photos. A class in darkroom work will help develop a feeling for print quality. Experimentation with digital photography can be an exciting and very accessible way to begin or to augment this learning process.

The criteria for good design in a photograph are similar to good design in layout or illustration. Figures 8-26 and 8-27 show a highly creative and effective use of photography for self-promotion. A photograph, however, communicates in a particular and powerful way. We have a special relationship with photography based on history, memory, and its similarity to the retinal image.

# SPECIALTIES

## PRODUCT PHOTOGRAPHY

Any area in which the intent is to promote or sell a product is called product photography. The product can be food, automobiles, furniture, clothing, fine art, or a wide range of other items. The metal sculpture in Figure 8-28 is captured in all of its surface texture and complexity through the art of the photographer. Still-life photographs enhance the beauty and desirability of many products (Figure 8-29). Often this sort of product is prepared for the camera with special gels and coatings that intensify lighting effects.

When the assignment comes from an art director at an advertising agency or directly from the client, the photographer is often told what to shoot within very narrow specifications. The challenge in this form of photography is to

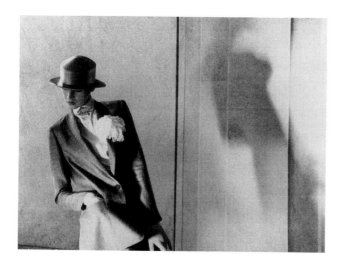

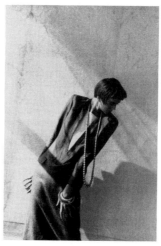

8-24, 8-25 **Nana Watanabe.** (President, Nana Inc., New York).

8-26, 8-27 **Nora Scarlett,** a New York photographer, created these self-promotional direct mail pieces. She located or created all the necessary still-life props for this creative series.

help sell the product in a way that is personally and aesthetically satisfying.

Most photographers doing this kind of work are freelance, and many work through an agent who solicits work from clients. The "rep" usually will get a 25 to 30 percent finder's fee from the assignment. Major catalog houses and department stores have their own in-house photographic staff and facilities.

Regional advertisers, too, often make use of an in-house photographic staff. However, national advertisers usually hire dependable freelancers whose previous work suits the project at hand.

When shooting a fashion layout for a catalog, newspaper, or direct mail piece that calls for a model, the photographer will work with the art director and with assistants who help with the details of clothing, makeup, props, and so on. It is important that all people at a "shoot" show respect for one another's professional abilities.

## CORPORATE PHOTOGRAPHY

Large corporations need a great deal of photography for annual reports, presentations, and other publications. The company's art director or designer often hires a photographer for an individual assignment and offers suggestions regarding the project. The public relations executive also may become involved in the considerations. Sometimes an in-plant photographer on the staff does some of the photographic work. This photographer is often a generalist working out of the public relations (PR) department and shooting everything from "candid" news release photos to carefully composed and lighted architectural interiors.

Architectural photography calls for a special skill in handling building interiors and exteriors. Lighting an interior so the bright chandeliers as well as the details in dark corners of the room are all properly exposed and not distorted calls for considerable expertise. Photographing exteriors of tall buildings often requires special equipment that will correct for parallax. Architectural photography is a specialty in itself, and these photographic specialists work for a variety of interior design firms, landscape designers, and corporate accounts.

**8-28** **Linda Threadgill,** artist, and **Jim Threadgill,** photographer. *Patchwork Pin.* 1984.

**8-29** Poster by **Chuck Byrne** and **Julius Friedman** for the Detroit Institute of Art.

## EDITORIAL/ ILLUSTRATIONAL PHOTOGRAPHY

This kind of photography illustrates an accompanying story—anything from fiction to a feature article on restaurant dining. Photographic illustrations are sometimes closely art-directed by the designer. The necessary props and set

*(left)*
**8-30  Gregg Theune.**
UW-Whitewater
Photographics
Department. This still-
life was assembled and
photographed to repre-
sent the UW-Whitewater
College of Arts and
Communication. It was
used as a newsletter
cover design.

*(right)*
**8-31  Maureen Fahey.**
This image was con-
structed in Photoshop
using stock photography.

may be provided, or the photographer may be asked to find or construct them.

This form of illustration leaves room for creative interpretation, but communication remains the primary objective (Figure 8-30). Digital photography has made a great contribution to photo/illustration.

## FINDING PHOTOGRAPHS AND PHOTOGRAPHERS

Stock photography agencies sell photographs to anything from advertising agencies to magazines (Figure 8-31). They have thousands of images on permanent file that are constantly updated. Any type of photograph is available by transparency or CD rom, and agencies specialize in everything from architecture to current events to the history of civilization. The Bettmann Archives, Black Star Publishing Company, and the Free Lance Photographers Guild are three of hundreds of such services providing images for use in editorial work, advertising, and television. Pricing is based upon size, use, and client. Check

your college or university library for books listing such picture sources and describing their specialties. Professional photo researchers are available to help you secure the necessary image.

The *American Showcase* is a full-color reference book used by advertising agencies, public relations firms, and others who want to hire freelance photographers and illustrators. Each portfolio page of images is accompanied by the name and address of the photographer who shot them. (You can order the book from American Showcase, Inc., 724 Fifth Avenue, New York, NY.)

Photographers specialize in a variety of areas, each of which calls for unique expertise. As a designer, know what you

8-32 **Phariny Kanya.** This image was constructed in Photoshop, using a combination of original digitized imagery and stock photography.

need to communicate and work with a photographer or learn how to do it yourself (Figure 8-32). Insist on high standards and become familiar with the best quality work being done. Photography is a powerful tool for communication. *Protect the integrity of the design/photo field by refusing to appropriate any image without authorization.*

## PROJECT

Illustrate the cover of a tape or compact disc you enjoy, incorporating photography and/or illustration. Find several images that are appropriate. You may research and obtain authorized copies, shoot them yourself, locate copyright-free art, or generate the imagery through your own drawings. Do not appropriate a professional photographer or illustrator's work from magazines or other printed sources. Choose the images you'll work from based on print quality, design quality, and visual information.

Combine the imagery with the title of the recording and the name of the artist. Prepare your piece to actual size. This may mean you'll need to use various traditional illustrator's mechanical enlarging and reducing aids, darkroom skills, or digitized images. Check with your instructor to see what medium you should pursue. Always keep your treatment appropriate to the subject matter and content, and remember to use the gestalt unit forming techniques to integrate word and image. Complete the CD package, including all typography.

### Objectives

Practice creating and integrating imagery in a layout design.

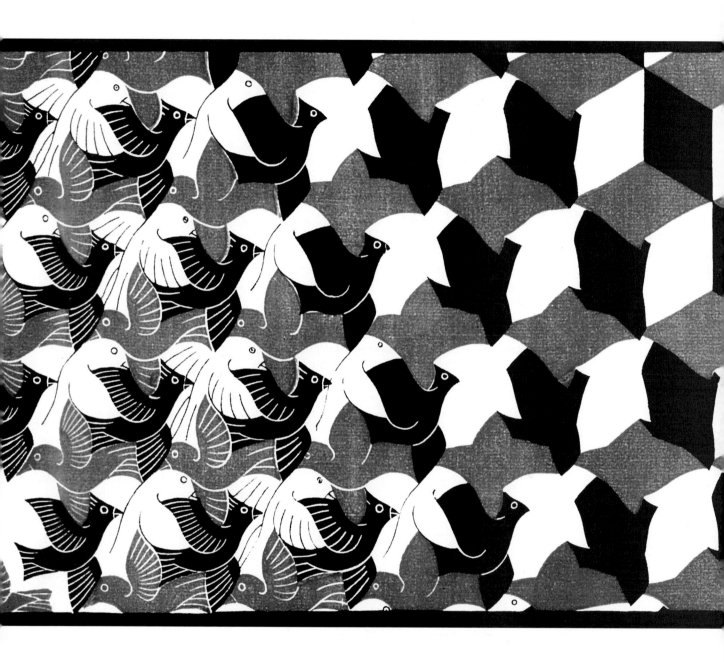

ADVERTISING DESIGN

# THE PURPOSE OF ADVERTISING

Advertising differs from pure graphic design in intent. It seeks primarily to persuade. Information is secondary. Both purposes involve visual communication.

The successful advertisement (1) attracts attention, (2) communicates a message, and (3) persuades an audience. Advertising can have many different looks. It may appear in television, newspapers, direct mail, magazines, billboards, outdoor displays, and point-of-purchase displays. Whatever the medium, it is characterized by an attempt to persuade an audience, with the intent to boost sales, profits, and share of the market.

There are elements of information in an advertisement and elements of persuasion in pure graphic design. Among the current issues in advertising theory is the discussion about how much of advertising is informational and how much persuasive. The proponents of the "advertising as information" school assume the consumer initially buys the product based on information supplied by advertisements. Future purchases are based on first-hand assessment of the quality of the product. This theory states that the persuasive element in advertising is secondary to the information supplied.

To what extent is this view of advertising true? Probably the ads that are most useful in informing consumers are those on a regional level announcing events such as plays, concerts, and meetings. The consumer might miss an opportunity to participate without an advertisement.

Those who believe the function of advertising is persuasion maintain that advertisements exist to change perception. Advertising induces the consumer to believe the product has certain desirable qualities or associations. Soda pop and blue jeans become associated with youth, zest, and popularity. Ads for them "sell" an attitude and a lifestyle.

The purest example of advertising for persuasive purposes can be found in national advertising, especially of long-standing and leading products. The public no longer needs pure information on these products. What sells such a product to the public is the associations they have with it. Many of these associations are generated by advertising. (Figure 9-1).

Most advertisers want both persuasive and informative qualities in their advertising. The closer an advertisement comes to pure information, the closer it comes to pure graphic design. The closer a graphic design such as a poster comes to not only announcing an event, but also persuading ticket purchases, the closer it comes to pure advertising. Figures 9-2 and 9-3 are part of an integrated campaign created for the Minnesota Zoo by Rapp Collins Communications. Several examples of this integrated campaign will be used throughout this chapter.

What nobody knows about you is_____
_____
_____

Leave your mark.

9-1 Ad layout courtesy of Apple Computer. **Gavin Milner/Bob Cockrell,** art directors; **Harold Einstein,** writer; **Ed Adler,** producer; **Tom Nelson,** photographer; Prepared by BBDO, Los Angeles, CA.

# TYPES OF ADVERTISING

Retail and national advertising are two major categories of advertising. Each can be divided into three major areas according to dollar volume: television, newspaper, and direct mail.

Retail advertising is so named because it is often sponsored by a retail establishment. It tends to be informational in nature, especially when announcing special discounts or availability. It often attempts to get people to go to sponsoring stores to buy items they have seen advertised nationally. Studies have shown that retail advertising encourages price competition.

National advertising is advertising run by manufacturers with a nationwide distribution network for their product. It tends to be persuasive in nature. It began when manufacturers wanted to differentiate their brands from similar or identical brands, and when there was a national delivery system for advertisements.

9-2, 9-3 Two advertisements created as part of the BUGS! ad campaign prepared for the Minnesota Zoo by Rapp Collins Communications. Creative Director **Bruce Edwards**, Art Director **Bruce Edwards**, Copywriter **Chris Mihock.**

# TELEVISION

The description of television will be brief, because it is outside the scope of this text. The majority of advertising dollars are spent on television. The content of national television advertising is strongly persuasive. Commercials may be a network advertisement, shown on national shows, a spot advertisement, prepared nationally and shipped to local areas, or a local advertisement, prepared and shown locally.

Market research is an important part of all advertising, especially in heavily persuasive advertising. The two primary marketing considerations in television advertising are program attentiveness and viewer volume.

Program attentiveness is how strongly viewers concentrate on a show. The maximum attention assures maximum recall. Unlike newspaper, direct mail, or other print media, the television ad occurs in time and cannot be reread.

The second marketing consideration is the number of persons viewing television programming. In the average home, a television set is on for almost seven hours a day. Certain hours are considered peak viewing periods. These prime-time slots cost prime dollars. Because so much money is at stake, there is a great deal of research into ad effectiveness.

The television advertisement is usually prepared initially in the form of a storyboard. When prepared two-dimensionally, it consists of two frames, one carrying a visual depiction of the scene, the other carrying words being spoken by an announcer or cast. The storyboard will depict only key scenes (Figure 9-4).

The visual is often prepared so that it will carry the message even if the volume is muted. The product name is often superimposed over the screen at the end of the ad. The audio is also written to carry the message alone, in case the viewer is temporarily out of the room or unable to see the screen.

# NEWSPAPERS

Newspaper advertising carries both regional and national ads. National advertising will often arrive as an "ad slick" ready for insertion. The creative work has been done at the company's ad agency. Regional display advertising often requires designing by the newspaper's staff of artists and copywriters.

## Advantages and Disadvantages

Some disadvantages will face the designer in newspaper advertising. First, the designer often must include diverse art elements and typefaces into a single ad. The logo and elements relating to a national campaign must often be incorporated into an ad for a local sale. Often the cost of an advertisement will be shared among manufacturers if their logos appear in the ad. This diversity can make the task of creating a well-designed, attractive advertisement a real challenge. Second, the designer must also create around the limitations of cheap, absorbent newsprint and hurried printing to meet daily, sometimes hourly, deadlines.

Single-item ads or large institutional clients like banks may use a full page with room for white space. These ads allow more leeway for design. No matter how many elements are in your advertisement, whether it is a national or retail ad, whether it is reproduced on newsprint or expensive glossy paper, good design will always aid communication. Given some creativity, it will also attract attention and help to persuade the audience.

The advantages of newspaper advertising are many. The paper is widely read. Circulation rates are available to help advertisers plan the number of people their ads are reaching. Moreover, the circulation is localized. It is therefore easy for a retail outlet to reach those people most likely to be interested in and able to travel to a sale. Finally, the copy may be

changed daily, and the updated ad will still reach its audience within a day.

### The Audience

Newspaper readership is varied in character. Young and old people from every social and economic group read the paper. When a product is of interest to a limited group, newspaper advertising is not advisable, because so small a percentage of readers would be potential buyers.

Newspaper advertising can be targeted to a limited extent, however, by considering the type of reader attracted to a certain type of paper. *The Wall Street Journal,* for example, has a different readership than the *New York Daily News.*

Advertising rates are based on the size of the ad, the circulation of the paper, and the position of the ad within the paper. The sports page, the society page, the home section, and the financial section are areas where advertisements allied to special subjects are likely to be seen by the desired group of readers. Advertisers will pay extra dollars to ensure that the appropriate audience sees their ad. Other positions within the paper that are worth extra money are on the outside pages, at the top of a column, and next to reading material.

**9-4** Storyboard of a TV advertisement created by Rapp Collins Communications for the Minnesota Zoo. Creative Director **Bruce Edwards,** Art Director **Bruce Edwards,** Copywriter **Chris Mihock.**

# DIRECT MAIL

Direct mail advertising comes in many forms. It is an exciting and growing area of advertising that has boomed partly as a result of credit cards and partly as a result of today's busy lifestyle. Direct mail accounts for most third-class mail and a considerable amount of first-class mail.

Direct mail is advertising in which the advertiser acts as publisher. The advertiser produces a publication (rather than rent space or time), selects the mailing list, and sends the publication directly to the prospects through the mail (Figure 9-5).

### Advantages and Disadvantages

The advantages of direct mail are substantial. First, the advertiser can use a mailing list that has been compiled to reach a specialized audience. Businesses sometimes develop their own mailing list. The primary sources of names, however, are mailing-list brokers. They are in the business of building and maintaining lists of individuals likely to have an interest in a given topic. Lists are usually rented for one-time use because they go out of date quickly and must be constantly updated. Second, direct mail does not have to compete for attention with other ads on a newspaper page or surrounding a television commercial. Third, it is flexible in its format. This feature makes direct mail challenging to the

designer. The size, paper, ink color, and folding characteristics are all additional variables to be designed. A piece that folds is a three-dimensional problem. It must succeed visually from a variety of positions. The design develops from front to back, building interest and encouraging the reader to continue.

One of the disadvantages of direct mail is that people are often hostile to it. If the audience throws away the envelop or catalog without even opening it, communication has failed. Studies have shown that a mailing that requires participation, such as a lottery, will increase effectiveness. Copy and graphics that present specific offers and a clear, simple message succeed well.

Forms of direct mail include letters, flyers, folders or brochures of varying dimensions and formats, catalogs, and booklets. A single mailing may consist of several pieces, such as an outside envelope, a letter, a brochure, and a business reply card. It might be part of a campaign of related pieces that are mailed out over a period of weeks.

# OTHER FORMS OF ADVERTISING

Magazines also offer a forum for advertising. A wide variety of magazines are published. There are general-interest magazines, such as *Newsweek* and *Life*, and specialty or "class" magazines, such as computer, religious, sports, and health publications. There are trade and professional magazines, such as *Print, CA,* and *ARTnews,* as well as professional publications for doctors, engineers, and so on. With magazines it is possible to target a specific interest group with your ad. Also, if you have a national product to promote, you may choose magazine advertising, because many magazines have national circulation.

Another form of advertising is billboard display (Figures 9-6*a, b,* and c).

**9-5** Studio 45. A direct mail piece created by the UW-Whitewater student design agency announcing an open house in their computer lab.

When designing for billboards, it is important to remember that the message will be seen from a moving vehicle at a distance of at least 100 feet (30 m). The visual and the copy must be kept simple. It is surprising how many billboards violate this principle. Type for billboards should be at least 3 inches (8 cm) high at 100 feet (30 m) and 12 inches (30 cm) high at 400 feet (120 m). A message of more than about seven words is difficult to read. A single image is easiest to grasp. An easily recognizable silhouette makes a strong visual that can carry much of the message. A strong intellectual and visual unity is important. The problems presented by transit advertising and outdoor advertising in general are similar to those for billboards. The audience is always in motion. The form of the appeal must be bold and simple, with details eliminated.

Point of purchase advertising is a growing area of importance. It is primarily three-dimensional. The term "point of purchase" describes the display that is present along with the product in the store. Studies have shown that purchase of many items is based on impulse. More than one-third of purchases in department stores and almost two-thirds of the purchases in supermarkets result from display of the product. The display in the store, especially supermarkets, consequently plays an important part in advertising products. Package design can be considered a form of point of purchase design. This is a growing and challenging area to investigate.

# CORPORATE IDENTITY

Large companies and institutions often have a master plan that coordinates all of their designs. This plan begins with the trademark and applies it to the layout of business cards, letterhead, adver-

**9-6a, b, c** Billboard created by Rapp Collins Communications as part of the BUGS! campaign for the Minnesota Zoo. Creative Director **Bruce Edwards,** Art Director **Bruce Edwards.**

tisements, product identification, and packaging. Even the company uniforms and vehicles are a part of this identity program. The accompanying illustrations from J. I. Case Company show their strong corporate logo applied to signage, package design, and vehicles (Figures 9-7 through 9-9).

Corporate identity is a specialized branch of advertising and design. Every aspect of typography, imagery, and application must be considered part of an integrated presentation. This integrated image presents the corporation to the public in a positive and memorable light. It not only communicates an image, but attempts to persuade the public that the company, hence the product, is superior.

A graphics standard manual is presented to company personnel detailing

the appropriate use and placement of the trademark and related materials. The identity program must be flexible enough to be adapted to future needs. It is one of the most comprehensive applications of design and advertising.

# WORKING WITH OTHERS

Advertising takes teamwork. You must communicate closely with copywriters, photographers, illustrators, clients, and market researchers. Either the visual or the verbal element may be the departure point for developing the message. An integration of form and content, of design and communication is at the heart of good advertising.

Work with others to establish key information. Who is the audience? What is the nature of the product? Where will the ad appear? What is the purpose of the ad? What is the budget? Once you have answered these questions, then you can begin to translate this information into visual form.

A successful ad will attract attention, communicate through its unified

9-7, 9-8, 9-9 J.I. Case Company corporate logo applied to signage, packaging, and vehicles. Courtesy of J.I. Case, Racine, Wisconsin.

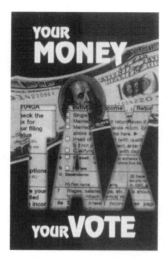
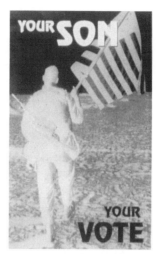

**9-10** **Terri Breese.**
Integrated ad campaign
created to encourage
voter participation.

arrangement of elements, and persuade through the interaction of strong and appropriate copy and layout (Figure 9-10).

# EXERCISES

1. Find some persuasive ads in a magazine. How do they catch their intended audience? What associations with the product do the ads induce? How?
2. Find an ad for a product that targets different audiences by appearing in two magazines in a different format.
3. Turn off the sound and watch some television commercials. Does the visual convey a complete message?
4. Scan your local newspaper. Which advertisements grab your attention? How do position and design affect their success?

# PROJECT

## *Magazine Advertisements*

Design two magazine advertisements in an 8½″ × 11″ (20 × 28 cm) format for a nonprofit, public service organization. Your task is to warn readers of the hazards of alcohol abuse. The primary audience for the first ad is 18- to 24-year-olds. The second ad should communicate with the under-age drinker. Identify the magazines in which your ad will appear. Research and discuss in class some of the problems that might be targeted, such as drunk driving.

Prepare the ads for black-and-white reproduction, including an image, a headline, and a few lines of body copy.

In your thumbnails, try various approaches, including a path layout, grid layout, and a simple dominant image.

## *Corporate Identity*

Select a nonprofit institution and create a new identity program for it. Include logo, print advertisement, and billboard or signage.

## *Objectives*

Experiment with researching and targeting a particular audience. Practice both communicating a message and persuading an audience.

# THE DYNAMICS OF COLOR

Color for the designer and color for the fine artist is similar at the creative stage (Plate 1). A basic knowledge of color theory is useful to both. Later, in preparing art on the computer, or for the printing process, the designer needs to be familiar with how color is influenced by the computer and by printing technology. A great deal of new terminology must be understood. Let us first brush up on color as a creative and expressive communication. Then we will consider color from the computer and the printing perspectives.

## DESIGNING WITH COLOR

Every student who has completed an elementary course in art has heard that color is a property of light. Many people do not fully understand those words, however, until years after their art degree is completed. A young painter several years past her B.F.A. tells a story of looking around her living room for a composition to paint. "I considered the objects in the room and the space they occupied; the corners of the ceiling and the negative spaces in the staircase. I looked at the carpet and saw the standard 'landlord green.' And then I looked at the carpet again and realized that my mind was processing 'landlord green,'

10-1  Light waves of many colors join to make white light.

but my eyes were actually looking at black geometric shapes swimming beside a shining pastel/fluorescent color of fresh spring leaves. The sun was shining in the window of my dark living room and transforming my carpet. Color is a property of light, I thought. Oh!"

Color has been accurately described as both "the way an object absorbs or reflects light" and "the kind of light that strikes an object." The painter's carpet would appear to have a different color had it a deep shag texture or a slick, shiny surface. It would appear to have a different color under an incandescent or fluorescent light, under bright natural sunlight or light overcast cloud cover. Even the angle from which it is viewed has an effect.

Issac Newton first passed a beam of white light through a prism and saw it divide into several colors. The colors of the light wave spectrum are red, orange, yellow, green, blue, and indigo (Figure 10-1). In physics, mixing the colors of the light wave together will produce pure white light. It is these light waves, bouncing off or being absorbed by the objects around us, that give them color.

The three primary colors in white light are red, blue, and green. They are called "additive" primaries because together they can produce white light. The eye contains three different types of color receptors, each sensitive to one of

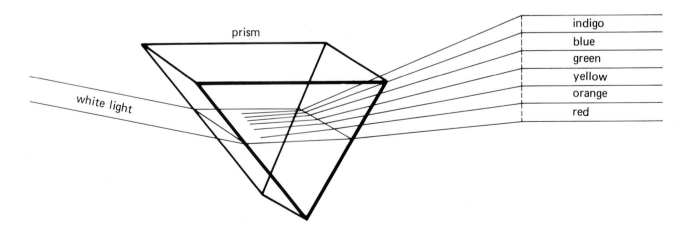

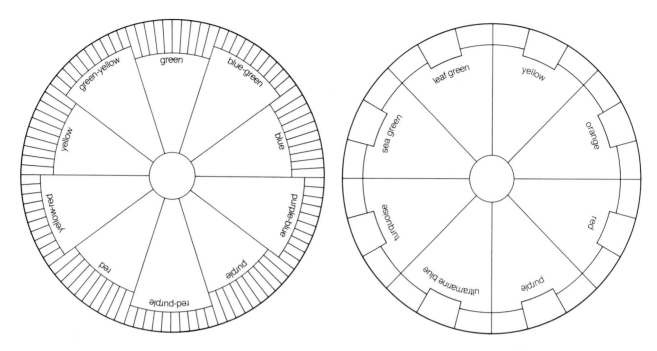

10-2 Two possible color wheels.

the primary colors of the light spectrum. This seems to suggest an active connection between our physiological makeup and the world in which we live (Plate 2).

The designer needs to understand that color is dependent upon light. Color is not an unchanging, absolute property of the object. It is dynamic and affected by its environment.

## THE COLOR WHEEL

For the artist and designer, mixing pigments will never produce white. Black is the sum of all pigment colors. Several color wheels have been developed to help us understand the effects of combining pigments.

The traditional color wheel, developed by Herbert Ives, begins with "subtractive" primary colors of red, yellow, and blue. Mixing these hues produces secondary colors. Mixing the secondary colors with the primary produces a tertiary color.

The Munsell color wheel is based on five key hues: red, yellow, blue, green,

and purple. Secondaries are formed by mixing these primaries. Although these two classification systems differ, the basic "look" of the resulting colors is similar. The color wheel is only a workable system, not an absolute (Figure 10-2). The CMYK process colors are also a pigment-based subtractive gamut.

## PROPERTIES OF COLOR

Every color has three properties: hue, value, and intensity. Hue is the name by which we identify a color. The color wheel is set up according to hue.

Value is the degree of lightness or darkness in a hue. It is easiest to understand value when looking at a black-and-white image. The darkest value will be close to black, the lightest close to white, with a range of grays in between. Value also plays an important role in all color images. Every hue has its own value range. Yellow, for example, is normally lighter than purple. Its "normal" value in the middle of a yellow value scale will be lighter than purple. In a

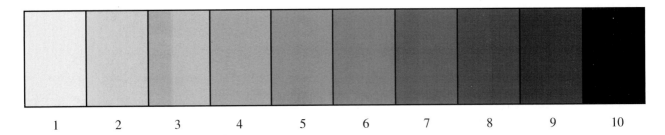

| 1 | 2 | 3 | 4 | 5 | 6 | 7 | 8 | 9 | 10 |

10-3  Changes in value.

value scale, the color values that are lighter than normal value are called *tints:* those darker than normal value are called *shades.* The addition of white will lighten a value, whereas the addition of black will darken it (Figure 10-3).

The third property of color is intensity or saturation. It is a measure of a color's purity and brightness. In pigments there are two ways of reducing the intensity of a color: mix it with a gray of the same value, or mix it with its complement (the color opposite on the color wheel). Low-intensity colors have been "toned down" and are often referred to as tones. Colors that are not grayed are at their most vivid at full intensity.

## COLOR SCHEMES

Color combinations are grouped into categories called color schemes. Colors opposite one another on the color wheel are called *complements.* Art that combines these colors is said to be using a complementary color scheme. Complements heighten and accent one another. They often are used to produce a bold, exciting effect. A split complementary scheme includes one hue and the two hues on either side of its direct complement. Colors next to one another on the color wheel are called *analogous.* An analogous color scheme is generally considered to be soothing and restful. A *monochromatic* color scheme is composed of one hue in several values.

In color there are no real absolutes. That is why this information is often called "color theory." It is unusual, but quite possible, to produce a tense, dramatic effect using analogous colors or a soothing, harmonious effect using complementary colors. Remember that these principles are not rules, but useful guidelines. You may choose to deliberately violate them for effect.

## THE RELATIVITY OF COLOR

Our perception of color is "colored" by many considerations. For example, the way each color looks to us is strongly affected by what surrounds it. This phenomenon is known as simultaneous contrast.

We automatically compare colors that sit side by side. When complements (such as red and green) are placed side by side, they seem to become more intense. They "complement" one another. A gray placed beside a color will appear to have a tinge of that color's complement in it because our eye automatically searches for it. Therefore a neutral gray beside a red will appear to be a greenish gray, while the same neutral gray beside a green will appear to have a reddish cast.

Value also is affected by simultaneous contrast. A gray placed against a black ground will appear to have a lighter value than the same gray placed against a white ground (Figure 10-4). Our eye makes a comparison between the black and gray and judges the gray as much lighter. In the other sample, our eye

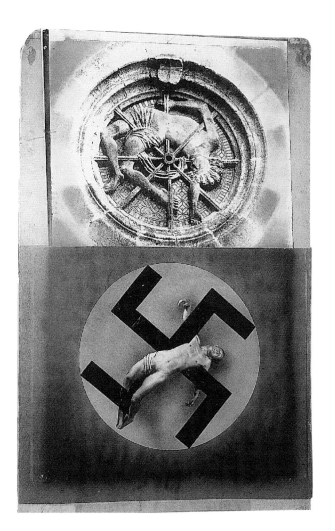

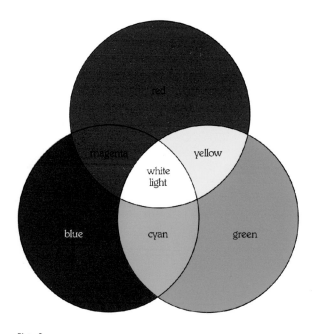

Plate 2 Red, green, and blue are the primary colors in the additive system. Red, green, and blue together produce white. In this system, cyan, magenta, and yellow are secondary colors.

Plate 1 "As in the middle Ages . . . So in the Third Reich." Photomontage by **John Heartfield,** 1934. This powerful comment on Hitler's regime is also a beautiful example of gestalt principles and the use of color.

Plate 3 In the subtractive color system, cyan, magenta, and yellow are the primary colors and their overlapping produces the red, green, and blue of the secondary colors. Cyan, magenta, and yellow together produce black.

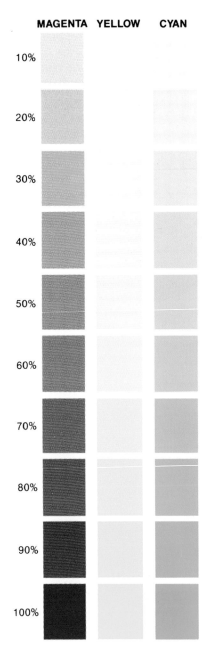

|  | MAGENTA | YELLOW | CYAN |
|---|---|---|---|
| 10% | | | |
| 20% | | | |
| 30% | | | |
| 40% | | | |
| 50% | | | |
| 60% | | | |
| 70% | | | |
| 80% | | | |
| 90% | | | |
| 100% | | | |

Plate 4 Changing tint values with screens. Material furnished by Hammermill Papers Group for plates 4 and 5.

Four-color pre-separated art

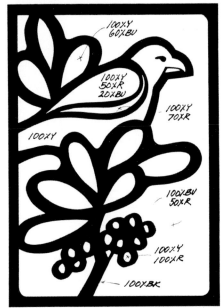

Plate 5 Tint screen percentages of the four process colors are combined to create this illustration.

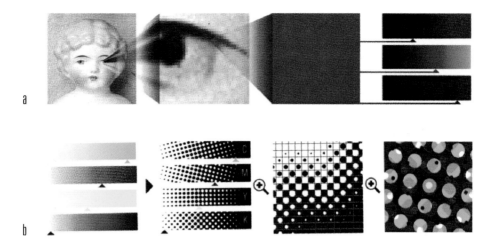

a

b

Plate 6a, b This illustration documents the process of converting an original image into pixels, converting to CMYK halftones, and finally to the four-color printed piece. Courtesy of Apple Computer.

Plate 7 **Tom Girvin,** art director, designer; **Anton Kimball,** illustrator; **Mary Radosevich,** production. Bright Blocks is a package design by Tom Girvin Design, Inc. This colorful package uses highly saturated color to target its young audience. The colorful design increased sales dramatically.

Plate 8 **Kazumasa Nagai** (Nippon Design Center, Inc.) Design for UCLA Asian Performing Arts Institute. This design demonstrates a strong use of value and color used as a contrasting accent.

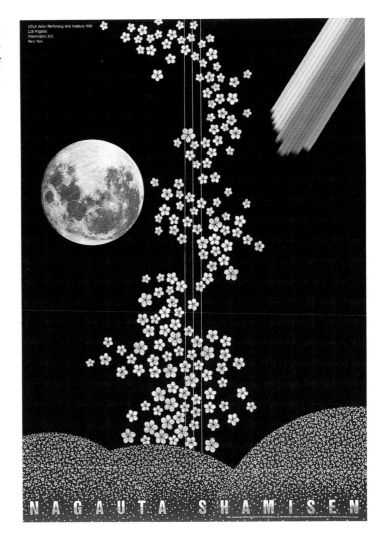

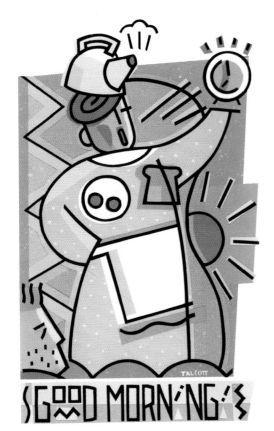

Plate 9 **Julie Talcott,** freelance illustrator. This computer-generated illustration uses complementary colors and strong repetition of line and shape to create this integrated design.

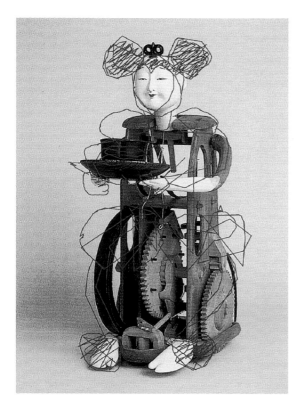

Plate 10 UCLA Extension Summer 1991 catalog. Art Director: Inju Sturgeon, UCLA Extension Marketing Department. Designer: Eiko Ishioka. A playful and highly skilled integration of 2-D and 3-D enlivens this in-house illustration.

Plate 11 **Linda Godfrey.** This freelance illustrator created a whimsical collage using photographic textures. The strong use of blue is accented with complements, and repetition is used throughout this creative design.

Plate 12 **Nora Scarlett.** Part of a series of self-promotional postcards created by this New York photographer. A wonderful example of repetition and gestalt closure.

Plate 13 **Phariny Kanya** created this image using original scanned photography placed in Photoshop. She then experimented with duotone and tritone settings in this surrealistic effect.

Plate 14 **Cliff Jacobsen** designed a series of calendar pages that repeat a visual theme and grid layout, while experimenting with very different colors and abstract computer images.

Plate 15 **Don Miller,** computer artist, created this powerful self-portrait on an Amiga computer, output to an inkjet printer. Miller often incorporates computer-generated files with traditional media.

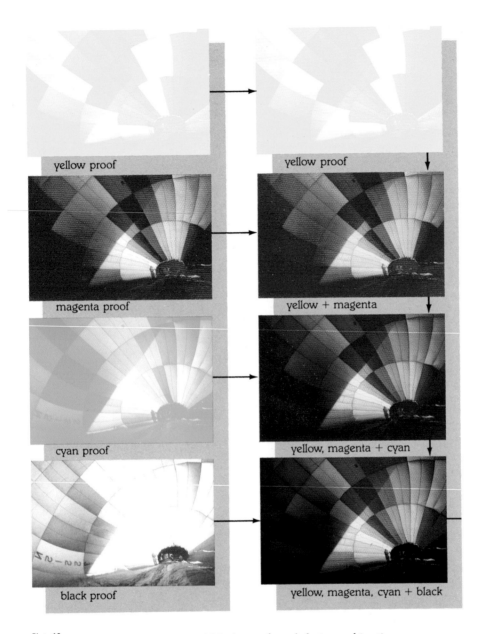

yellow proof

yellow proof

magenta proof

yellow + magenta

cyan proof

yellow, magenta + cyan

black proof

yellow, magenta, cyan + black

Plate 16 Yellow, magenta, cyan, and black proofs and their combinations.

Plate 17 PANTONE® Color Formula Guide

Plate 18 PANTONE® Process Color System Guide

looks at the white and judges the gray as much darker.

One designer first experienced this effect when she was a child, visiting her aunt for dinner. Butter in her own home was a yellow stick brought home from the store. On the aunt's farm it came straight from the cows, after a little churning. This fresh butter did not have a yellow food coloring added to it. When her aunt placed it on the table on a yellow plate, the niece would not eat it. It looked white and could not be the "real thing." Who would eat white butter? The aunt, however, knew about simultaneous contrast, although not by that name. She whisked the butter plate away and returned with the same butter, this time on a white plate. The young girl was delighted with the "new" butter. This time, compared with the white plate it sat on, the fresh butter looked yellow.

Simultaneous contrast means that color is relative to the colors surrounding it. This fact was first discovered in the nineteenth century when a French chemist named Michel Eugene Chevreul, also a merchant who dyed fabric, was disturbed by apparent inconsistencies in his bolts of cloth. He discovered that his dye remained consistent, but the viewing conditions did not. Bolts of the same color appeared to be different colors depending on the color of the fiber samples around them. He went on to research this phenomenon. In the twentieth century, Josef Albers made a further, intensive study of color. Albers experimented with simultaneous contrast and contributed greatly to our understanding of that effect.

# THE PSYCHOLOGY OF COLOR

Relativity also holds true in the psychology of color. Colors have the power to evoke specific emotional responses in the viewer—some personal, and some more universal. In general, for example, warm colors stimulate, whereas cool colors relax most people. Interior designers pay close attention to this relationship when they consider the color schemes for a dentist's waiting room or the newsroom of a daily paper. Can you imagine sitting in a dentist's chair while staring at a bright red or yellow wall?

Red, yellow, and their variations are referred to as warm colors, perhaps because we associate them with fire and the sun. Blue and green are considered cool colors. They also happen to be the

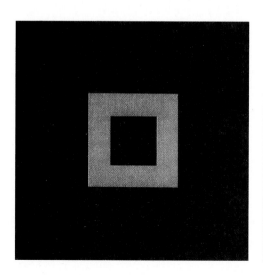

10-4 Simultaneous contrast gives two boxes of the same gray different apparent values.

colors of sky, water, and forests. The difference in the wave lengths of these colors may also account for our reactions to them.

## ASSOCIATIONS

Personal memories play a part in color perception as well. If your mother usually wore a particular shade of blue, and you loved your mother (and she loved you), then that shade of blue would have good associations for you. It would seem a warm, friendly color, although to other eyes it might look cool.

Along with personal associations, we have cultural associations with color. They often appear in our language: "black anger," "yellow-bellied coward," "feeling blue," and "seeing red" are a few examples. To a wedding we wear white, the color of purity; to a funeral we wear black, the color of mourning. These are not absolute; they change from culture to culture. For example, people in India wear white to a funeral. For a wedding, they favor yellow.

We can describe our culture's general color associations. It is by no means a description to be memorized and taken as "gospel." Color psychology is complex, affected by many considerations, but if you can combine this information with a light hand and sensitive eye, it may prove useful.

### Red

Red is a dramatic, highly visible hue. It is associated with sexuality and aggression, with passion and violence. It is also an official hue that is found in most national colors. Red is often the favored color of a sports car or a sports team. A dignified, conservative executive, however, is unlikely to choose red for a car or a corporate logo unless its intensity is toned down or its value darkened toward black.

### Blue

In its darker values, blue is associated with authority. Our executive might likely favor a navy blue car, suit, and logo. A middle-value blue is generally associated with cleanliness and honesty, and has a cooling, soothing effect. It is used as a background color in package design because of its quiet, positive associations. Even at full intensity, blue retains a calm quality.

### Yellow

Yellow is used in food packaging a great deal because it is associated with warmth, good health, and optimism. There remain in our language reminders that yellow also has been associated with cowardliness and weakness. That does not appear to be the case currently, however. Even our cultural associations are subject to change.

### Green

Green is associated with the environment, cleanliness, and naturalness. It is soothing and cooling, and consequently a favored color among manufacturers of such products as menthol cigarettes and non-cola beverages.

## SELECTING COLOR

Consider the psychology of the audience in a choice of color. A game or toy intended to appeal to children should have different color than one intended to reach adults considering retirement plans. Our color preferences change as we grow older. In general, youth prefers a more intense color that signals urgency and excitement (Plate 7). The subtle color preferences of age are associated with restraint and dignity.

The institution you are designing for should also affect the selection of color. Banks tend to prefer the darker values and the blues and grays that are associ-

ated with authority and stability. A physical fitness club would probably want more vibrant and intense colors. A restaurant may choose complementary colors that are toned down to an attractive and intimate level (Plate 9).

As a designer, individual color preference is not the only or even the primary consideration. Choice of color should reflect five psychological factors:

1. Cultural associations with color.
2. The profile of the audience and its color preferences.
3. The character and personality of the company represented.
4. The designer's personal relationship with color.
5. An awareness of current color trends.

## UNDERSTANDING ELECTRONIC COLOR

Color on a computer monitor is created in a manner much like a pointillist painting by Seurat. Computer images are composed of individual dots called pixels. The pixel is a rectangle of light on the computer screen that can be set to different colors. The more pixels, the better the resolution and clarity of the image. The resolution is determined by the hardware (Figure 10-5).

Most designers, as this book goes to press, work with a 24-bit system. Each pixel is represented by 24 bits of color information: 8 for red, 8 for green, and 8 for blue. There are 256 possible values of each of these three colors. These differing values of red, green, and blue can be combined to produce more than 16.7 million colors.

## COLOR MODELS

Designers study color theory in order to use it effectively. Color theory remains the same whether it be applied to a traditional or electronic design. But when using electronic color, it can be helpful to study its practical differences. It is important to understand the various ways color is created in order to see the final design printed and looking the way it was intended. The previous section of this chapter discussed creating color using pigment-based subtractive primaries. There are three color models you'll need to be familiar with when using computer graphics. These are the most prevalent color models.

**10-5** This enlargement of a digitized flower also shows the pixel structure.

10-6 The exterior shape represents the colors the eye can see. The black triangle represents the colors that can be shown on the monitor; the texture represents colors that can be printed on coated paper.

### RGB

The image on the computer monitor is displayed in the additive primaries RGB (red, green, blue) and is a back-lit image made by adding light. An image on the monitor may display colors in RGB that cannot be duplicated in the reflective copy of CMYK printing. Be prepared if the printout doesn't match the computer screen. They are displayed in different color "gamets" or models. Calibrating the monitor will help (Figure 10-6).

### CMYK

All of this electronic color is quite different from mixing and blending paint or colored pencils. When the monitor's colors are transferred to paper, or the file is ripped for offset reproduction, it is printed in the subtractive model of CMYK. The CMYK model is the basis for four-color process printing comprised of cyan, magenta, yellow, and black inks. (The K stands for black, which is added to give density to the final print.)

Additional information on CMYK can be found under "Process Colors" later in this chapter (Plate 3).

### HSL

Hue, saturation, and lightness are terms familiar to us from the world of color theory and a discussion of the properties of color. Computer programs allow the user to manipulate colors using this model and other models, by moving pop-up menu sliders. The intensity of a color will diminish when its saturation slider is moved (Figure 10-7). The lightness control will vary a color from white to black (this corresponds to value in pigment-based color models). If you're not concerned about preparing a file for four-color (process) printing, this can be a satisfying color model to use since it is the most intuitive and closest to the way mixed pigment color is used in painting and drawing.

## ANOTHER COLOR WHEEL

The RGB/CMY color model positions the two sets of primaries equidistant from one another. Each secondary color is between two primary colors, each color on the wheel is between two colors that are used to create it, and each color is directly opposite its complement. This is a helpful model to study in order to understand what is happening on the computer monitor.

Red and blue make magenta. In order to decrease magenta from an image, the red and blue must be decreased. Whatever is done to a color, it has the opposite effect on that color's complement. In other words, decreasing red will increase cyan (Figure 10-8).

Various computer programs that allow designers to do color correction have pop-up menus allowing this kind of manipulation. Photoshop is the best known and most effective color correction software in common usage by designers. Its

10-7 Photoshop slides allow careful control of hue, saturation, and lightness (value).

sliders allow the user to quickly manipulate color and see the resulting effects. It also allows the user to work from numbered percentages in order to specify colors that will match a CMYK print. And, finally, it allows the user to switch between color models, specifying that an image be created in RGB, CMYK, spot color, black and white, or duotone modes.

## COLOR GAMUTS

The visible color range of a color model is called a gamut. As the accompanying illustration shows (Figure 10-6), the eye can see more colors than can be created in either the RGB or CMYK color models. The gamut of RGB, however, is larger than that of CMYK. That means that if a design is created with the RGB mode, some of those colors probably cannot be printed using CMYK process colors. Photoshop will give you an Alert symbol (a triangle with an exclamation mark inside) in the Picker palette if your color is not printable. This allows the designer to substitute a printable color before sending the file for printing.

## COLOR IN PRINTING

In addition to applying the psychology of color theory to design work, the designer must stay within restrictions imposed by the technology of mass reproduction. Designs must be created within the limitation of the budget, equipment, expertise, and time available for a particular project. *The designer's use of color must be not only creative and appropriate, but practical and printable.*

## TINT SCREENS

In mixed pigments, color changes are created by the addition of a different pigment-based hue. White is altered to

10-8 Photoshop sliders control and demonstrate the relationship between RGB and CMY color systems.

gray by the addition of black; red is altered to a light pink by the addition of white; and green is created by the mixing of blue and yellow.

Additive color on the computer monitor is created though varying intensities of light, as just discussed. When the file is sent to press, in order to create a tint or a light value of a hue, the printer cuts back on the density of the ink through varying screens. Screens are available in gradients from 10 to 90 percent. There is a similarity between the tint screens of printing inks and the application of transparent watercolor. In both cases, white is made by allowing the white of the paper to show through, and lighter values are made by applying less pigment or ink.

In appearance, the value scale of printer's screens is similar to a value scale mixed by an artist combining pigments. However, if you look at the printer's scale under a magnifying glass, the screened dots will show up (Figure 10-9). All commercial printing is a form of optical illusion achieved not by sleight of hand, but by dot screens. The same black ink is applied to paper for a 90-percent gray or a 10-percent gray, but

10-9 A linen tester magnifies screened dots.

10-10 PANTONE® Color
Formula Guide.

the dot screen fools the eye into believing it is different. Where there are more dots the ink looks blacker. A solid ink is not screened, but is printed at 100 percent.

There is an analogy here with the computer screen. The image on screen is composed of dots, or pixels, of varying colors. The image the printer creates is also composed of dots, this time of solid colors of ink. The monitor uses varying intensities of light to create (additive) color while the printer uses varying densities of ink (subtractive pigment; see Plates 6a, b).

Plate 4 shows 10- to 100-percent tint screens of the three process colors: yellow, magenta, and cyan. Try looking at them with a magnifier. Changing the hue or making an ink appear darker is done by combining screened percentages of different colors. To change a cyan to purple, for example, a tint screen of magenta could be laid over it. The new color effects that are generated by using screens of process colors are referred to as "fake" colors (Plate 5). Figure 10-11 is a PANTONE® Guide that shows process color combinations, while Figure 10-10 shows an array of PANTONE® spot colors. When creating such colors electronically, or specifying by traditional paste-up mode, the designer should reference guides like this PANTONE® chart

and specify ink percentages or numbers rather than "going by eye."

It is important for the designer to correctly visualize these screened color combinations before sending them to the printer. The "comp" may have been prepared with markers or cut paper to show the client. Or it may have been generated on the computer and shown on screen. The goal is to arrive at a printed piece that matches your expectations.

## SPOT COLOR OR PROCESS COLOR?

If you're using one to three "spot" colors, there are several numbered guides to assist you. The most complete, PANTONE* MATCHING SYSTEM®, consists of a full line of color specification books, coordinated by numbers. These formula guides, first developed in 1963, enabled the designer to specify a color number that the printer could match, using a reference guide (Figure 10-10). This was much more scientific than specifying that a logo be printed in a bright cool red. Each ink color has its own number. Choose the ink color from the guide and enter it on your computer, or tell the printer its PANTONE® number. The printer then prepares the ink you have specified. To get the desired blue for your two-color design, you might specify a PANTONE® 313 with a 20-percent screen of black. A variety of reference books show screened percentages of these ink colors. They also show what happens when you combine two different ink colors in screened percentages. Using spot colors is usually less expensive than full process colors.

*All trademarks used herein are either the property of Pantone, Inc. or their respective companies.

## PROCESS COLOR SEPARATIONS

The offset reproduction of a full range of color, rather than just two or three colors, is done with CMYK process color. The three primary colors in process printing are yellow, magenta, and cyan, as we have discovered. The addition of black as a fourth color gives depth and solidity to the image. These four printer's inks produce the visual effect of full color (Plate 16).

Once the designer has given the printer a full-color illustration or photograph to reproduce, either traditionally or electronically transferred, the printer separates out the process colors. The artwork is separated into three color exposures from which the printing plates will be made. A black separation is also made. When the press is inked with each of these four colors, and the color is laid down from the plate onto the paper, an illusion of full color results. The varying densities of halftone dots overlap and lie beside one another, mixing optically. It is a truly effective illusion.

As with spot color tint screens, the mixing happens not within the pigment, but within the eye of the viewer. Unlike the even dot coverage of tint screens, a process color separation is made of dots of varying densities that correspond to the color density in the original image. This variation is why such a complex range of color can be produced from only four process colors. Examine the full-color images in this book with a linen tester magnifier.

## CUTTING COSTS

Each additional ink used in a design means the printer must do additional work preparing plates, negatives, and the press. The more ink colors you use, the more printing the design will cost.

10-11 PANTONE® Process Color System® Guide.

Combining screened percentages of inks will enable you to get the most out of each color you pay for, and can decrease the cost of the job.

Another way to get more color into a job without increasing the cost is by printing on colored paper. There are excellent reference books (often from paper companies) on using colored inks on colored papers. The color of the paper will show through, subtly altering the look of the ink. For this reason, white ink is seldom used in the printing industry. Opaque white is difficult to achieve. A study of how tint screens, ink, and paper interact will help achieve the effect desired effect at a minimum cost.

## HALFTONES, DUOTONES, AND TRITONES

Photographic prints used for halftones should have an extended tonal range with good contrast. If your negative has good detail, it can be converted to a good halftone, but while a poor negative or print with loss of detail can be improved, it cannot be converted into a high quality halftone.

Duotones and tritones are commonly used techniques for printing black-and-white photography using spot colors. Although these halftones are limited in color, there are many options to

consider (Plate 13). Electronic scanning can selectively enhance the tonal range, and different line screens can be employed from coarse to very fine. A halftone can be printed over a solid color or over a screened color to create a fake duotone effect.

A duotone is created by generating two halftone negatives from the same image. By printing these negatives in varying colors, different effects can be achieved (Figure 10-12a). Duotone effects depend as much on how you use the two colors as what colors you specify. For example, a black and violet duotone can be run with the black dominant or the violet dominant. The density range of each plate can be extended or compressed, producing shadow detail in one color while the other accents the highlights.

The tritone uses three colors for still more creative options. Black combined with two colors yields a new effect, as does printing with a warm black instead of a true black. A tritone can also be created during printing using varnishes as a third color (Figure 10-12b).

Whereas designers used to be dependent upon reference guides and the seat of their pants to specify these techniques, now it is possible to simulate them quite accurately on the computer. The effect of varnishes and various paper surfaces on ink color, however, are still difficult to visualize before printing.

Technology is changing fast in the design and printing industry, but many principles stay the same. A good design sense and a working knowledge of color theory, coupled with a basic foundation in computer graphics, will see you through.

# PROCESS COLOR SEPARATION SUMMARY

When a computer is used to generate four process color separations, a scanner first digitizes your photo into a fine grid of rectangles called *pixels* (see Plates 6a, b). A higher-quality scanner gives a finer grid with a higher resolution and more pixels. Each pixel is assigned a value for each of the three additive primaries (red, green, blue, or RGB).

The scanned image can be previewed on a color monitor. This display also uses RGB colors, but the final image will be printed with subtractive primary colors (cyan, magenta, yellow, or CMY), with the addition of black (K).

Translating the three RGB values into four CMYK values results in variations caused by switching from an additive (RGB) system to a subtractive (CMYK) system. This entire translation process can be done on a Macintosh or IBM personal computer as well as higher-end systems.

The final step is to turn the CMYK values which are continuous tone separations) into four halftone films. The halftones are translated into film for making printing plates. In the halftone

**10-12a** Photoshop pop-up menu showing a duotone curve on one of the colors that will be used to create a duotone. It controls the distribution of color throughout the darks and lights of the image.

**10-12b** Photoshop pop-up menu showing a tritone combination of inks.

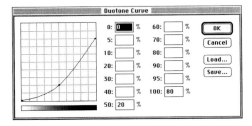

film, color shades are simulated by varying sizes of halftone dots.

# EXERCISES

1. Find printed samples of monochromatic, analogous, and complementary color schemes. Search for samples of color used in graphic design, advertising, or packaging that convey a particular mood and reach a particular audience.
2. Find an example of a two-color design that uses tint screens to achieve a multicolor effect. Analyze how this design was prepared for printing. Make notes and discuss them with your instructor.
3. Find a duotone or tritone and compare it under a magnifying lens to a traditional process color photograph. Then compare these halftone effects to the tint screen you analyzed.
4. Using a program such as Photoshop, practice converting from RGB to CMYK to HSL and manipulating the colors using slider controls.

# PROJECT

## *Word and Image Poster*

Prepare two full-color posters that combine the image of a famous person with a related word. The word related to each image can be a name or an association the image brings to mind. Pay close attention to integrating the typography with the image through various gestalt unit-forming techniques.

Choose a complementary, split complementary, or analogous color scheme and create two versions of the poster. Use tint, tone, and shade to give your color schemes different personalities.

## *Objectives*

1. Practice using color to express a mood appropriate to an image.
2. Practice integrating word and image from the standpoint of both pure design and content.
3. Control color and learn more about it by using different models and creating variants of tint, tone, and shade.

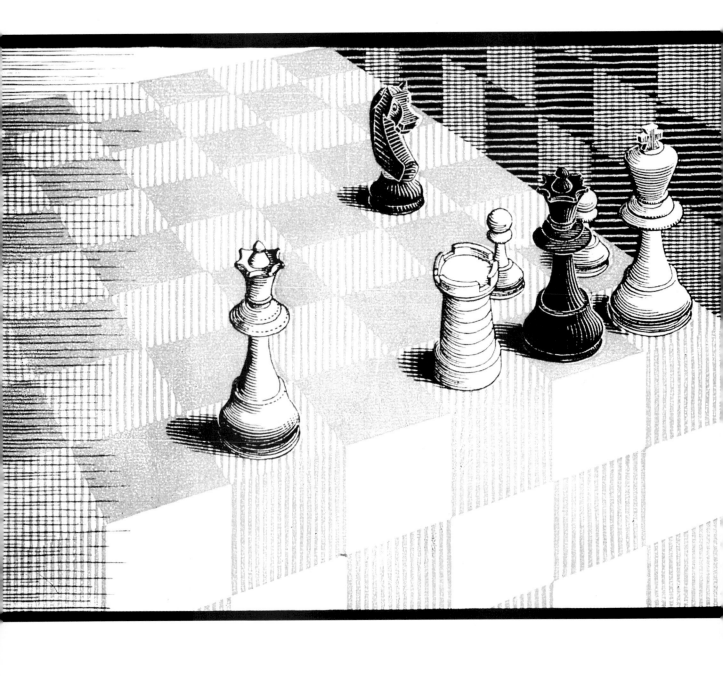

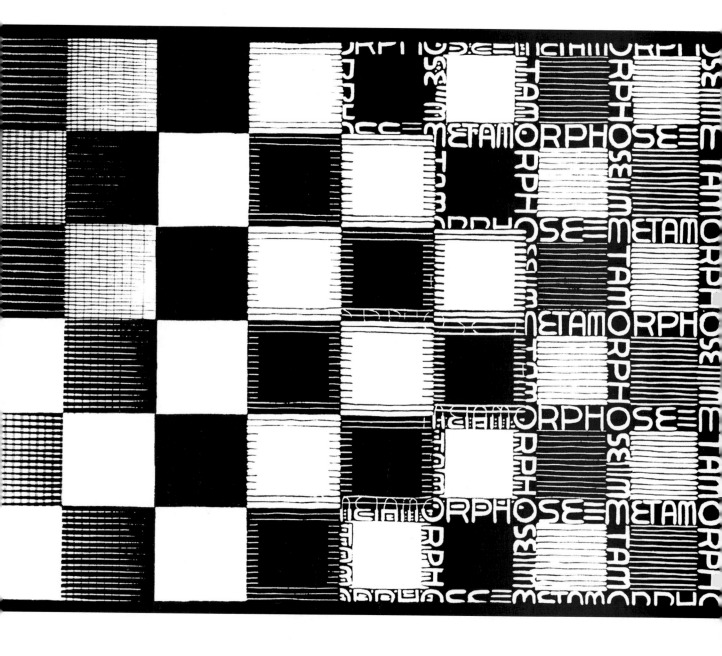

# PRODUCTION: THE TOOLS AND PROCESS

ELEVEN

## A DESIGNER'S TOOL

Computers have had a tremendous impact on the graphic design field, and it's worth spending a little time at the beginning of this chapter to understand how this invaluable tool works. Its applications in the design field are many.

CAD/CAM (computer-aided design and manufacturing) systems can generate three-dimensional models of a new automobile with the designer never touching anything but the computer. Design can go from the designer's computer to the offset press, all as digital files. The World Wide Web knits us together with an exchange of visual information and other data sharing like never before. The readily available multimedia and animation programs like Premiere, Director, After Effects, and Astond allow the designer to generate animation, interactive environments, and presentation graphics. Solid information about good design basics will continue to be very useful in all the new fields created through the continuing development of computer graphics (Figure 11-1).

The flexibility and convenience of this powerful tool are revolutionary. A designer can create multiple variations of an image or page layout, experimenting with color, shape, or grid effects. Changes from the client can be accommodated quickly, for example, with new type inserted or deleted and allowed to reflow into columns. Special effects in overlapping, tint screens, and manipulated imagery are readily achieved. *Now, more than ever, there is need for a designer's eye to be well educated and highly discriminating.*

Keep experimenting and asking yourself, "What is the relationship between the elements of the design? Does the form of the design succeed in conveying the message?" Special effects can be seductive. Always ask, "Are they also good design?"

11-1  Ad layout courtesy of Apple Computer. **Dennis Lim,** art director; **Grey Ketchum,** writer; **Karen Zimmerman,** producer; **Nigel Perry/Gary McGuire,** photographers. Prepared by BBDO, Los Angeles, CA.

# ANALOG AND DIGITAL DATA

Many users are unaware of the structure of the hardware they are manipulating. A basic knowledge of what makes it all work will help designers prepare their files most effectively, and a background in the terminology will help professionals communicate clearly about projects.

What is it that makes computers so different? The fact that they deal in digital information. The analog world is full of continuous tone photographs, long-playing records (remember?), and clocks with smoothly moving hands. We ourselves live in an analog world, with time flowing smoothly past, as day fades to night, as we grow up and gradually age.

The digital world, however, is full of discrete units of information, like music on CDs and digital clocks. Each piece of music or unit of time is a separate, discrete entity that can be accessed and manipulated. When a black-and-white continuous tone photograph is examined under a magnifier, all that's there is a close-up of continually changing gray values. When a digitized photograph is examined close up on a monitor, there are individual picture elements or pixels that give the illusion of a continuous gray. Each of those separate pixels can be manipulated, adjusting value, hue, and luminosity, giving the designer, photographer, or photo retoucher total control over the image.

## ANALOG TO DIGITAL CONVERSIONS

In a scanner or a digital camera, analog to digital converters (ADC) convert analog voltage signals to digital RGB values ranging from 0 to 255. In a flatbed scanner, for example, a page is placed face down on the scanner and a scan head moves along the page, illuminating it. The light reflected from the page strikes a series of mirrors that redirect it to a lens. This lens focuses the beam of light into a prism that splits the beam into red, green, and blue components. The red, green, and blue light beams strike rows of photosensitive CCD cells where they are converted into an analog voltage level. Finally, the analog to digital converter changes these voltage levels to digital information, storing the RGB levels for all the individual pixels in the image that are seen on the screen.

## THE SCREEN IMAGE

Raster graphics create the video display the same way a home television does. A raster beam shot from electron guns illuminates the display line by line. As it moves across the screen, the raster beam's brightness and color is determined by instructions from the computer hardware.

Each spot on the screen, called a pixel (indivisible visual unit), represents a location in memory. A digital image is broken down into pixels, each of which can be individually accessed and manipulated. Each pixel location in memory is composed of a bit map that has an "on" or "off" command stored several bit planes deep. All computer graphics comes down to "on" and "off" commands (Figure 11-2).

11-2 All computer graphics are created by "on" and "off" commands, represented here as 1 and 0, or black and white.

| 1 | 0 | 0 | 0 | 1 |
| 0 | 1 | 0 | 1 | 0 |
| 0 | 0 | 1 | 0 | 0 |
| 0 | 1 | 0 | 1 | 0 |
| 1 | 0 | 0 | 0 | 1 |

a

b

**11-3a,b** This bitmap shows the on and off commands that are represented on the monitor as pixels forming a simple "x."

The resolution of a screen controls its sharpness and clarity. You may have noticed the jagged edges on some computer displays. Because each spot on the screen is a pixel corresponding to a spot in memory, the number of individual pixels will determine the resolution of the image (Figures 11-3a, b). The screen, the file, and the printer may all have different resolutions. For print graphics, a high final resolution is mandatory.

## OBJECT-ORIENTED AND BIT-MAPPED GRAPHICS

There are two kinds of image files in computer graphics. Vector graphics and raster graphics are also known as object-oriented and bit-mapped graphics. Illustration and drawing programs are generally vector graphics programs. They are also known as object-oriented programs. Images are created by lines drawn between coordinate points and are not composed of pixels. These images can be selected and moved, separately from other objects. Illustrator and Freehand are vector graphics programs. They create images with clean, sharp edges. Remember René Descartes? A 17th century philosopher whose most famous words were, "I think, therefore I am," Descartes also created the Cartesian coordinate system that vector graphics is based upon. In this coordinate system X and Y are a two-dimensional graphic, and X, Y, Z are three dimensions. It is interesting to realize that computers use information from that long ago. Objects created in vector graphics are easily selected and manipulated (Figure 11-4).

Bit-mapped programs use raster graphics to create images. This means

**11-4** Vector graphics are created by lines drawn between coordinate points.

11-5 **Todd Hubler.**
This close-up shows the pixels that create the digitized image.

each pixel is individually manipulated through color and size to create a "map" of your image. This is done by accessing the individual bits in each pixel. Photoshop and Fractal Painter are both bit-mapped graphics programs (Figure 11-5). These programs seem to have a more intuitive feeling, seeming to operate much like paint or drawing materials. Bit-mapped images will lose data when changed in size, unlike vector graphics that retain their clarity as they are scaled up or down.

Page layout programs will accept both forms of graphics. This is usually where type, illustrations, and photographs are compiled for printing. PageMaker and QuarkXpress work with outline vector graphics fonts to give sharp, clear, resizable typography.

# HARDWARE AND SOFTWARE

The hardware are the physical components that make up a computer graphics system. This hardware is driven by software programs that tell it what to do. The central processing unit (CPU) is the main part of the system that houses the hard drive. This hard drive, along with the built-in floppy disk, CD-ROM and/or Zip and Jaz drives, give access to

personal file storage. There are various forms of external storage. The visual display terminal (VDT) shows the images as they are created.

# MEMORY

All of a computer's ability to store, recall, and display images is based on the simple notion of on or off (Figure 11-2). A single piece of information like this is called a bit. It can be used to represent a black or a white pixel. A group of bits can handle grays and even complex colors. Eight bits are called a byte and can store 256 different grays or colors per pixel. Three bytes (24 bits) gives the capability of rendering 16.7 million colors. Full-color images use 24 bits to represent each pixel within an image. A full-color image, especially in high resolution, will take up much more memory than a gray scale image because it uses more bits of information (Figure 11-7).

# RAM AND ROM

There are two kinds of memory in a computer. An integrated circuit chip on the computer's motherboard has a permanent memory called ROM (Read Only Memory). It holds the computer's essential operating instructions. The RAM (Random Access Memory) is the memory

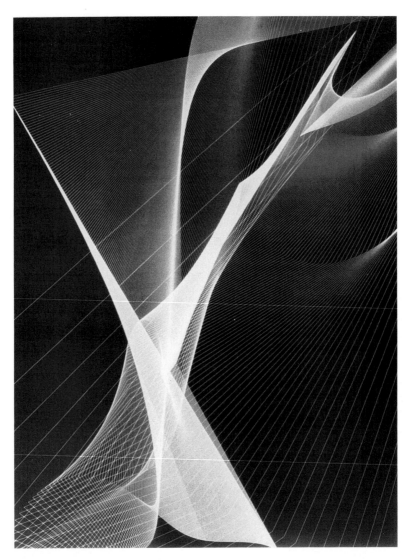

**11-6** "No Hope Can Exist Without Reason." **Melvin Pruett,** computer artist; and **Julius Friedman,** art director/designer. This image was used as a poster for Brown Cancer Center.

**11-7** A bit of information is organized into groups called a byte. Four bytes currently make up the Macintosh "word."

used to actively create your files. When you launch an application or open a document, it is loaded into RAM and stored there while you work. Enough RAM is needed to hold the software you're using and the data you generate.

In this author's assessment, 32 Mb (megabytes) of RAM currently provides enough memory for minimum student needs in static 2-D digital imaging, but more is always better. RAM chips also range in speed (measured in ns or

nanoseconds). Be sure to buy the ones specified for your computer.

Most RAM chips are soldered onto SIMM (Single In-line Memory Module) boards. They're fairly easy to plug in and can be added to your system to increase its memory capacity. Each system has a particular configuration of SIMM or DIMM boards. Make sure any RAM chips will fit your particular board.

## STORAGE DEVICES

Where do you store these large files you've created? Hard drive space is always too short, but two gigabytes is a good base. You can add an internal drive to most machines. Designers resort to a wide array of external portable storage devices that allow them to bring their images to the service bureau, or to archive files (see the section later in this chapter on the production process). Obviously, whatever route you choose, the vendors you deal with must be able to support it. Some current alternatives include ZIP drives, EZ drives, Jaz drives, and Syquest storage drives. Electronic file transfer is becoming a reality.

# INPUT/OUTPUT DEVICES

## INPUT DEVICES

There are many peripheral devices to put data into a computer. Scanners come in many varieties, from flatbed to transparency to drum scanners. Their operation is discussed later in this chapter, related to prepress. The higher the resolution a scanner can produce, the more it will cost to purchase (Figure 11-8).

Digital cameras and video cameras are two other forms of input. A digital camera captures a continuous tone, analog image and converts it to digital data, saving it to a hard drive in digital form. Still video cameras can be mounted next to the computer system and take the place of more expensive 3-D scanners. Higher end video cameras are often used in the field by news organizations. A transceiver allows images to be transmitted via standard telephone lines anywhere in the world.

There are a tremendous variety of input devices around, and careful background research will help to determine

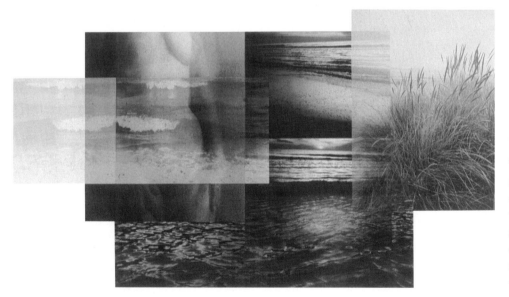

**11-8** A. E. Arntson. This image was created in Photoshop with 300 dpi "Leaf" film scans. It was stored on a Syquest as an 80 meg file and output at a service bureau as a 30 × 36″ photographic print.

which will meet your particular needs and budget lines.

## OUTPUT DEVICES

Will you want a print of your design for a portfolio? That image on the screen needs to be output in a usable manner, unless you plan to use it for a Web site or to download to video for viewing. There are a variety of printers on the market.

A PostScript-equipped printer that can read EPS files is an important piece of equipment. PostScript is a device-independent format that means the file will print out at whatever dpi the printer is capable of delivering. That's why it's possible to print a design on a desktop 300 dpi printer for proofing and then send it to a 3000 dpi image setter for high resolution output.

There are a variety of printing technologies available for your studio or computer lab, and each creates a slightly different kind of image.

The Inkjet printer sprays ink drops onto the paper where they form characters or shapes. Thermal inkjets use heat for maximum image quality. An inexpensive printer, it often does not achieve realistic color output, but can work well for charts and graphs.

Thermal wax transfer printers use thin colored ribbons of wax that are heat embossed onto the page. They give vibrant, saturated colors. It uses four separate passes under the colored ribbons to make a print, and registration can sometimes be a problem.

Dye sublimation printers heat up colored ribbons until the pigments turn into gas, which is absorbed by the polyester coating on the paper. The output from these printers is continuous tone, and thus can simulate a traditional photograph.

Electrostatic printers work the same as photocopy machines. Iron filings are fixed onto the page with heat. The laser printer is an electrostatic printer. The laser printer gives a good image and is suitable for high volume demand, capable of producing many thousands of prints in a month.

An imagesetter is a high resolution device found at service bureaus and commercial print shops that exposes the image onto film that is then chemically developed, in preparation for offset reproduction.

## A FLEXIBLE TOOL

There are many new avenues of non-print design and communication opening up as computers continue to develop. Interactivity is a quality unique to computer graphics that is shared by no other medium. This technology has the power to reshape our perception of ourselves and the world in which we live. Wonderful as this electronic tool is, for an artist and designer, the greatest tool of all is a flexible, curious, open mind. Education is a lifelong process—especially now, as changes come ever more quickly and challenge our understanding of the world and how we function in it.

# PREPARING CAMERA-READY ART

## THE PROCESS

The first step in preparing art for the printer is the job of the graphic designer. It is the designer who is responsible for decisions about the placement of elements, the location of color, the choice of imagery, and the type style. Once the design is approved, the job is sometimes turned over to a prepress artist who prepares the design for printing. Many entry-level jobs for designers are in pre-

press production, but many designers who generate their own electronic designs also prepare their own prepress files.

Preparing art for the printing process has changed a lot in recent years. Most of it in the United States is now done with electronic prepress techniques. An understanding of the terminology will provide a strong foundation for the new designer. It is possible to better understand the computer language and printing process when one begins with a historical knowledge of traditional techniques. Much of the terminology is the same, for a good reason. The final stage of reproduction on press is still much the same, whether the design arrives electronically or mechanically. So we'll include a brief discussion of the terminology and preparation of traditional mechanicals. Some one- and two-color jobs are still reproduced by this method.

## AN OVERVIEW

The traditional pasteup artist prepares a black-and-white version of the design that is *camera ready*. It may have been printed out on a laser printer or created by hand. All of the components of the design are assembled and colors specified before sending to a process camera to have film shot and plates burned (Figure 11-9*a*). If any artwork is to be reproduced in full (process) color, it must be sent separately to be color-separated by a laser scanner. All photographs must also be sent separately to be made into halftones. A process camera will produce negatives of the black-and-white artwork. These negatives are prepared for plate-making by a technician called a *stripper*. The plate is exposed, put on the printing press, and the final printed copies of the original layout are produced in whatever colors are specified. In the digital prepress version, all scans are placed on the computer file to be sent to the printer or service bureau, where the negative is created by *ripping* that file onto a negative. The remaining steps are the same as in the traditional process (Figure 11-9*b*).

Both the electronic and traditional process require high standards from everyone involved. Often the printer can answer questions about the equipment a job will be run on that will influence preparation of the artwork. This chapter will discuss the preparation of artwork for the offset press, the most common method of reproduction.

## TERMINOLOGY

To the printer, the terms *art* and *copy* refer to all material to be reproduced. The copy is the typeset material, whereas art is everything else. All photographs,

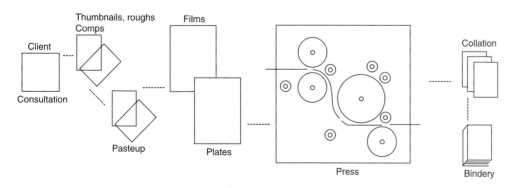

11-9a  Traditional print method.

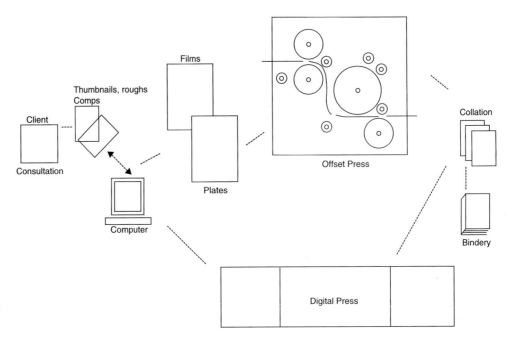

**11-9b** Electronic print method.

illustrations, and diagrams are called art. In general, they fall into two classifications: line art and continuous tone images. The latter are prepared differently on a traditional *mechanical,* depending on whether they are to be reproduced in one color or several.

### Line Art

*Line art* is made up of a black-and-white image with no variation in grays except those created by optical mixing. In the traditional process, anything that is line art may be pasted up directly onto a board. It is ready to be photographed for reproduction. Anything that is not line art must be handled separately because it must be converted at the printer's or via electronic prepress into line art dots called screens or halftones. The printing press will only reproduce line art (Figure 11-10).

Typeset copy, pen-and-ink drawings or diagrams, high-contrast black-and-white photography, India ink solids, and line art scans are all forms of line art. Screens printed on a 300 dpi (dots per inch) laser printer do not generate clarity of reproduction. If working with a traditional preparation, don't send a laser printed screen or halftone, instead ask the printer to strip in a screen at the negative stage, unless you're working with large, special effect dots (Figure 11-11).

### Continuous Tone Art

Art that produces a graduated or blended variety of values is called *continuous tone* art. It includes photographs, illustrations, or diagrams done with pencil or paint, and any other method that produces a variety of values. When creating such art on computer, the image is scanned and incorporated into the digital file, and the resolution is an important factor that is discussed elsewhere in this chapter. In a traditional prepress process, the position of these elements must be indicated on the paste-up, and the continuous tone art is sent

11-10 Copyright-free line art.

separately (Figure 11-12). It must then be converted into line art and placed in position on the negative at the printers. Continuous tone images are converted into a special dot screen called a halftone screen (Figure 11-13). Art that is sent separately to the printer must be clearly marked as to position in the final file for printing.

When preparing a traditional pasteup, two- or three-color art must be broken into black and white for the printer. Each color must be prepared in black on its own separate acetate overlay or somehow separated from other colors. The goal of the traditional prepress artist is to physically separate the various colors and screens in the design (Figure 11-14). All of these overlays must be positioned in perfect registration with one another (Figure 11-15).

The electronic prepress artist sends a file with the process or spot colors prepared and with line art or continuous tone art in place, often on software lay-

11-11

ers. The final offset color printing is done by making a separate negative and plate for each necessary color. The different inks will be laid on the paper by the press in succession. Direct Digital imaging can skip the negative and plate stages and go directly to press.

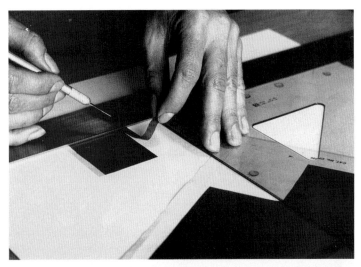

**11-12** Create a "window" for a halftone.

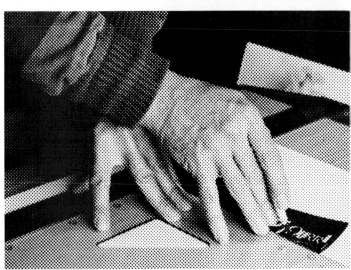

**11-13** Halftone dots enlarged.

**11-14** Acetate overlays have various pasteup applications.

### Spot Color Variations

Reversals and tint screens are some line art variations that can add interest to your one- or two-color art (also called spot color). They should be planned out at the design stage. A reversal can also be converted to a tint screen (Figures 11-16*a, b, c, d*). The screen percentage and color can be created by the electronic artist on the file or specified by the traditional process on an overlay. Crop marks indicate on both traditional and electronic prepress where the end of the page should be. They tell the printer where to trim the sheet. Registration marks indicate how the layers of color should overprint.

### Registration

There are three types of color register: nonregistered, commercial register, and hairline register. Nonregistered colors do not abut. Commercial register (sometimes called lap register) means that slight variations in placement of color of about one row of dots are not important. Hairline register is a term for extremely tight registration, where the tolerance is not greater than half a row of screen dots. Traditional acetate overlay separation is appropriate for nonregistered or commercial registration. It is not suitable for hairline registration. When preparing an electronic file, trapping becomes an important consideration to ensure successful, tight registration of colors that lie side by side. Some software programs, such as Quark, do automatic trapping, inserting *choaks* and *bleeds*. In some cases the printer or prepress service bureau will trap your file for you. It's important to clarify expectations.

## COMMON GROUND

As you have seen, there are some differences in traditional and digital prepress preparation. There are many similar concerns, however, that intersect at the printing process itself. Careful consideration of LPI, dot gain, and paper quality is necessary to ensure quality output whether via traditional or digital means.

*Dot gain* occurs when a halftone dot prints larger than intended. It causes a printed piece to look very dark and contrasty. When examined under a magnifier (a linen tester or loupe), the halftone

11-15 Accurate registration marks are important.

a

b

c

d

**11-16a** Line art reversed.

**11-16b** Specify percentages for screen tint.

**11-16c** A dropout—line art reversed out of a tint screen.

**11-16d** A surprint—line art superimposed over a tint screen.

dots appear to be large and bleeding into the white spaces. An absorbent paper can cause dot gain, as can problems with the press itself. A poor photographic halftone can also be responsible for dot gain. The fewer the reproduction steps between the original photo and the printed image, the less opportunity for a dot gain problem to occur.

*Lines per inch* (LPI) refers to the screen frequency of the actual printed piece. The higher the lines per inch, the finer the printed image because the rows of halftone dots are closer together and are very small. However, the higher the LPI, the more tendency there can be toward a clogging of halftone dots, or dot gain. Coated papers will handle higher screen frequencies than uncoated or newsprint:

120–150 LPI for coated paper stock

85–133 LPI for uncoated paper stock

60–80 LPI for newsprint

In traditional prepress, the printer is generally responsible for worrying about dot gain and establishing an appropriate LPI for the designer's paper choice. In electronic prepress, the designer must take a more active role in this area, as discussed in the next section.

## DIGITAL PREPRESS

Computer technology is continually changing how images are created and reproduced. We can merge design and production into a much more integrated process than before. Designs can be previewed on the computer screen (or in a proof stage), changes suggested by the client, adjustments made by the designer, and the final design sent to the production people via electronic files. Color correction, photo retouching, and color separations can be done on the desktop system before sending to a

service bureau or printer for a high resolution output to film. And once the design is in digital form, there are vast possibilities for reutilization.

While this all may sound simple, it is actually quite complex. There are lots of ways to corrupt a digital file and confuse the printer. As with the traditional printing process, clear communication between designer, prepress technician, service bureau, and printer is a must.

## THE RIP

The designer may generate all the elements of an electronic file or may hire a service bureau to create the high resolution scans for images. Once the publication is assembled, the designer or someone he or she designates will need to verify that the file is ready for raster image processing (RIP) on an imagesetter. A typical computer monitor has a resolution of 72 dpi (dots per inch), while a typical laser printer has a resolution of 300 dpi. The imagesetter that will send a file to film, however, usually has a resolution of 2400 dpi or higher. The pages might print fine on a laser printer, but fail to print on an imagesetter, since it calculates pixels by a different method. It's a safe bet that if the pages won't print on a laser printer, they probably won't print on an imagesetter either. How do you ensure that those pages are ready to RIP? Many of these considerations are especially important when using imported elements and multiple programs.

### Some Do's and Don't's

It's important to keep an electronic file clean and neat. If you don't need something in a file, delete it. Don't cover it with a white rectangle or leave it on a hidden layer.

Avoid putting files into files, and then putting these files into yet more files. This process is referred to as *nesting* and it can snarl the RIP by requiring many unnecessary steps of electronic memory (Figure 11-17).

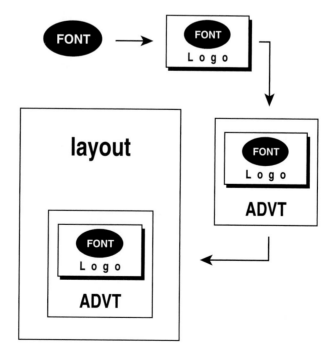

11-17 Avoid "nesting" electronic files as shown. Import each element directly into the page layout program.

When using multiple programs, it's best to assemble all the elements in your final output program.

Do any manipulation of those elements in the original file before importing. Rotate and resize the image in Photoshop, for example, before sending it to Quark. Don't plan to resize, mask, or rotate an imported graphic. They make the RIP work much harder. When you use a large graphic, build a new file with only that graphic to the right scale. Then import that into your layout for fine tuning.

Avoid scaling graphics up or down by large amounts. The data may stay the same, and you can end up with a very tiny, very high resolution image, or a very large, relatively low resolution image.

Scan an image at approximately the size it will be in the final publication. If it is necessary to drastically reduce the size of an image, plan to also use the software program to reduce the resolution (DPI).

# FONTS

Fonts are composed of a *printer font* and a *screen font*. The printer (PostScript) font allows typography to output to print, while the screen font is a cruder version that shows up on the monitor. The RIP needs to find and use exactly the font used to create the document. It can't be some other vendor's version of Helvetica. It has to be the exact one used in your publication in order for the line breaks to work out correctly. Send all printer and screen fonts along with your document (Figure 11-18).

Don't rely on pop-up menu styles to create bold, italic, or condensed versions of your font. These variations are not specially designed typography. They are computer-generated distortions and will not RIP well. Use the real fonts in the font menu. Avoid Truetype fonts, which do not RIP well for print graphics.

# SCANNING

In traditional printing, the designer sends a continuous tone photograph or transparency along with the pasteup or mechanical, and specifies where the image should be inserted and resized. The printer then creates a halftone negative at the correct lines per inch (LPI) for the press and the paper choice. Traditional photographic halftones, however, are less and less common. The primary tools for creating a halftone today are the computer and imagesetter.

When the designer is creating the publication electronically, the photo is usually scanned on a desktop scanner or sent to a prepress service bureau for a high-end drum scan. The designer needs to be familiar with terms such as LPI and DPI, and understand their relationship in order to ensure good quality results.

A higher resolution has more dots per inch (DPI). That refers to how many dots fit within each inch to re-create an

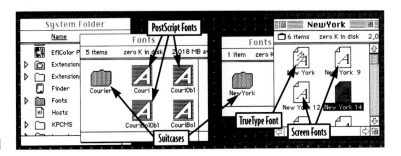

11-18

image. More DPI produces more data and potentially a finer reproduction of an image or typography. A 72 DPI *low res* scan can show jagged edges of pixelation when printed. However, avoid scanning at a higher resolution than is needed, which wastes time and file size.

## LPI AND DPI

When the continuous tone photograph is halftoned in the traditional process, it is converted into dots on a photographic negative. When a continuous tone photograph is scanned via the digital process, it is converted into dots on an electronic file. The more dots, the higher the resolution or DPI.

There is a relationship between the resolution of your scan and the lines per inch of the final printed piece. For a good quality printed piece, it's important to pay attention to this relationship.

Do you know the optimum LPI (lines per inch) of your printed piece? If not, ask the printer and look at the list on page 202. LPI is sometimes called screen frequency or screen ruling. For halftones, a final DPI resolution of 1.5 times the LPI usually works well. The formula is LPI $\times$ 1.5 = DPI scanning resolution. (Remember that resizing the image will change the DPI and plan accordingly.) LPI will vary depending upon the paper used for printing as mentioned earlier in this chapter. This is true whether preparing traditional or electronic files; but in traditional mechanical preparation, it's usually the printer's problem to figure out. It's still best to consult with the printer about LPI.

### Scanning Suggestions

Using a retouching program to "sharpen" an image will produce a cleaner looking file. A blurry scan may not be improved with higher resolution, but it will look better when software sharpening filters are applied, such as Photoshop's Unsharp Mask filter.

When scanning, crop away the white borders. They create data that adds to the file size. If cropping is desirable, do that in the scanning stage to save memory and reduce file size.

A line art image will not need to be halftoned when it is scanned. When printing line art scans, use very high resolution and use sharpening. Image resolution does not need to be higher than the output resolution, but if the file is going to an imagesetter for a RIP, try for at least 800 DPI on a line art scan. On a 300 DPI scanner, this can be achieved by scanning a larger image and downsizing it.

Every time material is duplicated photographically, there is some image degeneration, or loss of information. Provide film from the imagesetter to the printer in the proper format to avoid a duplication step. Ask the printer if film should be provided emulsion side up or down, in negative or positive, and provide that information to your imagesetter bureau. Oftentimes the imagesetter is operated by the printing company, and that simplifies communication.

## FILE LINKS

To insert scans or other graphics files into a layout program, the computer must find those files. To find a file, the computer searches along a path established when the graphic was imported into the layout program. This path is known as a link.

There are several reasons why this link may not be found. If the graphic was renamed, or moved to another folder, that can break the link. All graphics files should be sent to the service bureau along with the job, which is usually assembled in a page layout program. These files should be located in the same folder that uses the graphics.

## FILE FORMATS

The way the image is stored on the disk determines which programs can open, read, and edit that image. Two of the primary formats for storing graphic images on disk are TIFF and EPS, although there are many more formats. If an image is not stored in the proper format, it will not appear as an option to open or import into another program.

TIFF (Tagged Image File Format) is a widely used bit-mapped file format. It is appropriate for scanned images. Almost every program that works with bit maps can utilize the TIFF format.

EPS (Encapsulated PostScript) is an object-oriented file format that is excellent for storing graphics of any kind. You need a PostScript printer to print an EPS graphic. A PostScript file is a series of text commands that are a page-description language. It's a programming language that is created to put type and graphics on paper. EPS is a refined form of PostScript that will allow an object-oriented *or* bit-mapped program to open the file for editing.

GIF (Graphics Interchange Format) is the image file format of the Compu-Serve online information service. GIF supports 256 indexed colors; most image-editing programs can read and write GIF image files, but it is not compatible with page-layout or illustration programs. Useful for multi media and Web page design.

PICT is a Mac object-oriented file format. It handles bitmap and vector image well. They should be converted to TIFF or EPS before placing in a page-layout program, such as PageMaker or QuarkXpress.

Once you understand the basic concept of file links and file formats, it clears up a lot of questions about why an image may not appear on screen when imported into another program. At a more advanced level, you'll be learning more about this topic.

## COMPRESSION

Sometimes a file is simply too large for the storage device. In that case, data can be compressed to shrink the number of bytes needed for storage. There are two methods used to compress bit-mapped data, called *lossless compression* and *lossy compression*. Lossless gives less compression, but preserves the original image. Lossy methods give high compression, but lose information in the original file. For example, JPEG is a lossy compression method that throws away some of the high-frequency variations in color. RLE is a lossless method that depends upon batch processing adjacent pixels with identical values.

# CONCLUSION

There is a great deal to know about preparing artwork for reproduction, whether it be by traditional or electronic means. Sometimes it seems there is little information in common between the two methods. However, at the heart of both traditional and electronic prepress is the final reproduction. The better a beginning designer can understand the tools and procedures of prepress, the better that designer will comprehend the problems and solutions involved in producing a quality design. Finally, all art prepared for offset reproduction must be clean and accurate, whether prepared by traditional or electronic means.

### Preparing Electronic Files for a Service Bureau

- *Assemble your file in a page layout program like Quark or Pagemaker. It's easier to RIP (raster image*

process) files from a layout program rather than an image manipulation program.

- Bring all your images from Illustrator, Freehand and Photoshop into the final document as EPS files.

- Check the automatic trapping option in Quark and Pagemaker, and ask the service bureau to check your trapping.

- All files must be CMYK before they're assembled into Quark or Pagemaker (if you're doing full color output).

- Only CMYK colors will print accurately. If you're using Photoshop, check the color picker menu for an alert symbol. If the triangle has an ! in it, that means the selected color won't print accurately.

- Include all your original EPS scans and vector graphic files.

- Be sure all documents are linked. Check the links menu in Quark and Illustrator. If files are missing, locate and include them.

- Supply all fonts used in your document. Supply both screen and printer fonts. To do that, look in the system folder; find fonts. Locate your font with a suitcase icon by it. Inside this are the screen fonts. Find your printer font. It will have a page icon and will be identified as a PostScript file.

- Organize and label these files on a disk. Do a "print window" from the desktop menu of your file folders on the disk. Highlight the file to print from. Send this print, along with a black-and-white proof print of your file to the service bureau.

# REVIEW

## Common Prepress Terms

art
copy
line art
continuous tone art
halftone
LPI
spot color
process color
registration marks
trim marks
dot gain
font
film/plates
mechanical (traditional)
acetate overlays (traditional)
camera ready (traditional)

## Electronic Prepress Terms

DPI
electronic file
software layers
scanned image
analog
digital
vector graphic
raster graphic
printer font
screen font
file links
file formats
RAM
ROM

# GLOSSARY

**abstraction** A simplification of existing shapes.

**acetate overlay** A clear plastic overlay that permits the positioning of units on a pasteup that cannot be put together on a single sheet.

**additive primaries** Red, blue, and green, which combine to produce white light.

**aerial perspective** The creation of a sense of depth and distance through softening edges and decreasing value contrast.

**aliasing** The visual effect that occurs on a computer's visual display screen whenever the detail in the image exceeds the resolution available. It looks like "stair stepping."

**analog** A signal that may be varied continuously. Computers cannot process this kind of signal, so their information must be converted to digital. Analog refers to everything in the real, non-computerized world.

**analogous colors** Hues that lie next to one another on the color wheel.

**applied art and design** Disciplines that use the principles and elements of design to create functional pieces for commercial use.

**ascender** The section of a lowercase letter that extends above the x-height.

**asymmetrical balance** The distribution of shapes of different visual weights over a picture plane to create an overall impression of balance.

**balance** The distribution of the visual weight of design elements.

**bit** Abbreviation of Binary Digit. The most basic unit of digital information. A bit can be expressed in only one of two states, 0 or 1, meaning on or off, yes or no. This is actually the only information that a computer can process. Eight bits are required to store one alphabet character.

**bit map** A text character or image comprised of dots. A bit map is the set of bits representing the position of items forming an image on the display screen.

**bitmapped** A font or image comprised of dots (pixels), as distinct from an object-oriented graphic. Characterized by jagged edges. Also known as a raster image.

**bleed** The part of an image that extends beyond the edge of a page and is trimmed off.

**body type** Type smaller than 14 point, generally used for the main body of text. Also called text type.

**boldface** A heavy version of a typeface.

**byte** A unit of information made up of eight bits. Bytes are commonly used to represent alpha numeric characters or the integers from 0 to 255.

**CAD/CAM** Stands for computer-aided design/computer-aided manufacturing.

**camera-ready art** Artwork that has been assembled and prepared for reproduction on a process camera.

**CD-ROM** Compact disk-read only memory. A storage system of large capacity.

**centered type** Lines of type of varying length that have been centered over one another.

**central processing unit (CPU)** The part of a computer system that contains the circuits that control and execute all data.

**character count** The number of characters in a piece of copy. This number is used in copyfitting calculations.

**choke** A method of altering the thickness of

a letter or solid shape, used in trapping to ensure proper registration of colors.

**closure** When the eye completes a line or curve in order to form a familiar shape.

**CMYK** The process colors of cyan, magenta, yellow, and black inks used in four-color printing.

**cold type** Copy prepared by photographic keyboard typesetting.

**color** The way an object absorbs or reflects light.

**color wheel** The part of color theory that demonstrates color relationships on a circle.

**combination mark** A trademark that combines symbol and logo.

**complementary hues** Colors that are opposite one another on the color wheel.

**comprehensive (comp)** A highly finished layout for presentation.

**computer graphics** The branch of computer science that deals with creating and modifying pictorial data.

**continuation** When the eye is carried smoothly into the line or curve of an adjoining object.

**continuous tone** An illustration which contains continuous shades between the lightest and darkest tones without being broken up by the dots of a halftone screen or a digital file.

**continuous-tone art** Black-and-white art, such as illustrations or photographs, with a range of values. Must be reproduced with a halftone screen.

**copyfitting** The process of determining the amount of space it will take to set copy in a specific type size and style.

**corporate identity** The elements of design by which an organization establishes a consistent identity through various forms of printed materials and promotions.

**counters** The white shapes inside a letterform.

**crop** To eliminate the unwanted sections of image area.

**cropmarks** Short fine lines drawn on the image to indicate a cropped area, or at the corners of a pasteup to indicate where printed sheet will be trimmed. When used to indicate trim size, they can be called trim marks.

**digital** A signal that can only be in one of two states, on or off. Information, such as sound or image that is in a form that can be electronically manipulated.

**DIMM** Dual in-line memory module.

**direct advertising** Any form of advertising issued directly to the prospect through any means that does not involve the traditional mass media.

**direct mail** Advertising in which the advertiser acts as publisher.

**direct marketing** Sale of goods or services direct to the consumer without intermediaries. Can include door-to-door sales.

**disk** An off-system data storage device for computers, consisting of one or more flat circular plates coated with magnetized material.

**display type** Any type larger than 14 point.

**dot gain** An aberration that can occur in a printed image, caused by the tendency of halftone dots to grow in size. This can lead to inaccurate and coarsely printed results.

**DPI** Dots per inch. This refers to the number of dots (resolution) a device is capable of producing.

**dropout** Copy that is reversed out of a halftone or a tint screen background.

**duotone** A two-color halftone reproduction made from one-color, continuous-tone artwork.

**Egyptian** A slab-serif type category.

**E-mail** Electronic mail. Letters, memos, etc., sent between computers either over a network or with a modem over phone lines.

**EPS** Encapsulated PostScript, a standard graphics file format based on vectors, or object-oriented information.

**figure-ground** The relationship between the figure and the background of an image.

**focal point** The area of a design toward which the viewer's eye is primarily drawn.

**font** A complete set of type of one size and one variation of a typeface.

**four-color process** The printing process that reproduces full-color images by using cyan, magenta and yellow plus black for added density.

**Gestalt** A unified configuration having properties that cannot be derived from simple addition of its parts.

**GIF**   Graphic Interchange Format. A file format used for transferring graphics files between different computer systems via the Internet. It creates very small data files.

**gigabyte**   A unit of measure to describe 1,024 megabytes.

**gripper edge**   The leading edge of paper as it feeds into a press. Usually it calls for an unprinted margin of about 3/8'' (1 cm).

**gutter**   The inner section of a page caught in the center binding.

**halftone**   The reproduction of continuous-tone art, such as a photograph, through a screen that converts it into dots of various sizes.

**hard copy**   A printed copy of an image produced on a computer screen.

**hardware**   The physical components of a computer graphics system, including all mechanical, magnetic, and electronic parts.

**HLS**   Hue, Lightness and Saturation. A color model.

**horizontal balance**   The visual balancing of the left and right sides of a composition.

**hot type**   Typesetting in which the type is cast in molten metal.

**hue**   The name of a given color. Hue is one of the three properties of color.

**intensity**   The saturation or brightness of a color. Intensity is decreased by the addition of a gray or a complement.

**Internet**   An electronic network that spans the globe.

**JPEG**   Joint Photographic Experts Group, a lossy data compression file format that creates small, compressed files by discarding part of the data before compressing. The reconstructed file usually looks quite good on photographic images.

**justify**   To align lines of type that are equal in length so both edges of the column are straight.

**kerning**   Selectively altering the spaces between letter combinations for a better fit.

**keylining**   Drawing an outline on a finished pasteup to indicate the exact position for art that will be stripped in by the printer. Used when hairline registration is important.

**layout**   The hand-rendered plan for a piece to be printed.

**leading**   The amount of space placed vertically between lines of type.

**line art**   Black-and-white copy with no variations in value. Suitable for reproduction without a halftone screen.

**LPI**   Lines per inch. A printing term referring to the resolution of an image.

**logo**   A trademark of unique type or lettering, spelling out the name of a company or product.

**lowercase**   The small letters of an alphabet.

**masking film**   A red film used to block out selected areas of a pasteup where screened images will be positioned on the negative.

**master page**   The page to which certain attributes can be given, which can then be applied to any other page in a document.

**mechanical**   A camera-ready pasteup, which contains all copy pasted in position for printing.

**menu-driven**   A computer graphics system that operates when a user selects options from those displayed on the monitor.

**modern**   A type category that has great variation between thick and thin strokes and thin, unbracketed serifs.

**monochromatic color**   The use of a single hue in varying values.

**network**   The connection of two or more computers. This assemblage of computer hardware and software allows computers to share data, software and other resources.

**nonobjective shapes**   Shapes that are pure design elements, not related to any pictorial source.

**non-photo blue pencil**   A light blue pencil whose lines will not reproduce when photographed by a process camera.

**object-oriented**   Graphics applications that allow the selection and manipulation of individual portions of an illustration or design. This is a characteristic of a vector graphic file and is the opposite of bitmapped graphics.

**old style type**   A type category characterized by mild contrast between thicks and thins, and by bracketed serifs.

**pasteup**  An assemblage of the elements of a layout, prepared for reproduction.

**phosphor**  A material coating the inside of a picture tube. When an electron beam hits this coating, the phosphor emits light in proportion to the voltage of the beam.

**pica**  A typographic measurement of 1/6″ (0.4 cm).

**pictogram**  A symbol that is used to cross language barriers for international signage.

**picture plane**  The flat surface of a two-dimensional design, possessing height and width, but no depth.

**pixel**  An individual picture element. It is the smallest element of a computer image that can be separately addressed.

**point**  A typographic measurement of 1/72 inch, or 1/12 pica.

**PostScript**  A page description language used to describe how a page is built up of copy, lines, images, etc. for output to laser printers and high resolution imagesetters.

**preseparated art**  Art that has been separated onto acetate overlays by the pasteup artist before being sent to the printer.

**primary colors**  The three basic pigment colors of light—red, blue, and green—from which all other colors can be made are called "additive" primaries because when added together they produce white light. "Subtractive" primaries are the magenta, cyan, and yellow of process printing.

**process camera**  A large graphic arts camera used to make film negatives and positives for platemaking.

**proximity**  Visually grouping by similarity in spatial location.

**ragged right (or left)**  An unjustified column of type in which lines of varying length are aligned on either the right or left side.

**RAM**  Random access memory.

**raster graphics**  Computer graphics comprised of bitmaps that create a grid of individual picture elements (pixels).

**rebuild desktop**  Rebuilding the desktop gets rid of obsolete material that builds up as a computer is used. Doing this on a regular basis improves the operation of the computer. The desktop is rebuilt by holding down Option-Command while restarting the system.

**registration**  Fitting two or more printing images on the same paper in exact alignment.

**resolution**  The ability of a computer graphics system to make distinguishable the individual parts of an image.

**reversal**  A change to opposite tonal values, as when black type is altered to white.

**reversible figure/ground**  A relationship in which it is likely that figure and ground can be focused on equally.

**ROM**  Read Only Memory. ROM resides in a chip on the motherboard. This memory can be read from, but cannot be written to.

**rough**  A layout plan that comes after preliminary thumbnails, and is usually executed in half or full size.

**runaround**  Type that is fitted around a piece of artwork.

**sans serif**  Letterforms without serifs. *See* Serif.

**saturation**  The intensity or brightness of a color. Saturation is decreased by the addition of gray or a complementary color.

**scan line**  On a raster-scan computer monitor, one traversal of an electron beam across the picture.

**secondary colors**  Hues obtained by mixing two primary colors.

**serif**  The stroke that projects off the main stroke of a letter at the bottom or the top.

**service bureau**  A company used by designers for high resolution imagesetting, it provides an array of computer services from file conversions to scanning. Service bureaus RIP the information from disk onto film, for offset reproduction. Some printing companies do this work in-house.

**shade**  A darker value of a hue, created by adding black.

**shading film**  Commercially available textured screens of line art on a transfer sheet.

**shape**  A figure that has visually definable edges.

**similarity grouping**  The visual grouping of images with similar shape, size, and color.

**SIMM**  Single in-line memory module. This plug-in board contains the chips a computer uses for RAM.

**software**  Computer programs.

**spec**  Short for "specifying." To write type

specifications (line length, size, style, leading) on copy.

**stable figure/ground**   The unambiguous relationship of object to background.

**stet**   A Latin word used when marking up copy to signify "let it stand."

**stress**   The distribution of weight through the thinnest part of a letterform.

**subtractive primaries**   Magenta, cyan, and yellow—the colors left after subtracting one additive primary from white light.

**surprint**   Line art superimposed over a screened area of the same color.

**symbol**   A type of trademark to identify a company or product. It is abstract or pictorial but does not include letterforms.

**symmetrical balance**   The formal placement of design elements to create a mirror image on either side. A less common form of symmetrical balance also creates the mirror image vertically.

**tertiary colors**   Hues obtained by mixing a primary color with a secondary color.

**thumbnail**   A first stage, miniature plan for a layout.

**TIFF**   Tagged Image File Format. This widely used file format is used for saving scanned, bitmapped images.

**tint**   A light value of a hue, created by adding white.

**tint screen**   A flat, unmodulated light value made of evenly dispersed dots, usually achieved by stripping a piece of halftone film into the area on the negative that the artist has masked out.

**tone**   A hue that has been decreased in intensity by the addition of black or a complement.

**tracking**   The adjustment of space between characters throughout a range of text.

**trademark**   Any unique name or symbol used by a corporation or manufacturer to identify a product and to distinguish it from other products.

**transitional type**   A category of type that blends old style and modern, with emphasis on thick and thin contrast and gracefully bracketed serifs.

**trapping**   The slight overlap of two colors to eliminate gaps that can occur due to normal registration problems during printing.

**type family**   The complete range of sizes and variations of a typeface.

**typeface**   Style of lettering. Each family of typefaces may contain variations on that typeface, like "italic."

**typesetting**   The composition of type by any method.

**unjustified type**   Lines of type set with equal word spacing and uneven length.

**uppercase**   The capital letters.

**value**   The lightness or darkness of a color or a tone of gray.

**variety**   The variations on a visual theme causing contrast in a design.

**vector graphics**   A type of computer graphics in which graphic data are represented by lines drawn from coordinate point to coordinate point.

**vertical balance**   The visual balancing of the upper and lower portions of a composition.

**visual texture**   The visual creation of an implied tactile texture.

**weight**   The lightness or heaviness of a visual image.

**widow**   A short line at the end of a paragraph that falls at the top or bottom of a column or page, or a single word on a line by itself at the end of a paragraph. Also called an orphan.

**windows**   Solid black or red areas of the pasteup that will convert into clear areas on the negative for a screen to be stripped onto.

**word spacing**   The varying space between words, often adjusted to create a justified line of copy.

**x-height**   The height of the body of a lowercase letter like an *a*, with no ascenders or descenders.

# BIBLIOGRAPHY

*Topics are listed by chapters.*

## Chapter 1
### APPLYING THE ART OF DESIGN

Albers, Josef, *Interaction of Color.* New Haven, Conn.: Yale University Press, 1972.

Baumgartner, Victor, *Graphic Games.* Englewood Cliffs, N.J.: Prentice-Hall, 1983.

Behrens, Roy, *Design in the Visual Arts.* Englewood Cliffs, N.J.: Prentice-Hall, 1984.

Bevlin, Marjorie, *Design Through Discovery.* New York: Holt, Rinehart and Winston, 1985.

Buchanan, Margolin, *Discovering Design,* University of Chicago Press, 1995.

Itten, Johannes, *The Art of Color.* New York: Van Nostrand Reinhold, 1974.

Kepes, Gyorgy, *Language of Vision.* Chicago: Paul Theobald, 1969.

Lauer, David, *Design Basics.* Harcourt Brace, 1995.

McKim, Robert H., *Experiences in Visual Thinking.* Monterey, Calif.: Brooks, Cole, 1980.

Rand, Paul, *Design Form and Chaos,* New Haven and London: Yale University Press, 1993.

Supon Design Group, *International Women in Design,* New York: Madison Square Press, Distributed by Van Nostrand Reinhart, 1993.

## Chapter 2
### GRAPHIC DESIGN HISTORY

Bayer, Herbert, et al., eds., *Bauhaus 1919–1928.* New York: Museum of Modern Art, 1938.

Berryman, Gregg, *Notes on Graphic Design and Visual Communication.* Los Altos, Calif.: William Kaufmann, 1990.

Cirker, Hayward, and Blanche Cirker, *Golden Age of the Poster.* New York: Dover, 1971.

Craig, James, *Graphic Design Career Guide.* New York: Watson-Guptill Publications, 1983.

Friedman, Mildred, and Joseph Giovannini, eds., *Graphic Design in America: A Visual Language History.* New York: Harry Abrams, 1989.

Garner, Philippe, *Sixties Design,* Taschen, 1996.

Glaser, Milton, *Milton Glaser: Graphic Design.* Woodstock, N.Y.: The Overlook Press, Walker Art Center, 1983.

Grieman, April, *Hybrid Imagery. The Fusion of Technology and Graphic Design,* New York: Watson Guptil, 1990.

Hoffman, Armin, *Graphic Design Manual.* New York: Van Nostrand Reinhold, 1965.

Hurlburt, Allen, *Layout: The Design of the Printed Page.* New York: Watson-Guptill Publications, 1977.

Jackson, Lesley, *The New Look and Design in the Fifties,* New York: Thames and Hudson, 1991.

Meggs, Philip, *A History of Graphic Design,* New York: Van Nostrand Reinhold, 1992.

Motherwell, Robert, *Dada Painters and Poets.* New York: Wittenborn, Schultz, 1951.

Müller-Brockmann, Josef, *The Graphic Artist and His Design Problems.* New York: Hastings House, 1961.

Müller-Brockmann, Josef, *A History of Visual Communication.* New York: Hastings House, 1971.

Nelson, Roy Paul, *Publication Design.* Dubuque, Iowa: William C. Brown, 1991.

Pesch and Weisbeck, *Technostyle,* Zurich: Olms, 1995.

Rand, Paul, *A Designer's Art.* New Haven, Conn.: Yale University Press, 1985.

Rand, Paul, *Thoughts on Design.* New York: Van Nostrand Reinhold, 1971.

Scheidig, Walter, *Crafts of the Weimar Bauhaus 1919–1924.* New York: Reinhold Publishing, 1967.

Schwartz, Lillian, *The Computer Artist's Handbook, Concepts, Techniques and Applications,* New York: W.W. Norton & Co., 1992.

Snyder, Peckolick, *Herb Lubalin.* New York: American Showcase, 1985.

Varnedoe, Gapnik, *High & Low: Modern Art and Popular Culture.* New York: Museum of Modern Art, 1991.

Velthoven and Seijdel, *Multi Media Graphics, The Best of Global Hyperdesign,* Chronicle Books, 1997.

Wrede, Stuart, *The Modern Poster.* New York: The Museum of Modern Art, 1988.

## Chapters 3–5
### PERCEPTION

Arnheim, Rudolf, *Art and Visual Perception.* Berkeley: University of California Press, 1974.

Behrens, Roy, *Art and Camouflage.* Cedar Falls, Iowa: North American Review, 1981.

Bloomer, Carolyn M., *Principles of Visual Perception.* New York: Van Nostrand Reinhold, 1976.

Gombrich, E. H., *Art and Illusion: A Study in the Psychology of Pictorial Representation.* New York: Pantheon Books, 1960.

Gombrich, E. H., Julian Hochberg, and Max Black, *Art, Perception, and Reality.* Baltimore: Johns Hopkins University Press, 1972.

Goodman, Nelson, *Languages of Art.* Indianapolis: Bobbs-Merrill, 1968.

*Graphis Letterhead, An International Compilation of Letterhead Design,* Zurich, Switzerland: Graphis Press, 1996.

*Graphis Logo, An International Compilation of Logos,* Zurich, Switzerland: Graphis Press, 1996.

Gregory, R. L., *Eye and Brain.* New York: McGraw-Hill, 1966.

Gregory, R. L., *The Intelligent Eye.* New York: McGraw-Hill, 1970.

*Letterhead and Logo Design, Creating the Corporate Image,* Rockport, Mass.: Rockport Publishers, Distributed by North Light Books, 1996.

Meggs and Carter, *Typographic Specimens and the Great Typefaces,* New York: Van Nostrand Reinhold, 1993.

Steuer, Sharon, *The Illustrator Wow! Book,* Berkeley, CA: Peachpit Press, 1995.

Zakia, Richard, *Perception and Photography.* Rochester, N.Y.: Light Impressions Corporation, 1979.

## Chapters 6–7
### TEXT TYPE

Carter, Rob, et al., *Typographic Design: Form and Communication.* New York: Van Nostrand Reinhold, 1985.

Craig, James, *Designing with Type.* New York: Watson-Guptill Publications, 1992.

Dair, Carl, *Design with Type.* Toronto: University of Toronto Press, 1982.

Dürer, Albrecht, *On the Just Shaping of Letters.* Mineola, N.Y.: Dover, 1965.

*Graphis Book Design II,* Zurich, Switzerland: Graphis Press, 1995.

Graphis Brochures, *An International Compilation of Brochure Design,* Zurich, Switzerland: Graphis Press, 1996.

McLean, Ruari, *Jan Tschichold: Typographer.* Boston: David R. Godine, 1975.

Mossin, *Letter and Image.* New York: Van Nostrand Reinhold, 1970.

Ruder, Emil, *Typography.* New York: Hastings House, 1981.

*The Whole Mac Solutions for the Creative Professional,* Indianapolis, Indiana: Hayden Books, 1996.

Tschichold, Jan, *Asymmetric Typography.* New York: Van Nostrand Reinhold, 1980.

## Chapters 8–9
### ILLUSTRATION, PHOTOGRAPHY, ADVERTISING

Cassandre, A. M., *A. M. Cassandre.* St. Gall, Switzerland: Zollikoffer & Company, 1948.

Douglas, Torin, *The Complete Guide to Advertising.* New York: Chartwell Books, Inc., 1984.

*Dover Pictorial Archives.* Mineola, N.Y.: Dover, 1979.

*Graphis Advertising, The International Annual of Advertising,* Zurich, Switzerland: Graphis Press, 1996.

*Graphis Poster Design,* The International Annual of Poster Art, Zurich, Switzerland: Graphis Press, 1996.

Haller, Lynn, *Fresh Ideas in Promotion,* Cincinnati, Ohio: North Light Books, 1994.

Howell-Koehler, Nancy, *Vietnam, The Battle Comes Home: Photos by Gordon Baer.* Dobbs Ferry, N.Y.: Morgan & Morgan, 1984.

Hurley, McDougall, *Visual Impact in Print.* Chicago: Visual Impact, Inc., 1971.

Kerlow, Isaac V., and Judson Rosebush, *Computer Graphics for Artists and Designers.* New York: Van Nostrand Reinhold, 1994.

Leland, Karyn, *Licensing Art & Design.* Cincinnati, Ohio: North Light Books, 1990.

Nyman, Mattias, *Four Colors/One Image,* Berkeley, Calif.: Peachpit Press, 1993.

Pitz, Henry, *200 Years of American Illustration.* New York: Random House, 1977.

Steuer, Sharon, *The Illustrator Wow! Book,* Berkeley, CA: Peachpit Press, 1995.

*The Creative Illustration Book #7,* New York: The Black Book, 1996.

Vaizey, Marina, *The Artist as Photographer.* New York: Holt, Rinehart and Winston, 1982.

Whelan, Richard, *Double Take.* New York: Clarkson N. Potter, 1981.

Wilson, Stephen, *Using Computers to Create Art.* Englewood Cliffs, N.J.: Prentice-Hall, 1986.

Ziegler, Kathleen, *Digitaline Digital Design and Advertising,* Southhampton, PA, Dimensionals Illustrators, Inc., Distributed by North Light Books, 1996.

## Chapters 10–11
## PRODUCTION TECHNIQUES

Blatner, David and Steve Roth, *Real World Scanning and Halftones,* Berkeley, CA: Peachpit Press, 1993.

Campbell, Alastair, *The Graphic Designer's Handbook.* Philadelphia: Running Press, 1983.

Chartier and Mason, *Creating Great Designs on a Limited Budget,* Cincinnati, OH, North Light Books, 1995.

Dennis, Odesina and Wilson, *Lithographic Technology in Transition,* Delmar, 1997.

Evans, Poppy, *Graphic Designers Guide to Faster, Better, Easier Design and Production,* Cincinnati, OH: North Light Books, 1993.

Evans, Poppy, *The Graphic Designer's Source Book . . . An Indispensable Treasury of Suppliers,* Cincinnati, OH, North Light Books, 1996.

*Graphic Artists Guild Handbook: Pricing and Ethical Guidelines.* New York: Graphic Artists Guild, 1987.

*Pocket Pal.* New York: International Paper Company, 1986.

Sanders, Norman, *Graphic Designer's Production Handbook.* New York: Hastings House, 1982.

*The Whole Mac Solutions for the Creative Professional,* Indianapolis, Indiana: Hayden Books, 1996.

## PERIODICALS AND ANNUALS

*AIGA Graphic Design, USA.* New York: Watson-Guptill Publications, annual, 1980–present.

*Artists' Market: Where and How to Sell Your Artwork.* Cincinnati, Ohio: Writers Digest Books.

*AV Video.* Torrance, Calif.: Montage Publishing, Inc.

*Ballast.* Roy Behrens, ed. Cincinnati, Ohio: Cincinnati Art Academy.

*Communication Arts.* Palo Alto, Calif.: Coyne & Blanchard, Inc.

*Fine Print.* San Francisco, California.

Graphic Artists' Guild. *Handbook of Pricing & Ethical Guidelines.* Cincinnati, Ohio: Writers Digest Books.

*Graphis.* Zurich, Switzerland: Walter Herdig.

*How.* New York: RC Publications.

*Print.* Washington, D.C.: RC Publications.

*Print Casebooks.* Washington, D.C.: RC Publications, six annual volumes, 1975–present.

*Step-by-Step Graphics.* Peoria, Ill.: Dynamic Graphics Educational Foundation (DGEF).

*U & LC.* New York: International Typeface Corporation.

# INDEX